THE ART OF
LANDSCAPE PAINTING

To Francesca
with warmest Regards

Paul Strisik
1985

For my wife, Nancy

THE ART OF
LANDSCAPE
PAINTING

BY PAUL STRISIK
A.N.A., N.A.W.A., A.W.S.

Edited by Charles Movalli

WATSON-GUPTILL PUBLICATIONS/NEW YORK

First published 1980 in the United States and Canada by Watson-Guptill Publications,
a division of Billboard Publications, Inc.,
1515 Broadway, New York, N.Y. 10036

Library of Congress Cataloging in Publication Data
Strisik, Paul.
 The art of landscape painting.
 Bibliography: p.
 Includes index.
 1. Landscape painting—Technique. 2. Painting—
Technique. I. Movalli, Charles. II. Title.
ND1342.S77 1980 751.45'436 80–18651
ISBN 0–8230–0273–X

Manufactured in Japan

First Printing, 1980

4 5 6 7 8 9/86 85 84

CONTENTS

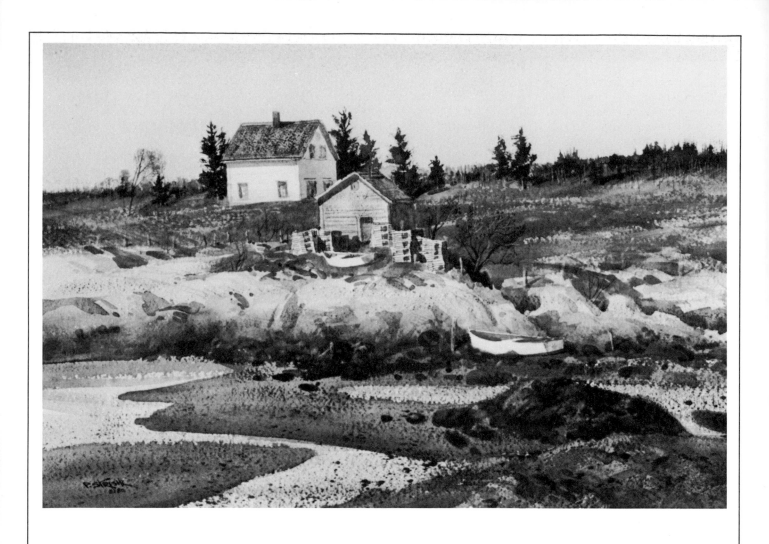

Low Tide, Indian River, watercolor, 14 x 21 in. (36 x 53 cm). I painted this typical New England house and lobster shack at low tide on a bright, clear day. I drastically rearranged the subject matter in order to create a composition with a simple center of interest; the arrangement leads the eye into the picture easily, from the foreground patterns to the skiff to the fish house and beyond.

Paintings have fascinated me for as long as I can remember. When I was eight or nine, one of my playmates lived in a house with fine paintings on the walls. At that time, paintings were not seen in homes as often as they are today, and I can still remember how impressed I was. There was a *magic* in those paintings that completely enveloped me. I can also recall having seen artists painting the Italian fishing fleet near my home at Sheepshead Bay, New York, when I was young. Spellbound, I'd watch them by the hour. Later on, I haunted the halls of the Brooklyn Museum; whenever I smelled turpentine, I would make a beeline for the busy copyists, whom I loved to watch. In those days, I had all sorts of interests, from photography to gemstone cutting, and I mastered most of these hobbies fairly well. But as soon as I started painting, I saw that it could *never* be mastered. It was more than a pastime. It was a profession—a profession of great responsibility and dignity.

My first teacher was a noted abstract painter who stressed personal expression over everything else. Yet I was unhappy during this period. I didn't see how his approach could ever lead me to the kind of painting I most admired in the museums. I once asked the teacher if I shouldn't at least be *able* to do a traditional portrait or landscape, even though we were working abstractly. He told me that *not* knowing how to do such things was a positive advantage: I had fewer conventions to "unlearn." He believed that academic training got in the way of self-expression.

At this critical time in my student life, I met Frank Vincent Dumond, a man of compassion and philosophy, at the Art Students League, New York City. When I joined his class, painting finally began to make sense to me. It's hard to explain the influence of a great teacher, for although Dumond's class was devoted to painting, he hardly ever talked about it in the cut-and-dried manner that every fact-starved student desires. Whenever I asked a technical question, he'd reply in a very abstract, philosophical way. Yet he *was* answering me. He tried to orient his students' minds so that we would someday be in a position to get answers on our own. He wanted us to use more than our eyes. He made us analyze nature, so that we could paint it without resorting to formulas. He stressed "cause and effect": if you understand the cause, you can paint the effect with greater insight.

Later on, when I began teaching art myself, I realized that the most a teacher can do is give you a better understanding of what good painting is all about. In business, the employer tells a new employee his duties, but he can't stand next to him all day long. If the employee is smart, he'll soon see ways that the job can be done more easily and efficiently. Innovations spring from his own ingenuity. That's the case with all good students, too.

Eventually, I stopped teaching because I couldn't say everything that I felt needed saying. At first, teaching was easy. I felt I knew what painting was all about. But the more I worked and thought about painting, the more complicated the subject became. I began to question much of what I had previously taken for granted, and it became impossible for me to convey this complexity to my students. Whenever I tried, I felt the students were anxious for me to stop "philosophizing" and to get down to explaining how to paint a tree or a rock. I understood the feeling, for I had felt much the same way when I listened to Dumond's long, involved lectures.

In writing this book, I'm not as rushed as I'd be if I were giving a two-week workshop; I can take time to talk about matters that are important to me. It would be easy for me to be dishonest and just give you a lot of technical tricks, but that would have nothing to do with art. Jay Connaway, the marine painter, once criticized a student's work by telling him that his technique was good enough to paint a masterpiece; he meant that his manual dexterity was ahead of his conceptual development. Technique is like language. A man could speak perfect English but have nothing to say, while someone else—an immigrant, for example, who spoke broken English—could have wisdom in every word. The artist's real contribution is the expression of his own reactions to the world around him. It is my hope that what I have to say in these pages will help you develop your artistic and conceptual awareness as well as your painting methods.

I believe it's best to begin painting with oil or acrylic rather than watercolor. When you learn to sculpt, it's better to start with clay than with granite, so that you can correct your mistakes and thus come closer to your intention. So it is with painting. Oil paint is a malleable medium and allows you to make changes as you work. I feel that I can get a better sense of a student's abilities by looking at his work in oil. He's worked and reworked the canvas till he feels he's come as close as possible to his intention. Watercolor can be scrubbed and sponged out, of course, but it has its limitations. It can run away with you, and you often have to be content with mistakes which do not show what you really intended to say.

Later on, as you get used to the various media, you'll find they aren't all that different. People talk about "watercolor subjects" and "oil subjects"—but they mean that they see ways a subject can be handled using mannerisms peculiar to watercolor or oil. It's not a meaningful distinction. I use whatever is at hand to record my response to a scene. The choice of materials has nothing to do with artistic expression. An artist could paint a subject in watercolor, oil, acrylic, or pastel; he could work smoothly or roughly, thickly or thinly. From a distance, each picture would have the same emotional impact; only when you got closer would you notice what materials were used. When we look at Michelangelo's work, for example, we never worry about his methods; we're too impressed by the way he makes us see and feel biblical events. He would affect us just as deeply if he had done his murals with a piece of coal on the side of a building. You can write a letter with a typewriter, a pencil, or a crayon. What you have to *say* is the important thing.

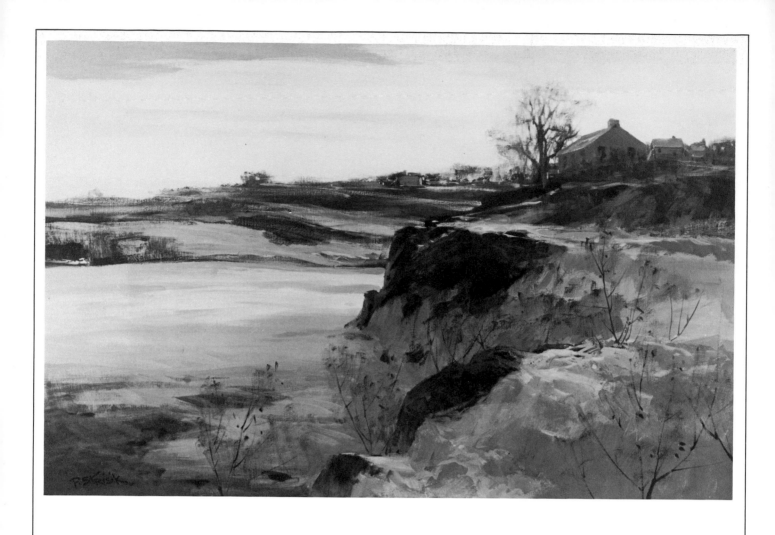

The Edge of the Quarry, acrylic on Masonite, 26 x 40 in. (66 x 102 cm). The somber, brooding winter light provided just the right mood for this type of subject. Although the picture seems heavily weighted to the right, the expanse of snow on the left helps balance the composition. Any strong interest on the left would have been introduced at the expense of the material on the right.

MATERIALS

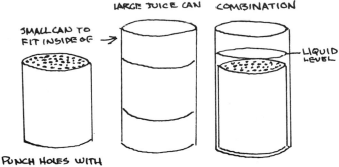

SMALL CAN TO
FIT INSIDE OF →

LARGE JUICE CAN COMBINATION

LIQUID
LEVEL

PUNCH HOLES WITH
LARGE NAIL —

(Top)
Figure 1. The Flo-Master felt-tip pen is refillable, and by varying the pressure applied to the tip, you can make both light and dark lines.

(Above)
Figure 2. My homemade brush cleaner is made of a small can placed upside down inside a larger one, which is then filled with kerosine.

(Opposite)
Figure 3. My brushes, from left to right, are: a No. 2 and a No. 6 round sable; a couple of No. 2 filberts (one has been worn down, but is still useful for fine lines); No. 3 and No. 4 filberts; Nos. 5, 6, 7, 8, 9, and 12 flat bristles. In addition, I use a large knife for cleaning the palette, a medium-size knife for scraping, and a small knife for scraping small areas and occasionally applying paint.

The so-called secret of the old masters, whose canvases were engineered to last, was nothing more than a deep understanding of the materials of their craft. Painters today should also try to learn as much about their materials as possible.

DRAWING MATERIALS

Before discussing painting supplies, I want to talk for a minute about drawing materials. You should always have a sketch book with you. Draw constantly—till you begin to *love* it. Drawing is understanding. You work slowly and get at the nature of the subject. When you paint, a few quick strokes can easily suggest an effect. But when you draw, you can take time to live with your subject, like a little insect, crawling over the surface. If you have trouble drawing a dory, for example, take a sketch pad to the waterfront and spend a day drawing one as it changes position in the water. By the end of the day, you'll have a firm knowledge of the character of dories and rowboats. A minute spent drawing is never wasted. Even quick notes are helpful, because they reveal the way you think.

You can draw with a pencil, soft charcoal, or a felt-tip pen. Use the tools that you find most comfortable. I tend to be too careful with the pencil. I like to work in large masses—as a painter does—and haven't the patience to build up my darks with repeated strokes of the pencil. I therefore use the refillable, felt-nib Flo-Master pen (Figure 1). With the Flo-Master, I can block areas in quickly and adjust tones by varying the amount of ink fed to the point. I also have control over the kind of ink I use and can make sure it's permanent. Most of today's markers use fugitive-dye inks which bleach out when exposed to sunlight. Opaque, pigmented inks, on the other hand, are light-fast.

BRUSHES

Prior to World War II, bristle brushes were a joy to use. The bristles were full and firm, kept their shape, and lasted a long time. However, they have been deteriorating in quality ever since. So we must make do with what is available. In this respect, purchase the best brushes obtainable on today's market. They should keep their shape with use and wear evenly.

You should select the type of brush that best suits your way of working (Figure 3). I prefer flats, since they hold more paint and therefore give me flexibility in manipulating it. Brights, which have shorter, stiffer bristles, wear out too quickly—and their square, crisp strokes can impose themselves on a painting.

I use the edges of my filberts—sizes 2, 3, and 4—to make fine lines. They're a little longer than the flats and can give me a sharp edge. Occasionally I use a sable brush for details, but only on small paintings. When I work outdoors, I may use as many as seven or eight brushes, keeping those I use for my darkest tones isolated so they don't become contaminated with white. In the studio, however, I use fewer brushes, since I can clean them as I work.

Cleaning Brushes. I always use kerosine to wash my brushes: there's little odor to kerosine, it doesn't evaporate, and it leaves the brushes soft, while also coating them with a slight film of oil. This film is good for them; they were coated with oil when they were still on the hog. Turpentine and mineral spirits also do a good cleaning job, but they evaporate in the container, have strong odors, and turn the bristles brittle. Soap and water may make brushes *look*

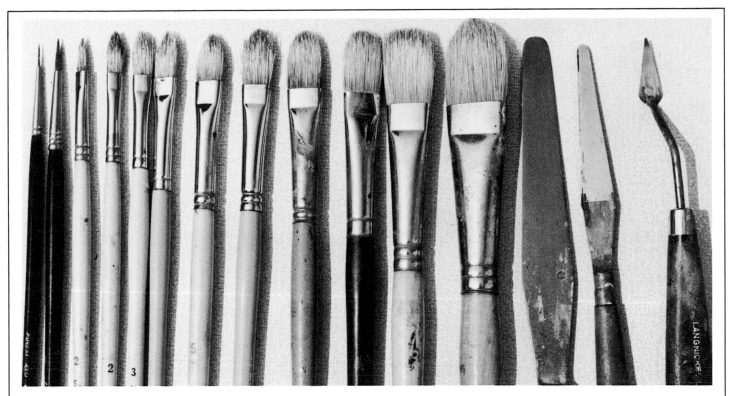

cleaner, but they really aren't. And the scrubbing process also takes too much time and effort.

I punch holes in the bottom of a small can with a large nail or punch and then place it inside a large juice can filled with kerosine (Figure 2). When I clean my brushes, the sediment falls through the perforations to the bottom. The holes in the smaller can treat the bristles more gently than the sieves that some people use. When the bottom of the contraption is finally filled with sediment, I throw it away and make myself a new one.

Repairing Brushes. When the ferrule of your brush becomes loose, don't crimp it with a pair of pliers. It'll simply wiggle in a different direction. You can buy a stick of ferrule cement at any fishing-tackle shop. First remove the handle. Then use a candle to melt the cement onto the brush, warm the ferrule itself, and insert the handle.

PALETTE KNIFE
A few touches with a palette knife can be useful when you paint, but don't use it to excess. Your pictures will have a mannered look, with heavy paint ridges taking precedence over your subject matter. In my opinion, palette-knife painters usually do their best work *in spite* of the knife, not because of it. I use it mainly when my paint becomes thick and unmanageable. It's better to scrape it off and try again than to throw good paint after bad.

PALETTE
I use a 20 x 24-in. (51 x 61 cm) cherry-wood palette. The size of your palette depends on your own preference, but I don't recommend getting one any smaller than 16 x 20 in. (41 x 51 cm). I don't like white palettes—particularly outdoors—because they catch the light and reflect it into your eyes. The white palette also weakens values, since almost any color looks dark when judged against it. My cherry-wood palette is a nice middle tone and makes a good background for judging color. I also like a wooden palette because wood is warm and keeps your colors from becoming too cool. You

can't help but judge the warmth or coolness of a mixture by its surroundings. On a warm wooden palette, yellow or orange doesn't look as warm as it does on a blue-gray palette. Therefore, you will tend to mix slightly warmer colors—and that warm bias will add to the luminosity of your painting.

I clean my palette after every day's work. If you're lazy, you can use Formica or glass and scrape the dried paint off with a razor blade. Both glass and Formica palettes are good. But I like natural materials; and every time I clean my wood palette, I feel I'm adding to its rich patina. It appeals to me in an esthetic way. If you also like a natural palette, cut a piece from birch or maple plywood and seal it with linseed oil so that the paint won't stain it too deeply. You can also seal the palette by coating it with floor varnish, allowing it to dry, and then sanding the surface with steel wool (using machine oil as a lubricant to avoid excessive abrasion).

TABORET OR PALETTE STAND
You can buy specially made taborets, but it's easier and less expensive to get a washstand, a side table, or any kind of small chest from a used-furniture store. My first taboret was a cheap piece of pine furniture. Now I use a small apothecary chest (Figure 4). I added large casters and put a piece of easily cleaned Formica on the top. My wood palette rests on one side, and the remaining space holds brushes, a can of kerosine, medium, and other miscellaneous materials. Paint tubes are stored in the drawers.

EASEL
My studio easel is an old, large traditional type made of oak, with a crank to raise and lower the canvas. If your studio is a permanent one, a good studio easel is an asset; otherwise, the portable French easel box is quite satisfactory.

PAINTING SURFACES
Painting surfaces vary in quality (some are fine for student work, but not for professional purposes) and have different characteristics. Often, the material you choose—whether it

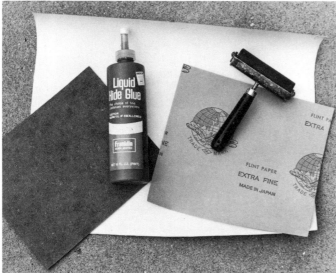

(Top)
Figure 4. My taboret is an old apothecary cabinet, mounted on casters so it can be moved around the studio easily.

(Above)
Figure 5. These are the materials you need for making your own canvas panels: Masonite backing, canvas, hide glue, sandpaper, and a rubber brayer.

be linen or cotton canvas, Masonite, or Upson board—is a matter of personal preference, but it's important to know about its properties and how to prepare the surface for oil painting.

Linen Versus Cotton. There's nothing wrong with cotton canvas, as long as it's a high-grade, tightly woven sailcloth. The Colonial painters used cotton canvases. However, most cotton canvas today is an economy product: it's loosely woven, with little tensile strength and an unpleasant "feel" when you work on it. Some cotton canvas is so weak that it can't be used for large paintings; the weight of the paint hanging on a large canvas will eventually pull the material apart. If you do decide to use a high-quality cotton canvas, run your hand over it before starting to paint. It will probably feel rough, the cotton fibers having been hardened by the glue sizing. You should go over it very gently with a piece of fine sandpaper. Don't overdo it.

Many artists prefer linen to cotton. There's nothing like the luxurious feel of traditionally manufactured linen, especially that made in Belgium. I prefer a fine weave; rough canvas is hungry for paint and swallows it up. A smoother surface will also give your pictures a more brilliant, enamel-like look. The tooth is less noticeable and doesn't attract attention to itself.

When I get a roll of canvas, I saw through the entire roll of canvas with a band saw, to cut it into convenient lengths for painting. The large roll is 84 in. (213 cm) long. I cut it into 23-in. (58-cm), 27-in. (69-cm), and 34-in. (86-cm) lengths. I use the 23-in. (58-cm) roll when I'm stretching any canvas with one 20-in. (51-cm) dimension. The 27-in. (69-cm) roll yields all my 24-in. (61-cm) sizes. And the remaining 34-in. (86-cm) roll takes care of my 30-in. (76-cm) canvases. If your canvas comes in shorter rolls, you can easily figure the best way to cut it. This simple procedure greatly facilitates the cutting and stretching process.

"All-purpose" Canvas. When working in oils, you should beware of the popular "all-purpose" canvases. Pre-primed with acrylic, these canvases are supposed to be compatible with either oil or acrylic paints. Yet in the opinion of many experts on paint chemistry, you should *never* use oil paint on any surface—canvas, Masonite, Upson board, or whatever—that has been primed with acrylic or any other nonabsorbent material.

Acrylic and oil paints are completely different media. To adhere to a canvas, oil paint needs to sink roots into the primer. It can't do that with acrylic; it just sits on the surface. In addition, the acrylic primer remains flexible long after oil paint has become hard as nails. The different rates of contraction and expansion will, in time, crack and separate the oil layer.

The reason acrylic-primed canvas is so popular is that manufacturers find it convenient and economical. The old-fashioned method—sizing the canvas fabric with glue to prevent rotting, then covering it with an oil-based white paint—is more time-consuming and costly to manufacture. Canvas can be quickly coated with acrylic gesso—gluesizing isn't necessary—and the product can be packaged within hours.

Canvas Panels. Cardboard-mounted canvas panels are all right for the student—your exercises aren't meant to be permanent—but not professional work. They have an unpleasant surface—and, more importantly, they're a commercially competitive product. Manufacturers turn them out cheaply and quickly, using thin canvas, inadequate priming, and inexpensive pulp boards so full of acid that they

quickly deteriorate. They also drink up all the oil in your paint, giving it an unpleasant matte finish.

You can make much more durable panels yourself, by mounting canvas to untempered Masonite (Figure 5). (Tempered Masonite has been oiled to make it waterproof, and the oil prevents a good bond between the board and the glue.) Since the weave is less important when canvas is backed by a Masonite support, you can use either linen or cotton.

You should first roughen the surface of the Masonite with extra-fine sandpaper. Then fine-sandpaper the *back* of the canvas before applying it to the Masonite, so that nubs pushing against the panel won't cause bulges on the surface of the canvas. To attach the canvas, use either a white glue such as Elmer's Glue-All or the older Franklin Liquid Hide Glue. I prefer the hide glue. When you use synthetic glues like Elmer's, you have to weight down the panel till it dries. With hide glue, on the other hand, you squeeze a bit onto your sanded panel, spread it with a rubber linoleum-block printing brayer, and put the panel aside while you prepare two more. By the time you've done the third panel, the first is tacky and you can lay the canvas on it, smoothing it out from the middle with your hand to eliminate all air bubbles. No weighting is necessary. The panels may warp slightly immediately after you've finished, but they'll straighten out again when completely dry. You should be able to do fifteen or twenty medium-size panels in an evening, trimming the edges with a razor blade after they've dried. Since hide glue is water-soluble, the caked brayer is simple to clean. In addition, the water-solubility makes it easy for a restorer to remove the canvas if necessary in later years. The white glue is much harder to remove.

Upson Board. Upson board is good only for student work. You can prime the pebbly side with a coating of dilute shellac (a five-pound cut), mixed with four or five parts alcohol. The shellac can also be used for priming pieces of all-rag mounting board for sketching purposes only.

Upson board became popular around 1910, and lots of artists worked on it. Unfortunately, like all cheap card board, the paper has sulfide in it, and sulfide soon mixes with the moisture in the air to create sulfuric acid. The material literally burns itself up—a process that is accelerated in a damp climate. Older boards actually powder to the touch!

PIGMENTS

I'm always hesitant to recommend specific colors. In the first place, pigments differ from brand to brand: one brand of cadmium red medium might be Winsor & Newton's cadmium red, Grumbacher's cadmium red deep, and some other maker's cadmium red light. I also dislike specifying a palette, since almost all manufactured pigments can have a legitimate function in a painting. I use a restricted, uncomplicated palette because it keeps me from getting lost in a rainbow of colors and leaves me free to concentrate on the more important aspects of painting: values, composition, and the like. I use the same palette inside, outside, and on all my travels. However, if you stick with a palette for too long a period, there's always a tendency to favor certain mixtures. Even if a palette works for you, it's sometimes smart to substitute different colors for a few favorite pigments. You're forced to find new solutions to your problems—and to learn more about color.

My Basic Palette: My palette always includes at least these basic colors:

Cadmium yellow pale	Ivory black
Cadmium yellow medium	Ultramarine blue deep
Cadmium orange	Cobalt blue
Yellow ochre	Phthalo blue
Burnt sienna	Titanium white
Cadmium red medium	

Optional Colors. I add other colors as necessary:

Raw sienna	Chromium oxide green
Alizarin crimson	opaque
Terra rosa	

I don't feel that greens are essential to have because if you have phthalo blue, you have almost every green made. You can mix blues and yellows in various combinations to obtain greens—vivid greens from phthalo blue and the cadmiums, and grayer greens from ultramarine blue and the cadmiums. Similarly, I create my own violets. I dislike too much violet in a picture and find that ultramarine blue and cadmium red medium give me a color that is usually violet enough for my purposes.

Black and White. Some painters don't use black, as they think it muddies color. Yet I've seen plenty of "muddy" pictures painted without black. There's just as much life to a green gray mixed by adding black and white to green as there is in a green gray mixed with "pure" color. It's still green gray, no matter how you get it. The main problem with black is a technical one. If you use lavish amounts of pure ivory black, for example, there's a chance of its cracking with age because of its high oil content. In that situation, I substitute Mars black, a stable iron oxide.

All whites are permanent, but I prefer titanium white because it works *with* me. Zinc white is more transparent, and you have to use *lots* of it—which is fine if you like heavy, impasto effects. But I don't paint that way. Nor do I find that zinc white makes cleaner tints than titanium, despite the claims of its admirers.

When I buy white paint, I also read the label to make sure it's ground in linseed oil. Many of today's paints are ground in safflower, a greasy oil that gives the paint disagreeable handling characteristics. Linseed oil also makes a tough and flexible paint film; it's the most durable of all the binders.

Of course, lead white is the best white of all. It's the color the old masters used; and if you look at their pictures, you'll notice that while other colors may have faded and cracked, the whites are still in good condition. Unfortunately, lead white is banned nowadays because of the danger of lead poisoning. That is a problem. Years ago, I saw a show devoted to nineteenth-century Italian painting. Of the thirty artists presented, four had died of lead poisoning. But I also noted that they'd been careless: one, for example, mixed paint on his forearm instead of his palette! He had absorbed the lead into his system.

An esthetic warning: always think twice before using white. It can give your pictures a chalky look. If you want to lighten a color, sometimes try using another color instead of white. If you want your paintings to have brilliance, think in terms of *more* color, not lighter color.

"Hues" and Bariums. Avoid all "hues." When the tube says that a color is a "cobalt blue hue," for example, this means the paint isn't cobalt blue at all; it was mixed to look like cobalt blue by using other colors. As a result, it won't act like cobalt blue when you use it in different mixtures.

I also prefer to buy pure cadmium colors instead of the cadmium-bariums. Barium won't affect the color quality;

it's simply an inert extender, added to make the color go farther. You'll probably use three barium-extended tubes for every one of pure cadmium, but they are satisfactory for student use.

Color Mixing. I can't teach you color; you have to learn about it by playing with the colors on your palette. However, here is a single exercise you can try: mix two or three colors, add white, and draw them out on the palette in graduating values. It's amazing what you can learn from such a simple experiment with the nature of the hues available.

However, I can give you a few *practical* pieces of advice about color mixing. First of all, put plenty of paint on your palette. And lay out all your colors when you paint, no matter how gray or colorless the scene appears. The palette is your keyboard, and it should have all the color notes, always arranged in the same order. Once the palette is set up, *use* the paint! Most students do little more than dirty their brushes with a little color and then try to wipe them off on the canvas. To mix color properly, you must have enough pigment on the brush in the first place. Use plenty of paint and you won't smudge areas together, thus giving your pictures a weak and indecisive look. Be prepared to wipe your brush every four to six strokes and then pick up more paint. You'll soon learn that two-thirds of your pigment normally—and rightly—ends up on a rag, either from wiping the brush or from cleaning off your palette. You can see brass on the ferrule of a good painter's brush; he wears away the chrome through constant wiping.

When you mix colors on the palette, don't work in little spots. Make big smears of color. If you discover that a green mixed from cadmium yellow and ultramarine blue needs to be warmer, don't put the extra yellow smack in the middle of the mix. It has to counteract all the original blue, and you'll need half a tube to change the color temperature of the mixture. It's much easier to add yellow to the *edge* of the color swatch, thus giving the yellow a chance to tell and also creating a smear of color that has variety within it: from a blue green near the center to a yellow green at the edge. The mix can yield useful colors in the future—unlike the smear made by putting all your colors in the center of a mixture and blending till you get a single flat, uninteresting tone. You may get the color you want, but it will be useful in only *one* part of your picture.

Remember, too, that you don't have to attract the viewer's attention by throwing your entire palette at the canvas. Often, you can get a powerful effect by limiting your range and using only a touch of pure color. The mood of your painting should determine your color scheme. Bright color would be called for in a lyrical piece such as a beach full of children, strollers on a sunny day, or a vase of flowers. However, in a picture of an approaching storm, you wouldn't paint a blue-shuttered rose-covered cottage at the end of the lane. You'd need elements that speak about the hard business of living. Cornwall, England, for example, is epic in character; when painting such a subject, you can't afford to get bogged down in "pretty" colors. That would contradict the subject's power and monumentality and would fight against your expressive purpose.

I once saw a portrait that was painted primarily with three pigments: yellow ochre, venetian red, and ivory black. The addition of a green tie gave the impression that it was full color. The painter suggested color instead of throwing raw contrasts at the viewer. Jay Connaway, the noted marine painter, often balked at pure color contrasts, noting

that anybody could paint straight from the tube. He wanted to use a more elusive, personal sort of color.

You're not making a literal copy of the scene; you *decide* whether or not to use color. It's the painter's personal tastes that give a picture character and personality. Color, as such, can even be a distraction. You've probably seen pictures that get their "punch" from vivid complementary contrasts: yellow trees against a blue sky or red flowers against a green drape. But who can work for a man who yells all the time? Eventually, you stop listening. Force comes from the suggestion of power in reserve.

MEDIUMS

I once asked an experienced picture-restorer at a museum which painting medium he thought held up best over the years. He recommended any medium with linseed oil in moderate proportions; it has proven to be a tough and permanent binder. It may yellow slightly—particularly when a picture's been stored in the dark. However, exposure to north light (not direct sunlight) for a few days will quickly bleach out most of the yellow. Of course, no medium is completely nonyellowing. No matter how careful you are, your pictures will "ivory" to some extent. This change isn't necessarily a fault; sometimes it unifies and mellows raw colors in a picture.

As long as there have been painters, there's been argument over the "best" medium. There is no ideal medium; each has its advantages and disadvantages. Since the troubles that befall a painting are largely due to problems with the binder, the medium is really a necessary evil. Most tube colors contain enough oil for direct painting, so medium should be used as sparingly as possible. One of the simplest and most popular mediums is that recommended by the chemist Ralph Mayer in his *The Artist's Handbook of Materials and Techniques*, a book every painter should own. The medium consists of one part stand oil, one part damar varnish (five-pound cut), and four to five parts turpentine. The varnish gives an added brilliance to the color, helps the pigment set up, and facilitates paint handling. It also gives a "drag" to the paint, so you don't slide all over the canvas. The turpentine makes it easier to mix paint and oil. Because it evaporates, it adds nothing to the final paint film. If you dislike the smell of turpentine, you can use mineral spirits or deodorized Renuzit. Buy *pure* mineral spirits at a chemical-supply house; it should have a USP rating to show that it meets certain drug standards. Renuzit is also good, since it's purer than most commercial paint thinners; none of the latter are suitable for use in the fine arts. Like canvas panels, they're designed for a short life span. After all, wall paint thinned with a commercial paint thinner is considered successful if it lasts for five or six years.

Every painter has his favorite medium. I like Mayer's, but you may want to experiment and see what works best for you. Some painters prefer a "richer" medium—that is, a "fatter" one, with more oil and varnish in it. It gives pictures more of a gloss. But I can get the same effect by varnishing my pictures after they're done. However, I don't want to make any rules: even if you do use my medium, you might want to use more or less than I do, and in the end our pictures would still have different chemical structures.

There are only two basic rules you should heed in using a medium. First, you should always follow the time-tested practice of putting "fat" over "lean." Each successive paint layer should have at least as much oil as the one before it.

Corrections made on a flat surface with a leaner turpentine medium, for example, will eventually crack. Second, you should avoid using too much medium as you work. Excess medium not only takes the life out of your color, but it also affects the longevity of the paint. In themselves, pigments are perfectly stable; it's the oil that yellows with age. So don't get into the habit of dipping into the medium cup with every stroke. The impressionists used paint straight from the tube, and I've been told that their pictures are the simplest of all museum paintings to clean and restore. A good conservator can make them look as bright and lively as they were the day they were painted.

VARNISHES

I never use my varnish (damar, five-pound cut) straight. I usually dilute it—half damar and at least half turpentine. This mixture amounts to a "retouch" varnish and is useful when I work over a dried picture. A wet, glossy stroke applied over a dried, matte area looks *darker*, even though it's the same value. To judge values more accurately, painters spray such matte areas with retouch varnish. Some prefer to "oil out," rubbing medium over the picture to bring back its color and shine. But by doing that instead of using a varnish, they add extra oil to the picture surface—and it's the oil that yellows with age.

I also use the retouch mixture as a final varnish. Straight damar would be too glossy; the picture would shine like a piece of glass. The final varnish protects the surface of the painting and makes the pigment look as it did when you first made the stroke. It gives it a fat, jewellike appearance. I add seven or eight drops of stand oil to the varnish to increase its durability and to make it more flexible.

I don't like matte varnishes. The varnish has been weakened with adulterants to create the matte finish—and a weak film is not what a painter wants. Today there are a number of new acrylic varnishes on the market, but I've had little experience with them. Since they're said to be superior to the older varnishes, they'd be worth investigating.

The Varnishing Process. For the sake of simplicity, I spray on varnish with an old-fashioned, breath-operated blower (Figure 6). These blowers are temperamental, but painters have used them for centuries. In addition, I can make my own varnish for this kind of sprayer; that way, I'm sure of the quality and don't have to waste money on fancy packages and aerosol cans.

Books are full of "rules" for varnishing. You're told, for example, to work in a dust-free room and to wait at least six months before varnishing a picture. Such rules are leftovers from a period when pictures were very smoothly painted and artists used the unreliable mastic and other varnishes instead of damar. A piece of dust caught on the glasslike surface of an old-master painting would have been very obvious. But the same fleck of dirt on our rougher paintings can hardly be noticed. Nor is it necessary to wait six months for a painting to dry. When using damar retouch varnish, you can spray when the work is newly dry—though it's probably best to wait a week. However, if you're applying varnish with a *brush*, wait several weeks until the surface is thoroughly dry and can withstand the action of the brush.

After it's been varnished, a painting may have a few dullish areas. Don't worry about them. When painters worked smoothly, it was easy to put a faultless layer of varnish over them. Nowadays, however, we paint in a rougher manner. It's hard to cover such irregular surfaces—unless you load on

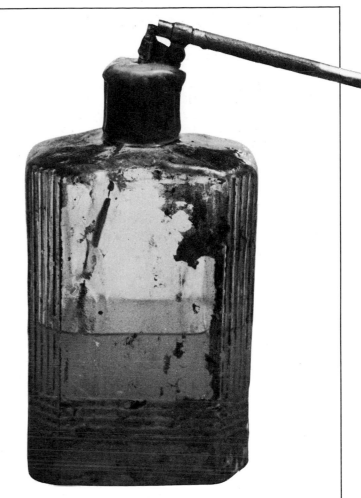

Figure 6. Varnish can be blown onto the canvas, using a traditional breath-operated sprayer.

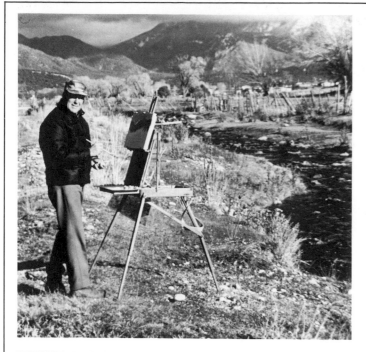

so much varnish that the overall picture surface becomes much too shiny.

TRAVEL AND OUTDOOR PAINTING

I'm as comfortable working outdoors as I am in my studio. My equipment is designed for outdoor work, and I feel there's an excitement with painting on-the-spot that gives a painter's work the ring of truth.

At least once or twice a year, I take painting trips to explore new subject matter and paint on location. I sometimes fly, sometimes drive to my destination. When I fly within the country, I take a minimum of supplies because I know I can always buy additional materials. But when I leave the country, I take everything I need—and then some.

Easels. When flying, I always carry the French easel-box; it's the ultimate in portability and convenience (Figure 7). It's been copied by Italian and American manufacturers, but the best is still the one imported from France. Lately, airlines have been restricting the size of carry-on luggage; after one trip, I was surprised to see my French box, its legs open, shooting down a luggage-conveyor belt. A solution to this problem might be to have a special suitcase built by a firm that specializes in salesmen's sample cases. You could even design built-in spaces to hold extra paints and equipment! Of course, you could also buy a cheap, standard-size suitcase just big enough to hold your easel securely.

When I drive to my painting spots, compactness isn't a major consideration. That's when the Gloucester or Anderson easel is by far the best (Figure 8). It's an unparalleled easel, designed by an artist and featuring a leg span that makes it almost windproof. It can hold any size canvas up to 30 x 40 inches (76 x 102 cm).

Sketch Boxes. When I drive or fly, I often carry small, self-contained sketch boxes. They're convenient, and you can use them in cramped spaces; they rest comfortably on your lap (Figures 9a and 9b). Called "thumb boxes" or *pochade* boxes, they come in several sizes: 4 x 6 in. (10 x 15 cm), 5 x 7 in. (13 x 18 cm), and 8 x 10 in. (20 x 25 cm). The old-time painters always used such boxes. I recently made a new one measuring 8 x 12 in. (20 x 30 cm), which I consider a better proportion than 8 x 10 in. (20 x 25 cm).

Traveling with Canvas. When I fly, I precut a fine-weave, lightweight linen into pieces that fit the two or three stretcher sizes I carry with me. I either roll up the canvas or lay it flat in my suitcase. I stretch a few canvases the night before I paint. Since I use a lightweight staple gun, I can easily remove the canvases the next day and then stretch some more. Back home, I can restretch the canvas or mount it on Masonite and continue working. I paint thinly when I travel, using a drop or two of cobalt linoleate drier in the white and the medium to ensure that the picture will dry overnight. Cobalt linoleate is the only drier a painter should use: never use any of the progressive driers such as Japan drier, manganese drier, or any of the old-fashioned siccatives! The progressive driers, whose drying action continues over a long period of time, can eventually cause cracking and a variety of other defects in the paint surface. Cobalt linoleate is not a progressive drier and will not continue to affect your painting. If you're worried about the surfaces of your pictures sticking together when you pack, you can place sheets of waxed paper between them.

It's possible to carry as many as fifty small panels on a painting trip—they are lightweight and fit into a compact space. Veneer door covering, cut to size and covered with

(*Top*)
Figure 7. I always use the French easel-box when I fly to a painting area. Here you can see me at work in the Southwest.

(*Above*)
Figure 8. The Gloucester or Anderson easel, folded into the tight 3½-ft. (1-m) bundle on the right, requires a separate paint box.

linen canvas, makes very light, sturdy panels. You can also glue canvas to all-rag, acid-free mat board. The panels are light, yet strong enough to keep from buckling while you work. Back in the studio, you can mount the panels on a piece of Masonite. Since the paper is acid-free, it won't crumble with time; and if a restorer ever needs to remove the canvas, he or she can easily take it off the mat-board backing.

Cleaning Brushes. When I travel, I carry kerosine in a screw-top jar and pour it into a can when cleaning brushes after a day's work. I pour the mixture back into the jar when I'm done. By the next day, the sediment—consisting mostly of heavy earths and metals (the cadmiums)—has settled, and I can again pour off clean kerosine.

Clothing. Outdoor painters have to be ready for all kinds of weather. I've painted in the freezing cold of the Canadian Rockies and in the heat of the Southwest. In Greece, I once worked in a deserted cafe, with an awning shading me from the sun and refreshing Greek coffee always ready.

As a general rule, you should wear dark clothing outdoors; it cuts down on the amount of light reflected off your body into the picture. On cold days, use insulated underwear, woolen pants, woolen stockings, ear muffs, galoshes that fit loosely (so that they create an insulating air pocket), and inexpensive cotton gloves. A snowmobiler's jump suit is also supposed to be good protection. If you must wear dark glasses, use Tru-color, a neutral gray lens that won't distort the colors as most sunglasses do.

When you're properly dressed, you'll find that heat, cold, or an awkward perch won't bother you; they're all part of the challenge. The only real irritants are the wind—tormenting and tugging at you like a great hand—and insects, buzzing and biting you. You can't do anything about the wind, but remember to add insect repellant to your painting gear.

Miscellaneous Travel Equipment. When painting in the snow, the old-timers used snowshoes, tarpaulins—and I've even seen the equivalent of snowshoes for the legs of easels! I don't carry that much gear. But I'm ready for any emergency. One time when I was painting in the Rockies, I walked back and forth so much that the packed snow in front of my easel became as smooth as ice. Reaching for a brush, I slipped, grabbed the easel, and broke one of its legs. But it was a temporary tragedy. I was saved by the fact that I always carry a small tool kit, pliers (to help with stuck tubes), wire, a knife, a file, and epoxy cement. At the motel, I glued the leg back together, bound it with wire, and the next day, found it stronger than before the accident.

SUMMING UP

After all this talk about materials, let me repeat that painting is based on the concept and judgment of the artist—not on his palette, medium, or tools. A professional painter could apply mud to a wall with his thumb or with a brush held in his mouth—and still get a good effect. It's the mind that makes the important decisions. The "rules" regarding materials are elementary:

1. Use a simple palette.
2. Use your medium sparingly, if at all.
3. And see that all your materials are permanent and compatible with one another.

(*Top*)
Figure 9a. Although my *pochade* box can be used on my lap, I mount it on a compact, lightweight camera tripod. I can then work standing up.

(*Above*)
Figure 9b. As you can see in this photo the box and tripod fit in a 14-x-16-in. (36-x-41-cm) bag.

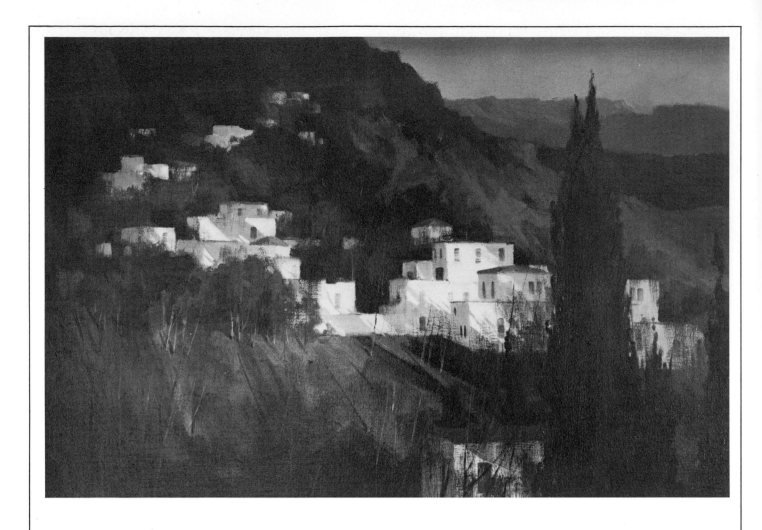

Mountain Village, Greece, oil on canvas, 20 x 30 in. (51 x 76 cm). This is an example of what I call an "emotional remembrance." During a visit to Greece, I was impressed by the small villages clustered in the hills. As I thought about the country later, one image always came to mind: brilliant white cubes set among rich, dark mountains. I decided to do a painting based on this memory. Staying faithful to my impressions, I used a simple S-curve composition to snake the viewer's eye up the hill.

The houses in the right foreground are the center of interest; the others are less brilliant in color. The nearby cypress trees, typical of Greece, give me a strong, dark foreground element. I feel that this picture—painted in my studio without any aids except my memory—expresses my emotional response to the country better than if I'd done it on location. That's the merit of occasional memory paintings: we recall only what impressed us and forget the other literal, commonplace facts.

CONCEPTION, COMPOSITION, AND DESIGN

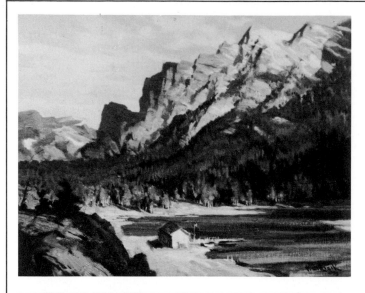

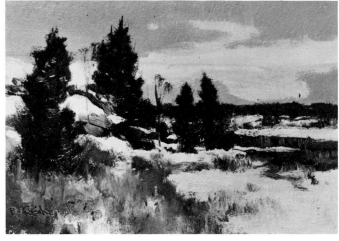

(Top)
Figure 10. *Two Jack Lake,* oil on canvas, 12 x 16 in. (30 x 41 cm). The small scale of the trees and boat house emphasizes the mountain's imposing height. I simplified the broken shapes of the mountain so that they'd make a more easily understood pattern.

(Above)
Figure 11. *Marsh Patterns,* oil on canvas, 6 x 9 in. (15 x 23 cm). Working with a hand-held thumb box on a gray, wintery day, I painted this picture quickly. I was striving to make a mood sketch that would be of use to me later in the studio.

In the previous chapter, I talked about the specific materials of the painter, and in coming chapters, I'll discuss some of painting's more mechanical aspects. Most students are deeply interested in these "facts" of the painter's craft. They want to know how to paint the details of a particular scene. Yet the scene itself—although it excites and inspires us—is only the beginning of the painting. It's the excuse for our making a personal statement about what we've seen and experienced. The *conception* of the subject is the important thing in art—that's the real measure of the painter. Composition, design, and color come afterward. Detail is merely additional entertainment—good for when the viewer looks more closely at your picture.

Arriving at a site, you should ask yourself, "What made me stop and look?" That sounds like a simple question; but once you've answered it, you'll have begun to understand the personal significance of the subject. A painting is often more exciting than nature because it's a distillation of the scene. It stresses the poetry and your sense of the subject. It's more truthful than "reality" because it's a frank expression of your feelings.

A SENSE OF PLACE

When you stand before a subject and think, "Oh, that's beautiful," you're not responding to the details of the scene. You don't even see them when you have that initial thrill; you notice the details only after you open your sketch box and begin to paint. Your original conception didn't include an inventory of trivia. So why put such trivia into the picture?

Imagine a painter who sets up his easel and spends three weeks on a meticulous rendering of a small town. Another artist comes along, does a sketch in an hour, and leaves. Both paintings are shown in the village, and our careful painter scoffs at the sketch: "It's not even the village," he might say; "he's left out the hen house, heightened the mountain, and cut down the trees!" Yet the townspeople immediately identify with the sketch. One painter gave them a blueprint of the village; the other, a sense of place.

People aren't interested in blueprints; they want to sense the painter's involvement and pleasure in the subject. In Figure 10, for example, I was impressed by the great height of the mountain. Therefore I did everything I could to emphasize this feeling. The horizon is kept low, and the pines in the left foreground are kept small so that they don't compete with the mountain. The small boat house and wharf also help scale the distant peak. I use the elements of the scene to emphasize my conception of the mountain.

The job of the artist, then, isn't to make blueprints. Many of the details you see at a given site are common to all scenes. They're not important to you unless they say something significant about your particular subject. Nature is a storehouse of material. The components of a picture are scattered helter-skelter, and you have to pick and choose among them. You have to give your conception the proper setting, just as you would set a diamond in a ring or arrange a group of actors so that each has an appropriate place in a tableau.

Facts. If "facts" were enough, you could take a photograph of the subject. Unlike the sensitive observer, however, the camera never selects or comments, never adds or subtracts. Think of all the disappointing slides you've taken on vacation. I often take slides myself—whenever I feel there's something valuable in the scene. Yet when I get them from

the processor, I often have trouble remembering why I bothered to take them. The scene is there—but the emotion and excitement are absent!

Unfortunately, students often think they have to mimic the camera. They want to put in everything. They feel that the detail *is* the scene—after all, doesn't it make the scene they love? They don't realize that no great painter has ever "copied" nature—if only because it's an impossible task.

That's one reason it's often valuable to work on a small scale. Figure 11 is a small 6-by-9-inch sketch in which I tried to capture just the basic landscape elements. The light in the sky is simply a few big strokes of the brush. I haven't room for superfluous detail—only for the big, simple units that first hit my eye: the sky, the dark trees, the snow, and the marsh grass. Embellishments are best left for the studio.

Description. I remember my teacher, Frank Vincent Dumond, telling me in class, "All the facts are accurately stated in your pictures, and I have to admit that you're a very truthful young man." I thought he was complimenting me. Then he said, "But you forget to include in your paint box the cement that holds all your facts together." I was painting a super-accurate description of the facts—at the expense of the whole idea.

Your eyes don't tell you what to paint—your mind and feelings do; but you don't have to do heroic exhibition pictures to make a personal statement. A small pear tree in your back yard can be an honest and moving subject for a painting because you understand that tree's struggle to grow and you have an affection for it. Such a picture may not set the world on fire, but the viewer responds to it because he feels you're sharing an emotion with him. Remember: anyone can *describe* things, but there's a magic to what the inspired painter does. That's what gives the artist's profession its dignity—and its almost religious character.

COMPOSITION AND DESIGN

The first question the painter asks himself is "What is there in this scene that *interests* me?" because the emotional response always comes first. If you were to place ten people in front of the same scene, they'd all see different things. A businessman's thoughts might go to the city on the horizon; he'd wonder about its manufactures, notice where the factories are—and then paint the smokestacks against the sky. A farmer, on the other hand, would see the rich earth and paint the fields that he himself had plowed, sowed, and harvested. These are two extreme cases, but each of us would find some aspect of the scene that appealed strongly to our sympathies.

The Personal Comment. To better understand how the same facts can elicit a number of different emotional responses, look at the photograph in Figure 12. It is one of my favorite painting spots along the Maine coast: a small cove bordered by some of the clapboard buildings typical of the area. I love places such as this and feel good just looking at them.

I wanted to suggest some of that pleasure when I painted this spot. In Figure 13, the sun was directly in front of me, and I was struck by the brilliant sky and the dark silhouette of the landscape against it. The water reflected the light from the sky, and its brilliance further emphasized the silhouetted bank and houses. When I painted Figure 14, I looked away from the sky and was attracted to the sweeping lines of the foreground. I emphasized the mud, the rocks, and the patterns made by the ocean at low tide. Finally, in

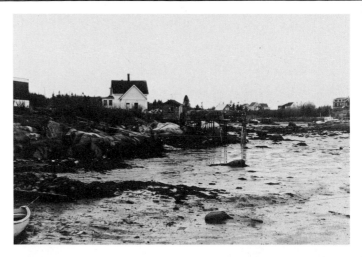

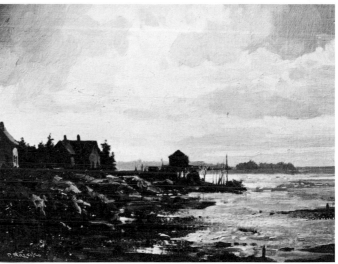

(*Top*)
Figure 12. This is one of my favorite Maine painting sites.

(*Above*)
Figure 13. *Breaking Sunlight*, oil on canvas, 12 x 16 in. (30 x 41 cm). This is a sky picture: looking into the sun, I silhouetted the land against it.

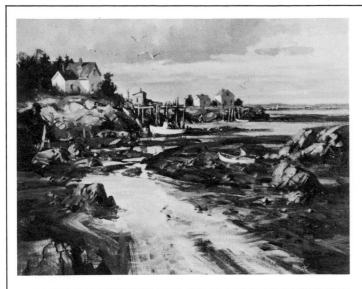

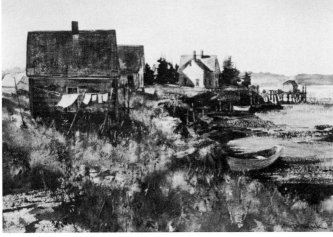

(Top)
Figure 14. *Tidal Flats,* oil on canvas, 16 x 20 in. (41 x 51 cm). A land picture: here I studied the broken shapes of the rocks and the pools of tidal water.

(Above)
Figure 15. *Island Houses,* watercolor, 14 x 21 in. (36 x 53 cm). A building picture: turning from the ocean, I played up the cluster of buildings and the interesting shape made by the wash on the line.

Figure 15, I ignored the ocean and the sky altogether and concentrated instead on the interesting shapes of the houses and the grassy bank.

Picking and Choosing. Composition is simply picking and choosing from among all the elements of the scene. I like to think of it as the placement of the *big masses* of the picture: you "compose" when you decide where to put the horizon, trees, buildings, and other elements of the painting. There are no hard-and-fast rules about placing these elements. Some teachers are dogmatic and make their students equally rule-bound and inflexible. I prefer to think of painting as a series of decisions, the exercising of personal taste, judgment, and discretion. Taste, not rules, is what gives a work of art its dignity, elegance, and "rightness."

Simplicity is one of the key elements of good composition. You have to learn to see the landscape in terms of a few large patterns. The eye naturally craves such ordering principles. If, for example, you were to cover a table with poker chips, laid side by side, the eye would immediately begin to organize them into groups of four, five, or six. The eye needs to simplify material in order to make *sense* of it. In Figure 16, I set up my easel at a site in the Canadian Rockies. I was surrounded by shrubs, dried grasses, evergreens, and mountains. But in settling on the basic composition of the picture (Figure 17), I ignored these details and simplified the scene, placing the big masses and determining how much water, mountain, and grass were necessary for my statement. Figure 18 is the final picture—built firmly on the foundation of my initial compositional masses.

COMPOSITIONAL PRINCIPLES

There are several important compositional principles to consider when selecting and placing the main elements of your picture.

Weight. Probably one of the most fundamental principles of composition has to do with weight. As you distribute the masses in a picture, each has a definite weight in relation to its size and position on the canvas. If all the objects were on the left side of the painting, for example, it would obviously be out of balance; you'd feel as if the picture were about to tip over. The same thing would happen if you were to concentrate all your interest on the right.

It's therefore necessary to balance your picture—but not in an obvious 50/50 manner, distributing your weights equally on both sides of the canvas. It's an old, familiar idea in painting that you should avoid halves: that is, don't paint a picture that is half in shade and half in light, half warm and half cool in color, half sky and half land, etc. Your picture will become too symmetrical—and monotonous. Of course, symmetry is useful in the decorative arts—in the making of wallpaper, fabrics, and jewelry. But in painting, we also want variety and interest as well as the decorative aspect.

I sometimes try to help students be less symmetrical by asking them to draw a border, a few inches in from two adjacent sides of their canvases. If you have a tendency to center things, you'll do it in the resulting oblong, and when you work out into the rest of the canvas, your weight will automatically be slightly off balance.

I tend to concentrate my main masses to the right or left of the picture, balancing them with a smaller weight on the opposite side. In Figure 19, the largest areas of wall, tower, and rocks are all on the left; this mass is then balanced by the smaller area of shadowed wall on the far right. The pic-

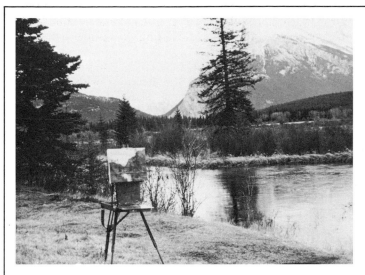

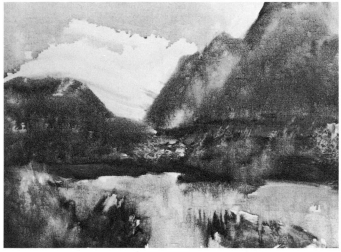

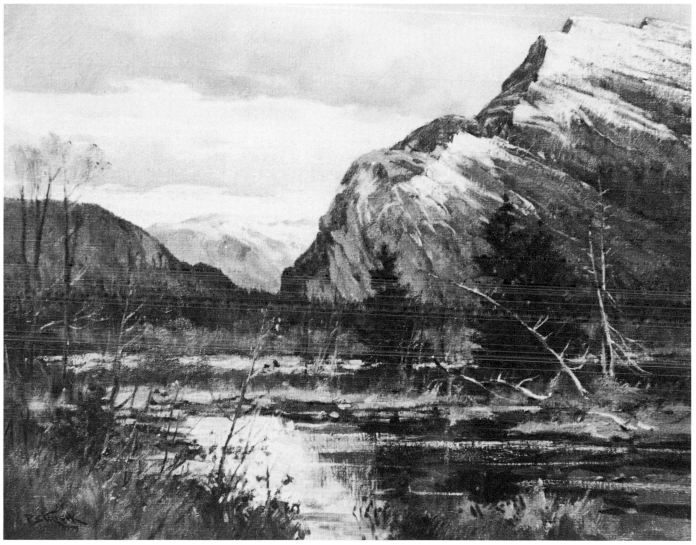

(Top, left)
Figure 16. Painting on the spot in Canada. The impressiveness of the surroundings has little to do with the details of trees and grass.

(Top, right)
Figure 17. The compositional scheme focuses on the big masses of sky, mountain, and foreground.

(Above)
Figure 18. *Mt. Rundel, November*, oil on canvas, 16 x 20 in. (41 x 51 cm). While relatively detailed, the final picture still adheres to the pattern determined by my compositional masses.

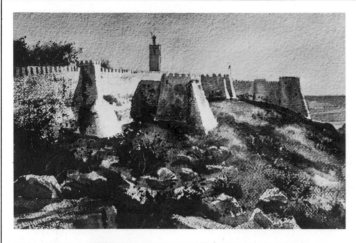

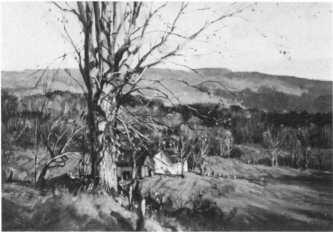

(Top)

Figure 19. *Fort at Agadir, Morocco*, watercolor, 11 x 17 in. (28 x 43 cm). I liked the contrast between the sunlit, whitewashed walls and the dark earth and sea. The minaret and the large area of sunlit wall form a natural center of interest.

(Above)

Figure 20. *From Morgan's Hill*, oil on canvas, 20 x 30 in. (51 x 76 cm). Cloud shadows suppress the unimportant lower corners of the canvas, and the shadowed background pines create space by separating the foreground from the distant mountain. The vertical lines of the tree relieve the dominant horizontality of the composition.

ture has a "dynamic balance." You don't feel that it tips one way or the other, yet it's not so perfectly balanced that it's dead and static.

The same idea is at work in Figure 20. The main mass is concentrated on the left, along with the foreground shrubbery, posts, and distant buildings. This heavy mass is then balanced by the trees and shadowed pines on the far right. These small masses balance the large tree because isolated spots always attract attention to themselves. In a mass of foliage, for example, you always notice the few leaves that catch the sun rather than the darker areas.

I've often read that you shouldn't put your main mass in the center of the canvas as that, too, creates an overly balanced composition. In Figure 21, however, the white house *is* centered, but the weights on the right—the massive pine, the large area of grass, the house near the frame, and the foreground rocks—keep the picture from becoming static. The pine, open ocean, and boats on the left help pull the picture back into a dynamic balance.

Figure 22 also again breaks one of the "rules" of composition: the houses are placed at an equal distance from the frame and from each other. Such symmetry could be very monotonous, but I've disrupted it with my placement of the dark trees. They keep you from noticing the even distribution of the houses. These two paintings should be a warning: don't let what you read in books—including this one—become hard-and-fast rules. You can do almost anything in a picture, if you have a good reason for it.

Center of Interest. In Figure 22, the white house is my center of interest. Every picture has such a center, and it's a fundamental principle of composition that the main contrasts and sharpest colors usually occur near this focal point. Other areas in the painting are subordinated to this center. One easy way to check your composition is to try titling your picture. If the obvious title is "The Old Barn" or "The Maple Tree," you're in no trouble. But if you want to call it "The Barn, the Stream, the Wagon, and the Mountain," you've probably emphasized too much.

Figure 23 shows a good example of a center of interest surrounded by subordinated areas. Again, I've weighted the picture to one side—the left, in this case—where I have my house, tree, water, and snowbank. The brightest highlights in the picture are on the house and bank. As you move away from this area, the snow gets grayer. There's little of real interest anywhere else in the picture. Cover the building and bank with your hand and see how vacant the painting looks.

The same principle is at work in Figure 24. Notice that the brightest area of foam is around the main breaker. The foam grays as it goes off to the right and as it comes forward—notice, for example, how gray the splash of water is in the lower left corner. The picture is like a piece of music, with a beginning, a climax, and an end. Of course, we need *some* interest outside of the focal point. A star needs supporting players to set him off. In Figure 24, the lesser waves are dull enough to avoid challenging the main breaker, yet light enough to attract the eye into the rest of the picture.

The sunlit tip of the lobster boat in Figure 25 is a strong center of interest. At the actual site, the distant rocks were low; I made them larger because I needed more light in the background to keep the boat from being too jarring a note. If the bow were brought up against dark pines, you wouldn't be able to take your eyes off it. The light had to be *related* to the rest of the picture.

Cloud Shadows. One particularly useful way to subor-

Figure 21. *Perkin's Inlet*, oil on canvas, 16 x 24 in. (41 x 61 cm). Foreground rocks and boats gradually lead you to the white house; its sunlit brilliance is the theme of my picture.

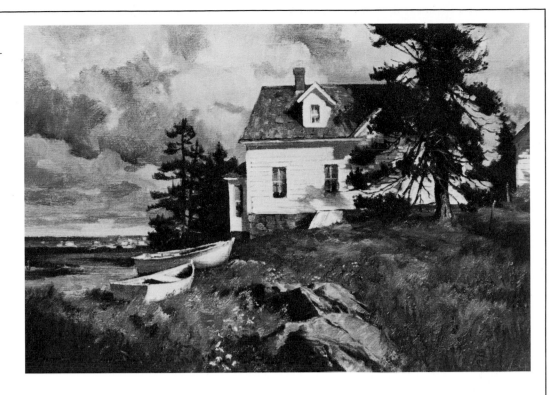

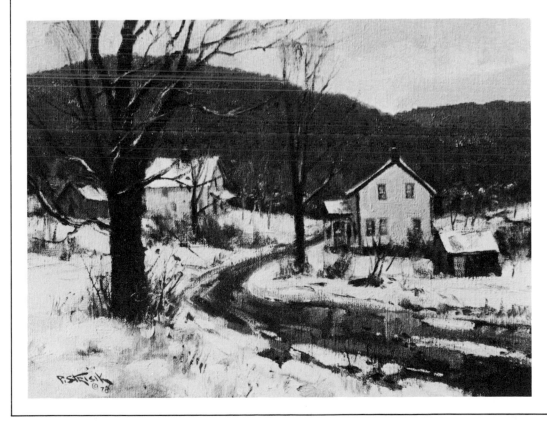

Figure 22. *April Snow*, oil on canvas, 12 x 16 in. (30 x 41 cm). The overcast day reduces everything to a few relatively flat compositional elements: the simple masses of mountain, trees, and snow.

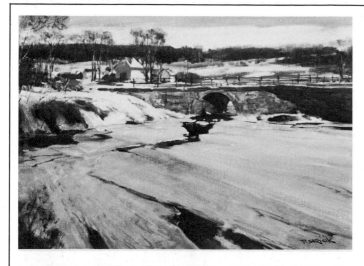

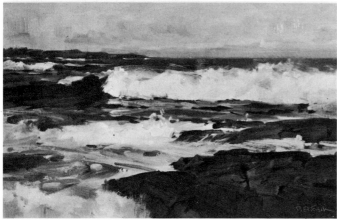

(Top)
Figure 23. *Frozen Inlet*, oil on canvas, 20 x 30 in. (51 x 76 cm). I carefully arranged the ice in this picture, taking what was in reality a disorganized mass and designing it so it leads naturally toward my center of interest. The simple right bank is a foil for the interest concentrated in the upper left.

(Above)
Figure 24. *Breakers*, oil on canvas, 10 x 16 in. (25 x 41 cm). The foreground rocks go out of the frame, suggesting a breadth of space beyond the limits of the picture. They're intended to make you feel as if you were standing on the edge of the North American continent!

dinate parts of a picture is through the use of cloud shadows. In fact, cloud shadows have always been called "the painter's friend." They change quickly, however, and it's necessary to determine your light and shadow pattern early outdoors—and stick with it. In Figure 26, I've thrown most of the foreground and distance into shadow, emphasizing only my sunlit barns and a few distant houses. Notice that to keep the barns from being too monotonous, I throw them, too, into partial shade.

Lines of Direction. You can make the viewer's eye move through your picture in a variety of ways: by your distribution of color and of light and dark weights, and also by the direction of your lines and angles.

In Figure 27, both the grassy areas in the right foreground and the clouds in the sky angle toward the barn, which is my center of interest. The brightest part of the sky is also nearest to the main barn; farther away from this spot, the sky gets darker in value. Similarly, in Figure 28, the road, fence, and rocks in the field all create lines that direct your eye into the picture. I diminished interest in the barns on the right by placing trees in front of them. The real focal point is the central group of trees; everything in the picture leads to them. I purposely made the snow lighter near the center of interest, graying it again as it moves toward the sides of the canvas.

Counterpoint. A shadow again leads you directly to my center of interest in Figure 29: the Greek church surrounded by cypress trees. Although the church is centered in the picture, I've varied the weights of trees and mountains so that the picture is far from static. However, this painting is an example of yet another compositional principle: notice that I've added interest to the composition by angling the foreground in one direction and the mountains in a contrary direction. These oppositions, which I call "counterpoint," strengthen the picture.

In Figure 30, the house is the key to the design, for its vertical thrust is a necessary counterpoint to what would otherwise be an excessively horizontal composition. If the house had not been present at the site, I would have had to invent something. The trees at the opposite end of the arch add another vertical element, as do the bushes in the foreground. I also added movement to the sky, slanting it and thus creating a foil to the placid horizontal scheme.

Before you begin to think of counterpoint as an inflexible principle, however, consider Figure 31. Here everything slopes toward the right, with the exception of a bit of snow near the frame which angles in a contrary direction. When I studied the site, I knew that, theoretically, the foreground should angle in a direction opposite to that of the mountain. But I *liked* the similarity of the angles, and so I retained it.

DESIGN

Once you've determined your placement of the main elements of a scene, you need to concern yourself with design. Design is the further refinement of compositional shapes into more considered, sophisticated forms. To some extent, this requires a stylization of the rhythms, shapes, and angles of your subject—aspects which are often only subtly *suggested* by nature. In design, then, there's a hint of caricature. You sense the character of what you see, exaggerate it, and thus express it better on canvas.

Design is what saves our paintings from being trite, banal, purely "naturalistic" pictures. It adds intellectual sophistication to our work. When you look at the work of great muralists and illustrators—Frank Brangwyn, for example,

Figure 25. *The Channel, Low Tide,* watercolor, 21 x 28 in. (53 x 71 cm). The rich light from the last slanting rays of the sun emphasizes the velvety darks and half-darks of this setting. The boat forms a natural climax to the picture.

Figure 26. *April Skies,* oil on canvas, 12 x 16 in. (30 x 41 cm). I transformed the old house at this site into a barn. I added the house on the far right, shadowing it in order to emphasize the light on my subject.

Figure 27. *Hilltop Barn*, oil on canvas, 20 x 30 in. (51 x 76 cm). On an overcast day, I look for subjects that form an interesting dark silhouette against the sky. Most of the weight of the picture is on the left; it's balanced by the smaller barn and distant mountains on the right.

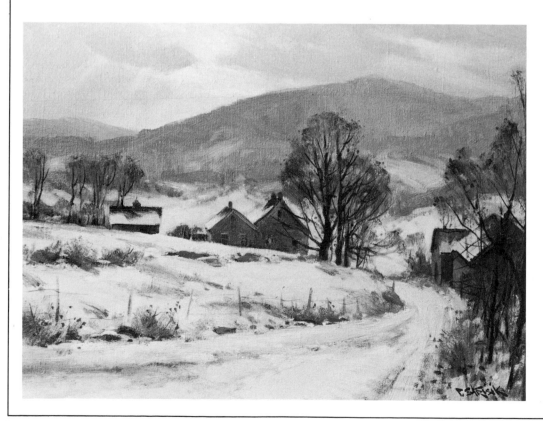

Figure 28. *Winter Valley*, oil on canvas, 12 x 16 in. (30 x 41 cm). The two main houses in the picture are similar in contour, and so I add a differently shaped barn on the left to break the monotony.

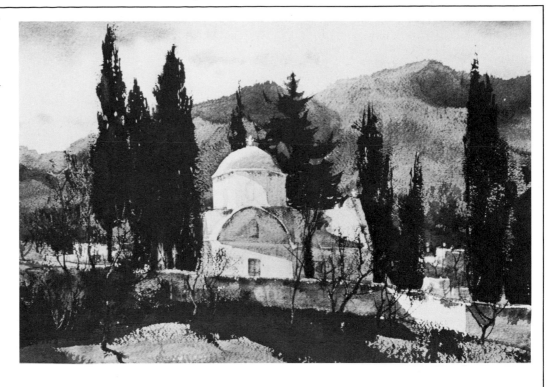

Figure 29. *Church at Arch-angelos, Rhodes*, watercolor, 14 x 21 in. (36 x 53 cm). I varied the heights of the cypress trees to make them more interesting to look at. I also added a sense of ''intimacy'' to the picture by using small trees to obscure parts of the wall and church; your eye goes directly to the sunlit part of the building.

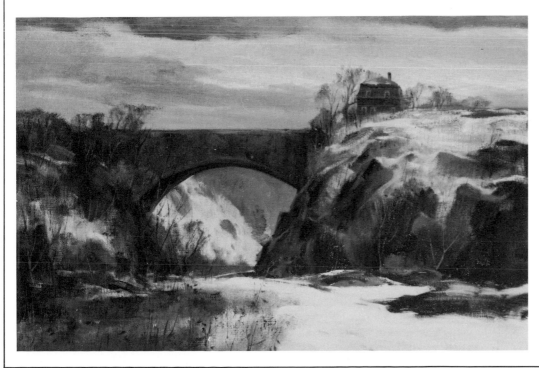

Figure 30. *Cove Bridge*, oil on canvas, 20 x 30 in. (51 x 76 cm). A simple winter pattern. I was struck by the mood of the scene and by the silhouette made by the bridge, cliffs, rocks, and house against the lighter snow and sky.

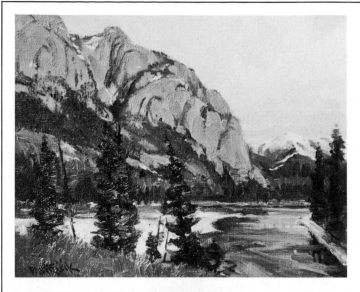

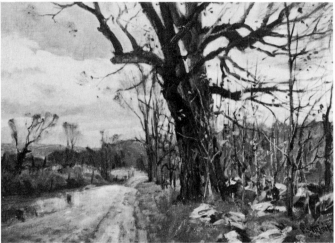

(Top)
Figure 31. *Mt. Corey, Banff*, oil on canvas, 8 x 10 in. (20 x 25 cm). The dark trees on the right stop you from following the shape of the mountain downward and out of the picture. I used dark foreground trees to throw the distant mountain back in space.

(Above)
Figure 32. *Clearing*, oil on canvas, 10 x 14 in. (25 x 36 cm). I painted this picture on a rainy day, sitting on the passenger side of my car with a small sketch box on my lap. The maple had many more branches than I needed, so I painted just enough to describe the character of the tree.

or N. C. Wyeth—you immediately see how they were able to fit the facts of nature into a coherent whole. Any religious picture from the Renaissance would show the same sense of design. The robes of a prophet or the Madonna are never photographically rendered; the painter picks just those folds that relate to the body, lead the eye to a focal point, or otherwise serve some pictorial function. You may not consciously realize how the painter is using the folds; but his care and consideration add strength and a sense of "richness" to the composition.

RHYTHMS

When you "design" the parts of a landscape, try to think of objects in terms of their basic, natural rhythms. In Figure 32, for example, I tried to capture the design character of a maple tree. In this scene, the road was lined with maples, but I subdued the others in order to concentrate on the dignified character of this individual tree.

Trees. All trees have much in common, but it's the differences that give each species its unique identity. The rhythmic growth of a maple is a direct result of its being a hardwood tree. It's a simple question of cause and effect. Since a maple's wood is so hard and strong, it can successfully put out horizontal branches; trees with softer woods— elms, for example—can't do this and therefore their branches grow vertically. I seized on this difference when painting the tree in Figure 32.

As you can see in Figure 33, fir trees also have an obvious pattern. They're simple, dark shapes with irregular masses of needles. They're far from the symmetrical, triangular Christmas trees that you see in many student paintings. Notice, however, that even when parts of them are lit by the sun, the highlights are still well contained within the dark masses of the foliage. Squint at a sunlit pine and you'll see what I mean. You mustn't lose sight of the tree as a *unit*.

Rocks. Rocks also have characteristic rhythms, depending on their geological history. When you first arrive at a site, the rocks may seem to have been dumped, helter-skelter, in front of you. But look for the rhythms that give cohesiveness to the mass. Don't work piece by piece!

What appealed to me about the scene in Figure 34 was the interesting outcropping of granite, but there was no way I could actually paint the countless facets of the ledge. Instead, I simplified the rock, reducing the details to a few characteristic, vertical rifts—and as I did so, I made the ledge larger so there'd be no doubt about which element of the scene interested me most.

In Figure 35, I wanted to emphasize the theme of conflict. The actual ledges were jumbled and broken, but on canvas I pulled them together and created a few powerful, weighty masses. Now you can feel the rocks and water as two simple, opposing forces. I'm not falsifying the site when I unify these rock masses. On the contrary, I felt the force of the elements when I arrived at the spot and didn't want to lose that essential impression by adding a lot of unnecessary details.

Water. More than almost any other subject, water must be painted in terms of rhythm (Figure 36). It's impossible to capture each rivulet and splash of foam. Rather than drawing the anatomy of the water, you should squint your eyes and look for areas of contrasting value. Squinting kills the unnecessary details. In this illustration, for example, the stream is suggested by subtle value changes in the churning rapids.

In Figure 37, I used the same method to paint the open

Figure 33. *At Okanagan*, oil on canvas, 8 x 10 in. (20 x 25 cm). In painting the pines against a light, overcast sky, I tried to capture the silhouette, without worrying about variations within the mass. They form a single unit. There were a number of pines at the spot; I chose the ones that looked best to me.

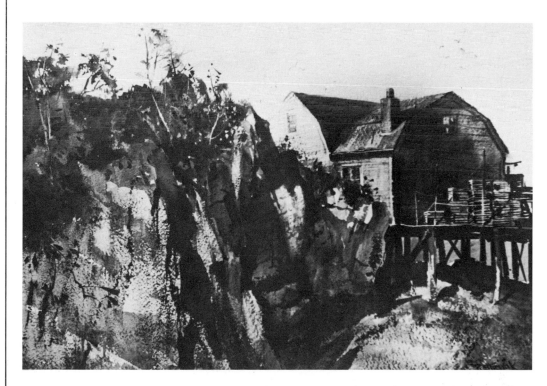

Figure 34. *The Ledges*, watercolor, 14 x 21 in. (36 x 53 cm). By obscuring much of the house with rock, I emphasized the fact that the ledge is the theme of the picture. A natural center of interest occurs where ledge and building meet.

Figure 35. *Rising Storm*, oil on canvas, 8 x 12 in. (20 x 30 cm). To emphasize the threatening mood of the scene, I treated the rocks in a massive, simple manner. I hid the wave below the edge of the rocks to suggest the conflict between surf and land.

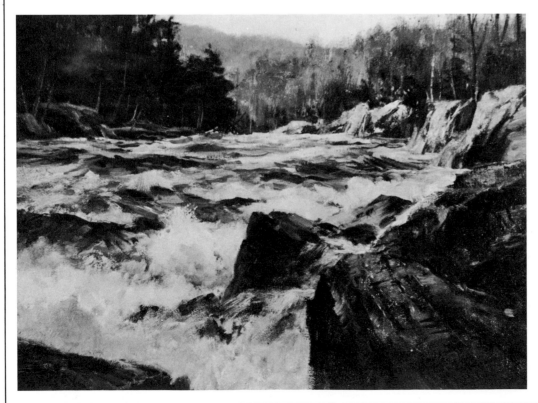

Figure 36. *Rapids*, oil on canvas, 12 x 16 in. (30 x 41 cm). The shadowed bank on the left is a foil to the sunlit one on the right. The nearby rocks are arranged to lead you into the picture. By keeping the water and rocks shadowed in the foreground, I emphasized the lighter areas of foam.

ocean. Students usually make foam too much like balls of cotton. If there's any breeze at all, the foam will be blown in one direction or another. Here, for example, the wind comes from the right and compresses the foam on the windward side of the wave, where you see the suggestion of a sharp edge. On the leeward side of the wave, however, the foam blows away, resulting in a soft edge. This contrast of hard and soft edges gives naturalness, weight, design, and beauty to the water.

SHAPES

The shape of each subject—trees, rocks, water—expresses the characteristics of that subject. But these shapes should also be pleasing in and of themselves—pleasing, that is, in an abstract way. Unfortunately, students are usually so busy trying to make things "look like" what they are, by describing textures and colors, that they hardly ever consider shapes. When you work piece by piece, you end up with a collection of unrelated parts. How often have you labored over a house in one of your paintings and finally sighed, "Thank goodness, that's done; now I can do the trees!" That's the *wrong* way to proceed. In a good picture, all the pieces fit like the parts of a well-designed machine; if you remove one part, the whole machine breaks down.

Not only must each shape be effective in itself, it must also have a fine relationship to each of the other shapes in the painting. And you must also give careful consideration to the spaces between your principal objects. You can paint a house and a tree, but if you ignore the design of the sky showing between them—what is called the "negative" shape, the area *between* your principal or "positive" objects—it may have an ugly repetitious contour and thus ruin your picture.

In Figure 38, I wanted to suggest the break-up of winter, but I also needed to make the shapes of the foreground snow patterns interesting. When students do snow patches, they think "snow patches." In reality, however, it's the dark areas, or the negative shapes, between the patches, that must be pleasing to look at. They must be varied in size, direction, value, and contour in order to be interesting as abstract entities.

Remember that the canvas has an independent existence. The landscape is one thing, the picture, another. You have to learn to use shapes that work with the *picture*. The student's view of the painting process is completely different from that of the seasoned professional. This has nothing to do with technical facility, but rather with a fundamentally different way of looking at the subject. This is to be expected; the most intelligent of men, given a paint box for the first time, wouldn't know how to see as an artist. Thinking naturalistically, the average student looks at a tree and sees the bark, branches, and individual leaves. The professional, on the other hand, sees a particular mass and shape against the sky. He sees the design possibilities, while the student sees only the parts that make up the whole. As a result, most student pictures are full of details that never quite fit together. The student uses his eyes, but the professional uses his judgment.

A Warning. Although it's necessary to look for the characteristic aspects of your subject, don't overdo it! Your pictures then begin to look like cartoons or posters. Design isn't an end in itself—it should be used to strengthen the theme of your picture. Because of an overriding interest in design during the 1920's and '30's, many of the landscape paintings

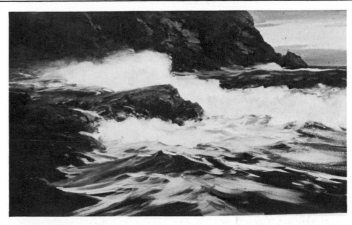

(Top)
Figure 37. *Monhegan Surf,* acrylic on Masonite, 26 x 40 in. (66 x 102 cm). When you paint marines, it's hard to think of different points of view—and even harder to discover "rules" that don't quickly become tricks. The only way to paint the ocean is to study, sketch, and analyze its movement. Don't paint it as "rocks and water." Look instead for a quality of the day or for the relationship between values and colors.

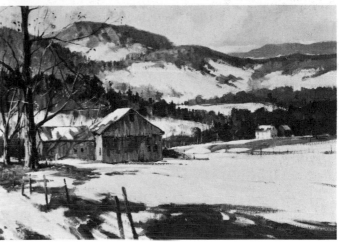

(Above)
Figure 38. *Melting Snow,* oil on canvas, 16 x 24 in. (41 x 61 cm). I use perspective to move your eye into the picture: all the foreground lines lead toward a point to the left of the barn. The main weight on the left is balanced by the small buildings on the far right.

from that period have a mannered, overly decorative look. Today these pictures look oddly false, like miniature stage sets. An artist's excessive concern with design keeps the viewer from relating to a familiar world—a world in which he can walk and breathe. Design is important, but it shouldn't threaten the viewer's emotional response to your painting.

SUMMING UP

Some people think being "original" means hitting people over the head with a bucket of paint. Yet "conventional" paintings can still be very inventive and creative. Each of the Rocky Mountain painters—Moran, Bierstadt, Church, and the rest—gave a highly personal turn to what, at a superficial glance, looks like extremely realistic, academic work. In our own day, Andrew Wyeth's viewpoint transfigures what at first appear to be careful transcriptions of nature. The fact is that if you took any two great painters—Velàsquez and Rembrandt, for example—and asked them to paint a portrait of the same person, they'd both get a likeness. But you'd also know who painted which picture. Powerful personalities put their mark on whatever they do. That's why I keep repeating that simply describing the facts of a scene has nothing to do with the painter's true craft. Painting the truth doesn't mean making a literal "picture of something." It means creating a faithful representation of an emotional experience.

On some days, we all go through the motions of painting. We squeeze out paint, but forget that it's not enough just to cover a canvas. Too many paintings are excuses for covering canvas! If you're not excited by the subject when you paint your picture, the viewer won't be excited when he or she looks at it.

At the same time, it takes tremendous strength of character both to stay faithful to good painting and to present a part of yourself in every canvas. The pressures of day-to-day life affect our work, and every painter has sold pictures that he'd love to get back and burn. My teacher Dumond used to say that "if you paint through the eyes of the buyer, you'll grow to hate your profession and, what's worse, yourself!" Nor, I should add, am I altogether pure and unsullied. In fact, when I lecture you, I'm really lecturing myself. I'm reminding myself what painting is all about. We all need such reminders if when the time comes to lay down our brushes for the last time, we are to have done enough sincere work to justify our craft.

To many students, this kind of talk may seem abstract and high-flown. But it's really very practical. Unfortunately, most people can't accept in painting what they *expect* in the other arts. Consider literature. Not being a writer, I might need ten pages to describe Rockport Harbor. I'd list all the details of the scene and hope that these pieces would give the reader a sense of the place. Tolstoy, on the other hand, could do the same thing in a paragraph. He would describe only the characteristic aspects of the scene. We don't expect him to tell us everything; if he did, we'd find his writing tiresome. Similarly, a young lawyer might take fifty pages to write a legal brief, while an experienced attorney, having learned how to get at the essence of the case, could present the same material in a couple of pages.

A good writer uses verbal symbols to create a mood. As a painter, you can actually show the viewer a tree or a mountain; but if you are not selective about which details to leave out or emphasize, then the writer's description will be a more effective statement because it's more personal. When you paint things *exactly* as they are, you don't show people anything they couldn't see for themselves—you're telling them what they already know. The viewer, however, doesn't want to sort out the truth all by himself—he wants you to help him. As Charles Hawthorne said years ago, the painter "must show people more—more than they already see, and he must show them with so much sympathy and understanding that they will recognize it as if they themselves had seen the beauty and the glory."

Now that you're familiar with a few basic design and compositional concepts, let's visit some painting sites. I often take photographs of a subject after I've finished painting outdoors; so in many of the examples which follow, I can show you what both the spot *and* the painting look like. Since I photographed each of the sites after I'd spent the day painting and the sun had changed position as I worked, you'll notice that the light in the photo doesn't always match that of the painting. When I look through these photos, I am sometimes surprised by the appearance of the actual site. Since the painting contains so much of my emotional response to nature, it *becomes* the place for me and I forget how the spot "really" appears.

Although this book is about oil painting, I include a few watercolors, too—for when we talk about composition, the same kind of thinking applies to *all* media.

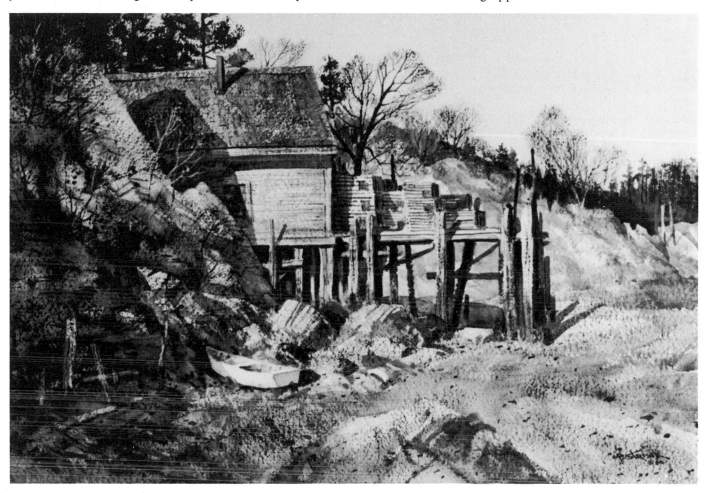

Hidden Wharf, watercolor, 14 x 21 in. (36 x 53 cm). This painting is a good example of how an artist can take a common subject and, with imagination and esthetic judgment, make a more interesting and personal statement. What appealed to me about this scene was the unusually high bank behind the wharf. By adding a bank in the foreground to partially cover the fish house, I created a sense of mystery and also placed an interesting cast shadow on the fish house. I rearranged or eliminated trees, brush, and other elements as needed to strengthen my composition.

Waterville, oil on canvas, 16 x 20 in. (41 x 51 cm). I'd painted this area before, usually from a more intimate vantage point, focusing on the bridge, parts of the stream, or the church. In this case, however, I wanted to suggest the character of a Vermont village, nestled in the mountains. The danger here, as with all panoramic views, was that the interest would be scattered over the canvas. I avoided this by selecting a center of interest—the church—and placing the buildings and trees so that they would lead to it. In the painting I eliminated the tower behind the church so the steeple wouldn't have any competition.

In painting the scene, I not only made the church the climax of the composition, but also simplified the surrounding buildings so that their character could be more easily understood. I eliminated many of the trees so the buildings could be seen and would better express the nature of the village. I heightened the distant mountain, which actually peaked to the right (not visible in the photograph), and so worked it into the painting because I felt it was an important part of the scene. I violated literal appearances to emphasize an emotional fact. It's like using little fibs to best express the truth. I'm sure that a resident of the town, looking at my picture, would recognize the place—and would, in fact, be unaware of any changes made in the actual scene. The resident remembers *emotionally*; he doesn't recall exact details.

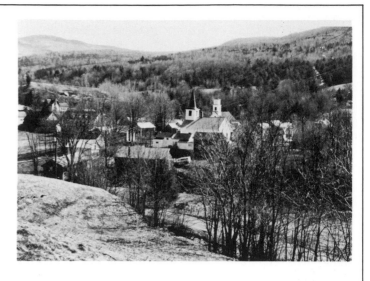

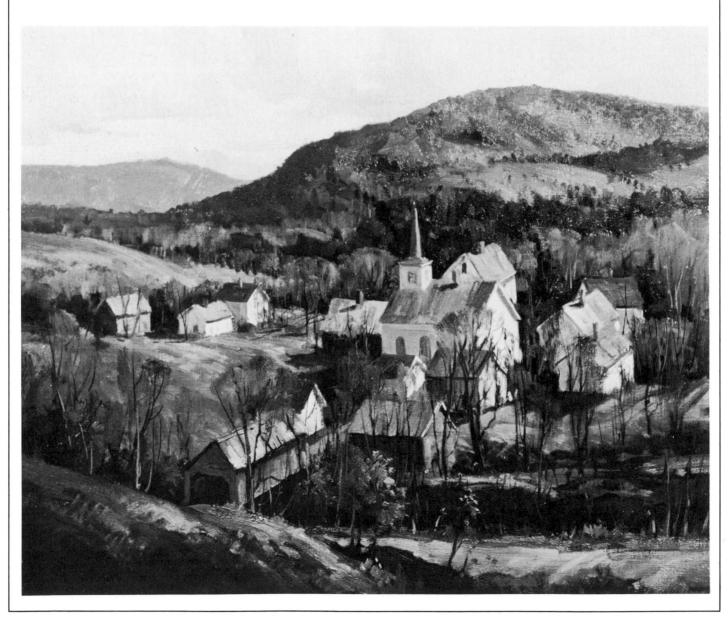

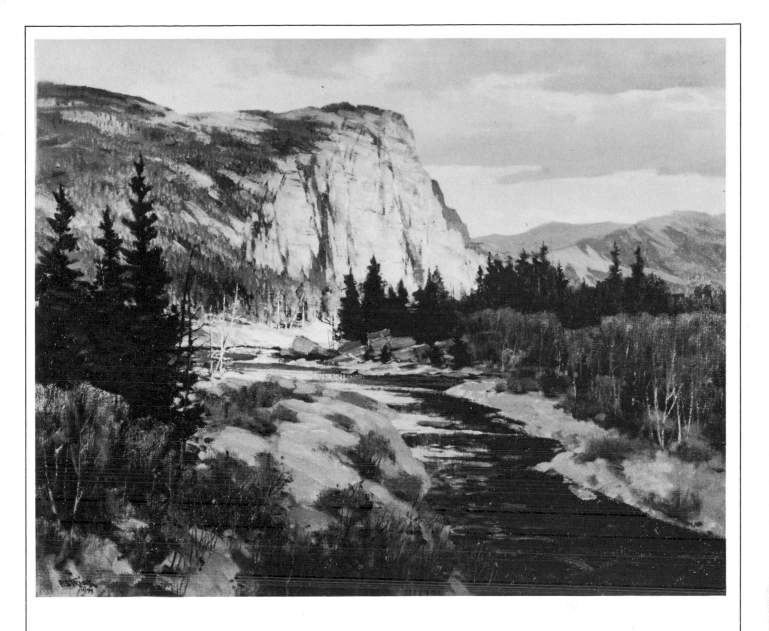

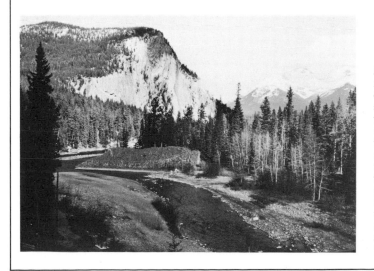

Bow River, Banff, oil on canvas, 24 x 30 in. (61 x 76 cm). Looking down at the Bow River, I was struck by the interesting pattern of the water and trees and by the dramatic way the light hit the stone face of the mountain. The sunlit mountain is a natural focal point for the composition. I lowered the distant snow-covered hills in the painting in order to emphasize the height of the sunlit mountain, which looks more dignified when unchallenged by its neighbors. I also redesigned the mountain, giving it a stronger shape—in the photo of the original site, it drops weakly out of the picture at the extreme left. The evergreens (on the right in the photo) were much too blocky in shape; I broke them into a more interesting *design*. I also gave the stone face of the mountain more character by emphasizing its striations and cracks. The picture is composed so that the distant mountains, the trees, and the stream all lead toward the main sunlit mass. I then emphasized this mass by throwing the foreground into shadow.

Hilltop Adobe, oil on canvas, 12 x 16 in. (30 x 41 cm). In contrast to *Bow River, Banff*, where I emphasized the large masses, I made this picture interesting by focusing on only a small part of the scene. That gave me a chance to make a simple and effective arrangement of shapes. Since I was painting a landscape and the sky was unimportant, I kept the horizon high and emphasized the foreground and buildings. I handled the field very simply; the eye slides over it, moving into the picture easily. By increasing the importance of the mountain on the left side of the photograph, I created a line of direction that leads the eye back into the picture and prevents it from slipping out of the painting. I also added a figure, some chickens, and a wheelbarrow to give my focal point additional visual interest.

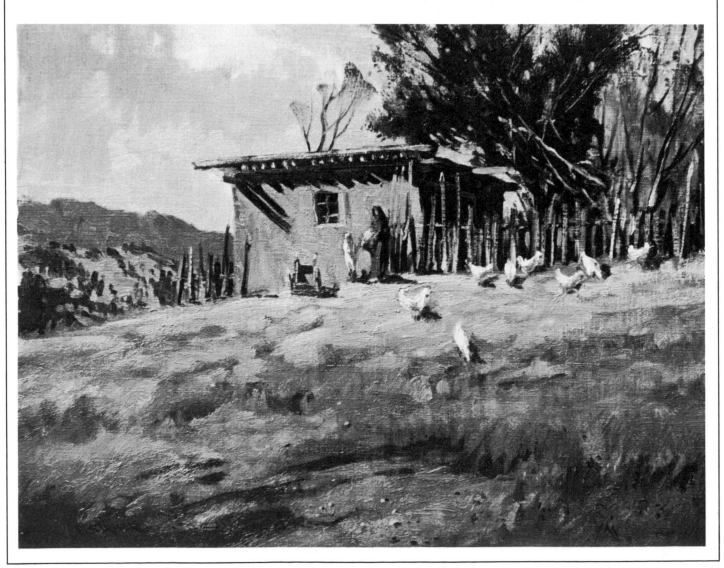

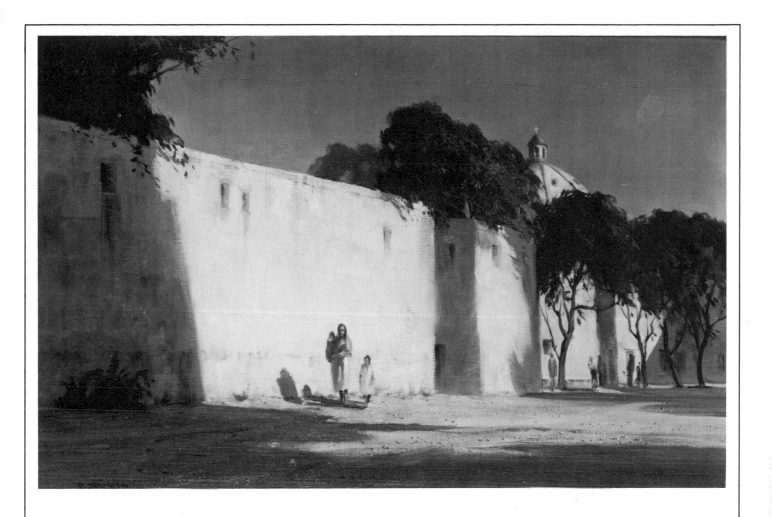

The Wall, Mexico, oil on canvas, 20 x 30 in. (51 x 76 cm). I was struck by the way the light hit the high white wall, yet the rest of the site was uninteresting and I had to improvise in order to add needed variety. In the painting, I broke the wall here and there and added shadows on the left and right, subordinating those areas and framing my figures. I balanced the figures by moving the church into the middle distance. The rounded dome of the church also helps relieve the dominant angularity of the composition.

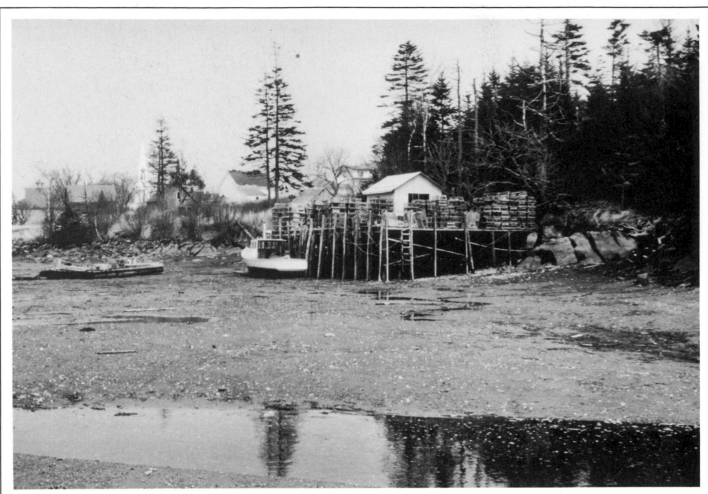

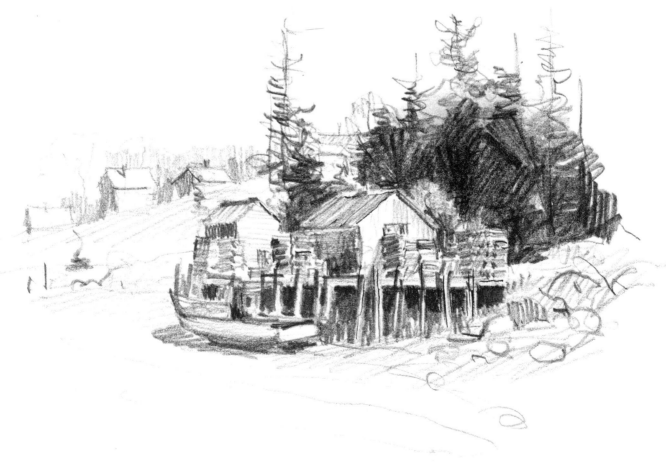

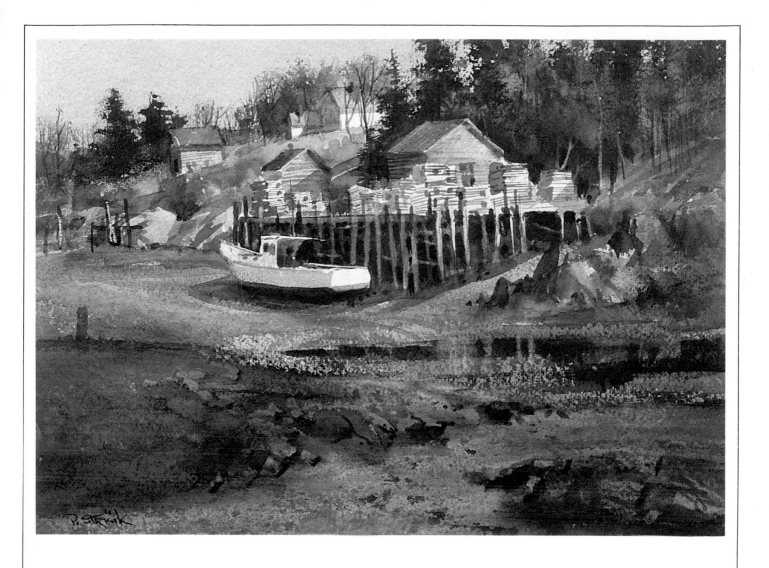

Clyde's Wharf, watercolor, 10 x 14 in. (25 x 36 cm). When I first saw this area, I wasn't very excited by it. I decided to draw, rather than paint; but by the time I'd finished my pencil sketch and worked out many of the compositional problems, I felt enthusiastic. I'd become familiar with the place and could see its essential character better.

In the painting, I gave a weathered tone to the newly built shack so that it would fit in better with the rustic subject matter. I used the mass of pine trees to set off the sunlit portion of the wharf. Since the factual appearance of these trees wasn't important, I didn't try to copy them literally—what counts is their dark value against the light wharf—and so I made them into a decorative shape, eliminating tall pines that would have dwarfed and detracted from my center of interest. I also removed the distant church steeple; it's too arresting for a background element. Since the distant land mass slopes downward to the left, I used dark pines at the far left to stop it from leading your eye out of the picture. The small piling on the left also functions as a stopping point. I gave the foreground water and mud a more dynamic design so it would lead you *into* the painting.

Along the River, oil on canvas, 16 x 20 in. (41 x 51 cm). When I did this picture, I was looking into the light with my hat down over my eyes, and after two hours I was exhausted. In the photo of the site, the large background mountain is a cool foil to the warm, sunlit trees; but its shape slants downward so strongly that it leads your eye out of the picture. The distant mountain on the right also slides out of the photo in the same direction.

In the painting, I exaggerated the downward thrust of the mountain, but I also made less of its mass. As a result, I could show more of the mountains in the distance and thus add air and space to the painting. Each of the small background mountains, as well as the clouds, angles in a way that leads your eye back toward the principal tree. I also tried to temper the dramatic movement of the mountain by breaking it with the vertical thrust of the foreground trees.

In terms of weight, the main masses in the picture are to the left: the mountain, bank, and trees. To keep from dividing the canvas in half, I made the main mass of foliage break across the center, embracing both sides of the picture. The mass on the left is balanced by the distant mountains and especially by the triangular bit of sunlit mountain directly above the glare on the water.

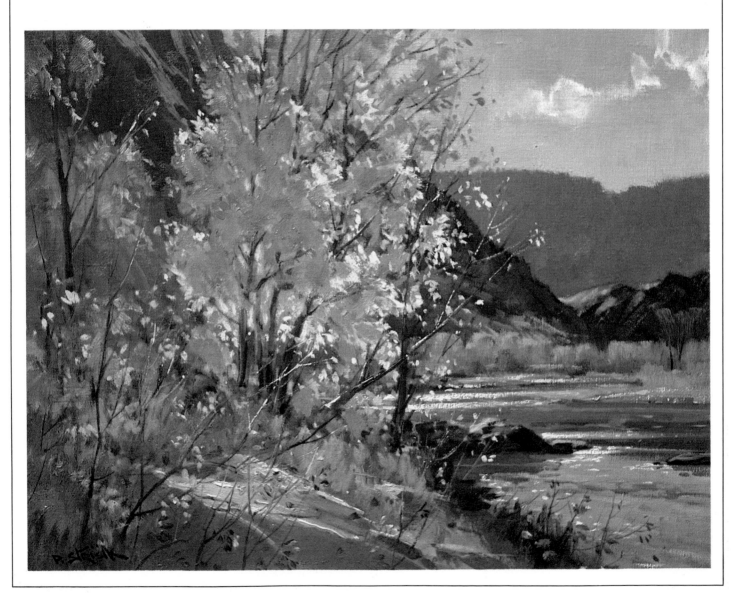

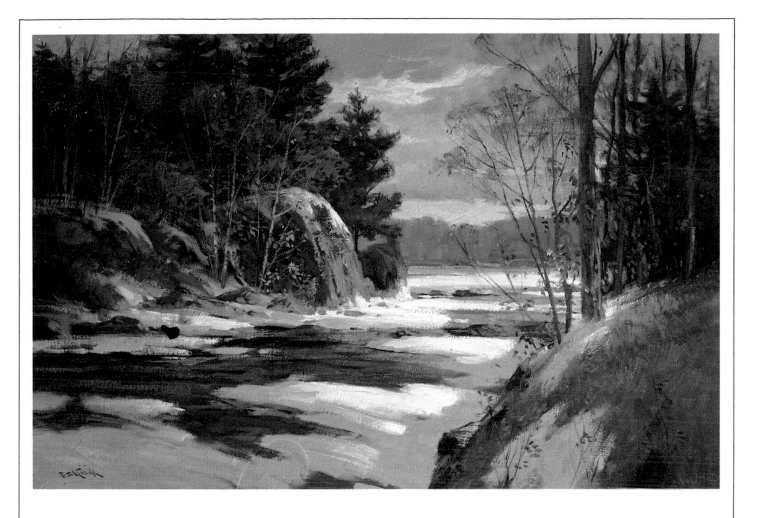

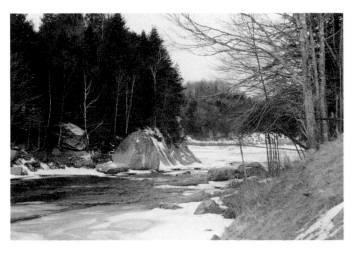

March Thaw, oil on canvas, 20 x 30 in. (51 x 76 cm). I photographed this typical scene in northern New England before the sun broke through the clouds and lit the distant trees, snow, and rocks. In the painting, I broke the contour of the background evergreens, giving them a more interesting shape. I used the trees and the shadow side of the boulder as a foil for some white birches and a few sunlit dead leaves which add sparkle to the scene.

I lowered the distant hill so it wouldn't compete with my center of interest. Since it is light in value, it contrasts with and reinforces the strength of the darker foreground. I made the open area of water more irregular and decorative in shape and simplified the trees on the right so they wouldn't compete with the interest on the left-hand bank. I made *one* distant rock the dominant one, reducing the others in size and nearly eliminating those in the water, which I felt wouldn't add anything to the picture. I not only designed the water and firs, but also used snow patches to give an interesting pattern to the nearby bank. Without the snow, the foreground bank would have been a monotonous quarter of a circle.

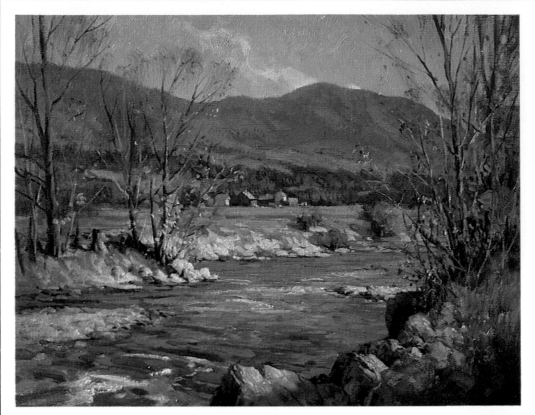

Vermont Stream, oil on canvas, 16 x 20 in. (41 x 51 cm). In the photograph below, the site looks unpromising. A bulldozer had recently widened the stream, piling mounds of pebbles along the sides. Although this was monotonous, I still liked the areas of light, the colorful water, and—what you can't see in the picture—the pleasure I felt standing on the riverbank. In the painting, I contrasted the cool stream with the warmth of the rocks, foliage, and mountain. By keeping the foreground in semishadow, I emphasized the brilliant light on the distant bank. Since the bulldozer had leveled the riverbank and destroyed the natural appearance, I had to rearrange the rocks. I used the strong verticals of the trees to relieve the horizontality of the picture.

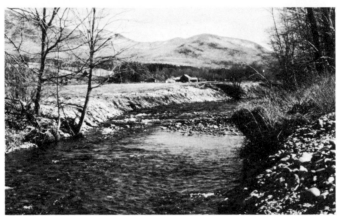

(*Bottom*)
Snow, Early Spring, oil on canvas, 12 x 20 in. (30 x 51 cm). This shows the same spot as the previous painting, but here we see it in winter. Since I was using a long format, I emphasized the horizontal breadth of stream and mountain, rather than the vertical dignity of the trees. I was looking toward the partially obscured sun, and the trees, hills, and buildings were silhouetted against the light snow and sky. The sky in this picture is warm and gray—the exact opposite of the cool sky in *Vermont Stream*. As a result, the water is gray, too. Notice how I emphasized the stream in the first picture and the mountains in this one.

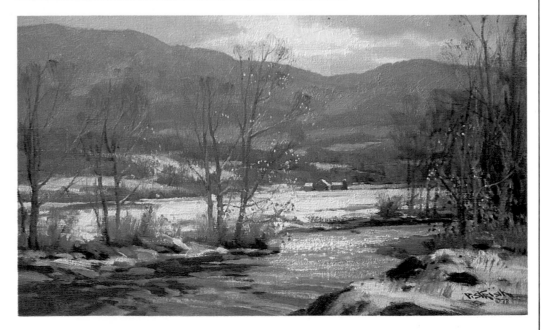

Fairfax Falls, oil on canvas, 16 x 20 in. (41 x 51 cm). I'd gone to this spot a number of times in the past, but I'd never been attracted to it. However, one October heavy rainfall increased the flow of water and added great excitement to the scene. In the final painting, I subordinated the sky so that the falls were clearly my main area of interest. The distant houses were in shadow, but I added sunlight to them, thus relating them to the sunlit foreground. By throwing the lower half of the picture into shadow, I emphasized the area in light.

As I look at this picture again today, several years after painting it, I feel that the foreground rock on the right is too high. I had wanted its dark mass to set off the brightness of the water, but instead it blocks the edge and hems you into the picture. Cover it with your finger, and you'll see how the painting suddenly has a greater feeling of openness and atmosphere.

Last Gleam, oil on canvas, 12 x 16 in. (30 x 41 cm). This painting was done on a gray, overcast day. The small, dark pine in the right foreground helps to distribute the evergreen theme throughout the picture so that all the trees aren't isolated in a clump along the ridge of the mountain. Cover the small tree, and you'll see how isolated the main clump appears. At the site, the snow was concentrated in a single drift, but I introduced other snow patches, all moving in directions that counterpoint one another. The biggest shape, the mass of pines, remains at the center of interest, just as the brightest patch of snow is also in the same area.

Winter's End, oil on canvas, 20 x 24 in. (51 x 61 cm). I saw this stand of pines in Vermont in the spring and was struck by their heroic character: they were lofty and monumental, with the weight and dignity of a piece of sculpture. I had to make two changes in order to emphasize this quality. First, the trees were standing at the edge of a cornfield, and since I found the cornstalks distracting, I replaced them with grass and rocks. I also added a few snow patches to give the foreground an interesting design. Second, I changed the sky, which was a solid blue that detracted from the rich green of the trees. Therefore I grayed the sky slightly. Now the whole picture works toward my central theme: a stand of pines.

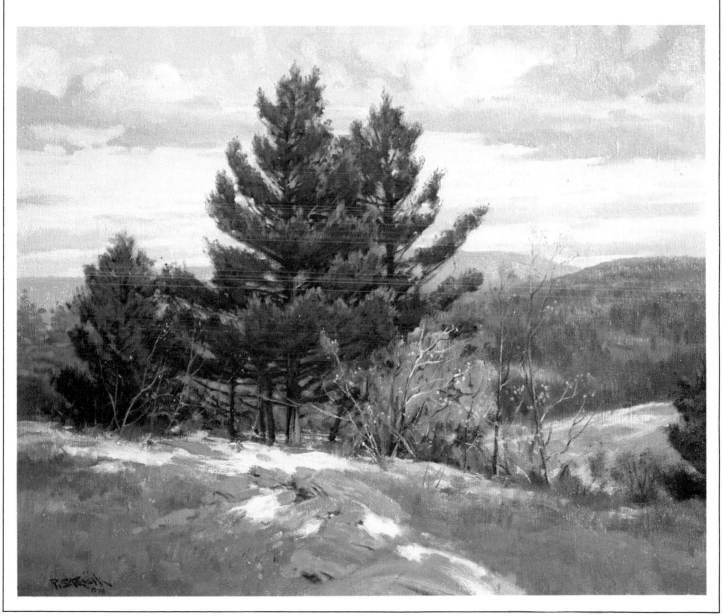

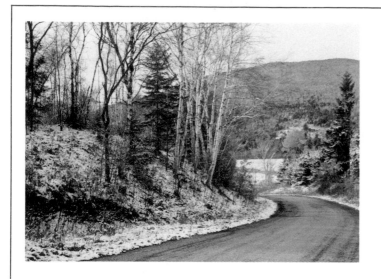

Birch Valley, oil on canvas, 20 x 24 in. (51 x 61 cm). While driving in Vermont one day, I suddenly found this "natural" composition. When I painted it, I reduced the number of trees to make the scene easier to understand. I also simplified the areas of snow: the fall landscape had only a light dusting, but by pulling the snow patches together, I was able to make more *sense* of the site. It's not so spotty and busy. In the photo, the background mountain slants rapidly out of the picture on the left; I redesigned it so that it not only would stay in the painting, but also its darkish mass would set off my snow-covered hill. I also added snow patches to the base of the distant mountain. The lines of the hills all counterpoint one another. The mountain slants in one direction, the snow patches in a different direction, and the foreground hill in yet another. The picture is really a series of angles, relieved by the vertical movement of the birch trees.

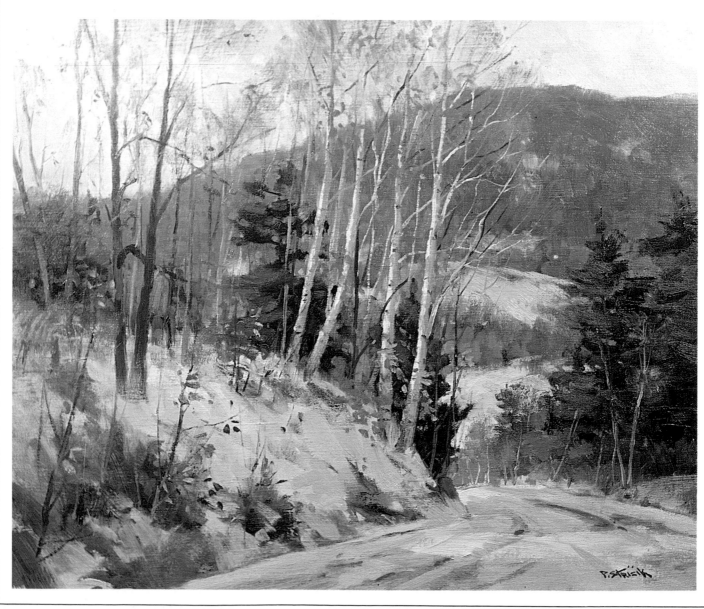

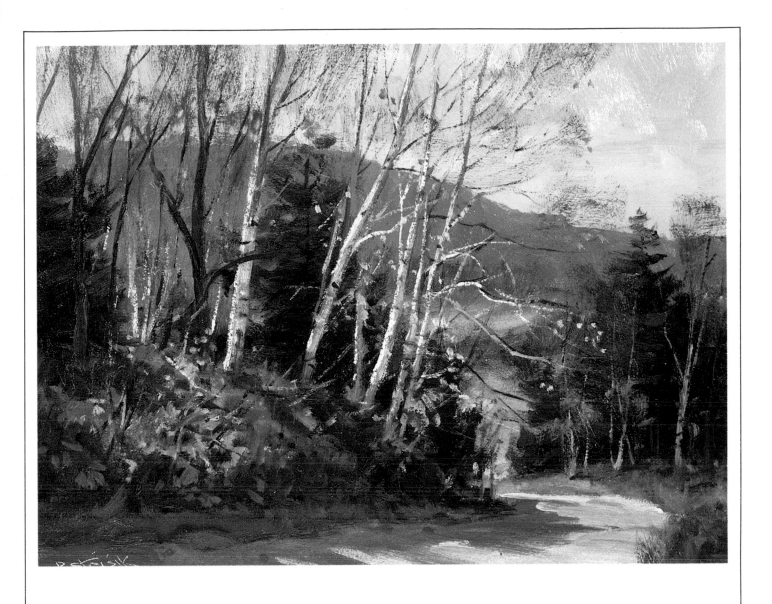

Duck Hollow Road, oil on canvas,
12 x 16 in. (30 x 41 cm). This paint-
ing shows the same spot in the
early fall. There is so much strong
interest in the foreground—the
dark evergreens, for example, and
the rich, warm color of the sunlit
hillside—that I subdued the distant
mountain, painting it as light areas
of color with no visible detail.

Young Aspens, oil on canvas, 8 x 10 in. (20 x 25 cm). Here we have a different sort of tree: the more lyrical aspen. The delicacy of its character is perfectly complemented by the quiet gray sky. The aspen's silver-green bark is beautiful in the woods—especially when seen against a dark background of evergreens. At the site, the aspens were in great profusion and disorder, so I emphasized just the few nearest to me. They're done in detail, whereas the others are merely suggested. I increased the interest at the focal point by adding some leftover autumn leaves, which I saw at the site and therefore used at my discretion. Notice that the leaves become duller as they move away from the center of interest. Since only the ones at the focal point are highlighted, the picture doesn't become a collection of disjointed spots. You should try making small oil sketches of anything that interests you; they will help familiarize you with the character of things.

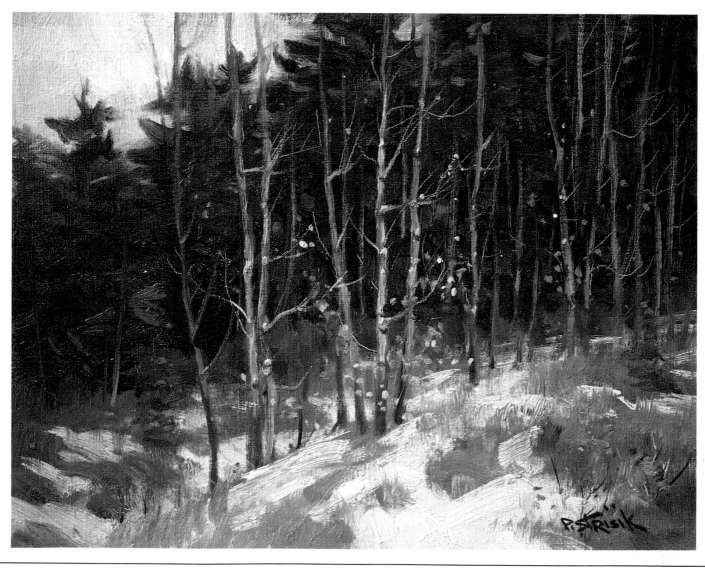

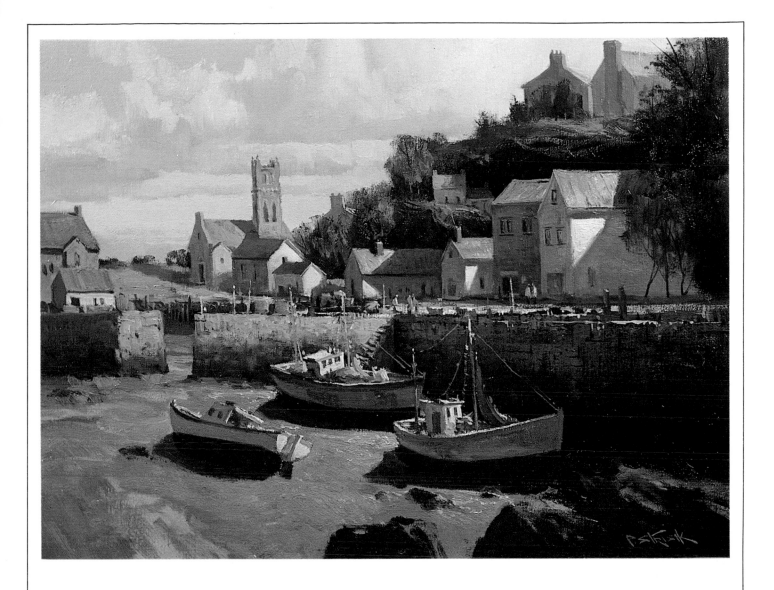

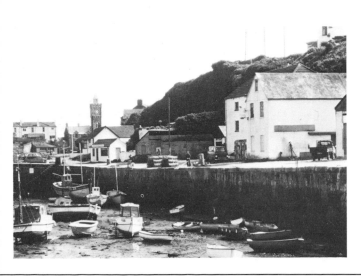

Porthleven, Cornwall, oil on canvas, 12 x 16 in. (30 x 41 cm). The light in the photo differs from that in the painting because I took it after I'd finished work, and the sun had begun to set behind the hill. In the painting, I compressed the background to show the opening in the seawall, which is a vital part of the character of the port. I also opened an area on the hill to the far left. The original scene was claustrophobic, and I felt the viewer should be able to escape into the distance. I added large foreground rocks; when compared to the shapes of the smaller ones in the background, they enhance the picture's depth. The rocks also break up what might have been an excessive amount of foreground sand—a mass that would have dropped awkwardly out of the bottom of the picture. Cover the rocks with your hand and see how weak the area looks. The two large buildings on the left balance the cluster of buildings to the right; they also stop your eye from following the line of the dock out of the picture. I made the top of the seawall more interesting by adding gaps and piles of paraphernalia. I also reduced the number of boats in the harbor. The upper half of the picture is so active that the viewer needs some relief in the simpler, lower half. The empty area of sand on the lower left is especially important; that's where the eye has a chance to rest.

St. Agnes Beach, Cornwall, oil on canvas, 24 x 30 in. (61 x 76 cm). This scene is typical of the Cornish coast. As you can see in the photo, the bluffs are all lit with a flat light. In the painting, I enhanced the effect of the distant headland by throwing the foreground rocks into shadow. I also simplified the rocks and gave them a more interesting contour. By redesigning the foreground rocks and water, I made them lead you into the picture. The shadow across the foreground is particularly important, for it makes you feel you're looking from a tunnel of darkness toward a brilliant light. Thus, the impact of the sunlit headland is greatly increased. This painting shows how much of the painter's craft is related to *judgment*. Judgment shows you how to emphasize the character and poetry of the scene and thus better share your excitement with the viewer.

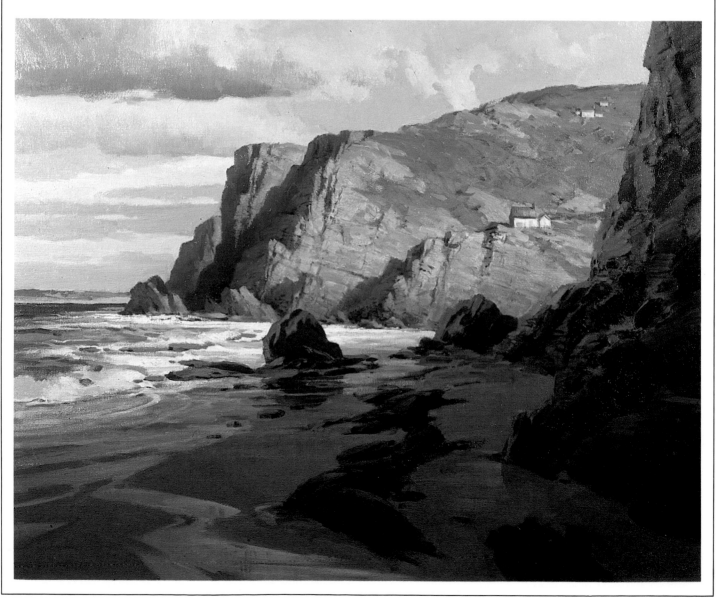

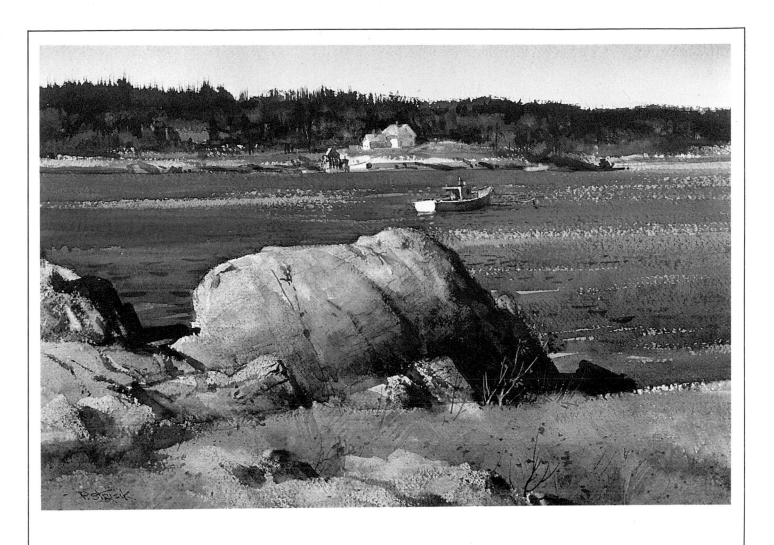

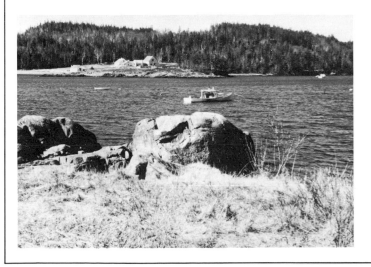

Morning, Cutler, watercolor, 14 x 21 in. (36 x 53 cm). I liked the contrast between the sunlit rock and the rich, dark water ruffled by a brisk wind one crisp autumn morning. When I painted the scene, I made the left-hand rock smaller so it wouldn't compete with the textures and patterns of the central boulder. I added flat rocks in the foreground to break the monotony of the grass and to provide a path into the picture. A small rock, introduced into the shadow of the bigger one, adds interest to the dark area. I reduced the size of the distant trees so that the foreground would remain the dominant area. Since the wind was steady that day, the water was a uniformly dark color; however, to create interest, I added light areas to show where the wind, weakening for a second, allowed the water to reflect the light sky overhead. This did *not* actually happen at the site, but I used my knowledge of wind and water to pictorial advantage. The boat adds sparkle to the water and forms an essential part of a natural progression through the picture: the eye moves from the rocks to the boat, and then to the distant land and buildings.

Vermont Farm, oil on canvas, 12 x 16 in. (30 x 41 cm). It was the first warm, sunny day after a hard winter. I felt the joy of being outdoors and wanted to convey that delight to the viewer. The clouds were moving rapidly, and in the painting I tried to suggest this feeling of motion by keeping their edges broken and soft; the wind prevents them from being solidly modeled. More than almost any other subject, clouds must be painted in terms of your *impression* of them. You can't paint them by direct reference because they move too quickly. In this painting, I arranged the clouds in a decorative pattern. The clouds overhead, near the top of the picture, are nearest to us and are therefore the largest. Since we're looking up at them, they're circular in shape, like an umbrella. In the distance, however, they appear smaller and more elongated. The cloud shadows on the landscape add variety and emphasize my center of interest. Against the light clouds, cloud shadows often look dark, but they're still not as dark as the real darks of the earth.

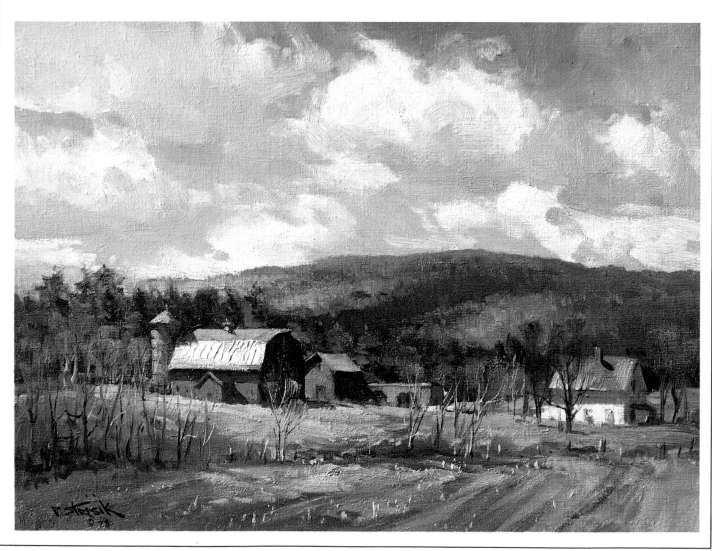

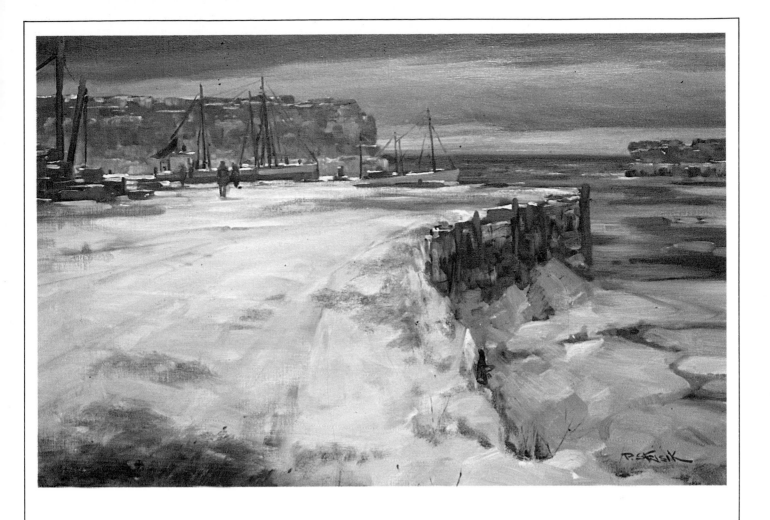

Lane's Cove, Winter, oil on canvas, 20 x 30 in. (51 x 76 cm). A gray day in Lane's Cove. I rearranged this site, as I often do when I paint, to make it more effective. The distant breakwater is, in actuality, equally high on the left and the right, and there's a narrow opening between the sections. However, I added variety to it by making one wall larger and then balancing its mass with the bit of breakwater on the right. If I'd made the mass on the right bigger, it would have detracted from my center of interest. The foreground snow leads into the composition. This snow is particularly effective because it's set off by the gray sky and the spongy, wet, darkish mass of harbor ice.

Evening Tide, oil on canvas, 20 x 30 in. (51 x 76 cm). This late-afternoon picture captures the time of day when the low-lying sun covers the foreground with rich, velvety shadows and brilliantly illuminates the distant surf. The nearby rocks break the horizontality of the picture. Since they're textured and exciting in design, the rocks make the distance seem all the more quiet and serene. The figures not only act as another needed vertical element, but they are also the culminating point in the composition.

LIGHT

If you're going to paint light, you have to understand how it works. I believe in cause and effect; if you understand the reason for a visual effect, you'll be better able to paint it. We should be "researchers" rather than "practitioners"—that is, we should discover the whys and wherefores of things, and not simply practice formulas given to us by our teachers. Just as a music teacher teaches *music*—not how to play the work of a particular composer—a painting teacher teaches *painting*. You must learn to analyze what you see, so you can eventually arrive at your own answers.

It would be easy for me to give you formulas. I could show you "how to paint a rock"—but to do the job properly, I'd have to discuss nearby rocks, distant rocks, sharp rocks, smooth rocks, rocks on sunny days, rocks on gray days, rocks in light, rocks in shadow, green rocks, brown rocks, etc. Your notes would fill a filing cabinet as big as a house. And you still wouldn't have all the "answers."

You have to learn to study nature as carefully as your artistic predecessors did. Carl Rungius, a famous wildlife painter, hunted animals, dissected them, and painted and drew their carcasses till they rotted. He also studied the habitats of his subjects and left, at his death, thousands of drawings and small oil sketches. Like most good painters, he analyzed nature so intently that he had no need for formulas. Likewise, when you paint the effects of light, you should continually observe and study nature; don't allow yourself to fall into clichés and easy formulas.

VALUES
To study light, it's a good idea to begin by looking at one of the most obvious characteristics we observe in nature: values, or the relative lightness or darkness of an object.

Lights and Darks. Painting students tend to be fascinated by color, but for the moment, I want you to forget about color. You may be surprised to find that it isn't as important an element in art as most people think. There were few truly great colorists among the old masters, who relied mostly on values to describe the effects of light. In fact, color isn't essential at all. When you look at a black-and-white TV show, you understand what you see: you know what's close and what's in the distance, what's rough and what's smooth, what's square and what's round. Sometimes, color can even be a distraction. For example, the black-and-white movies made in Italy after World War II had a stark dignity that perfectly matched their sober subject matter. Had they been filmed in color, I doubt that they would have been so effective.

For the moment, consider how a scene looks when you take a black-and-white photograph of it. This isn't easy, for most people rarely think in terms of light-and-dark relationships. When you see a luminous painting in a museum, afterward you tend to remember only the beautiful effect of light. You forget the darks that set off those brilliant lights. Similarly, if you look out a window, your eyes are immediately attracted to the lightest areas—you ignore the shadows. When I arrived at the site shown in Figure 39, all I saw was sunlight. A brilliant blast of light hit the farm buildings and ground, turning them into one light mass. If it hadn't been for a few form-defining shadows, I wouldn't have been able to see the architecture.

Value Relationships. A good painter seldom worries about isolated objects, concentrating instead on the relationships *among* the few simple masses that create an effect. Rich darks are necessary to reinforce lights, but the student

painting outdoors is usually tempted to isolate these darks, staring into them and thus misinterpreting their relationship to the light. If I look into the dark of an open barn door, for example, my pupils dilate to adjust to the weak illumination, and more light enters my eyes. Inside the barn I can see a hayloft, supporting posts, a wheelbarrow, and other details. But if I look at the sunlit side of the barn, my iris closes down, accommodating itself to the brilliant glare. In this context, the open door now appears much darker. To suggest the full impact of a scene, you have to judge the shadows while looking at the lights.

When I did the painting in Figure 40, I was looking into the light on a bright, overcast day. The light strikes the tops of the rocks, boats, and land, throwing the rest of the scene into shadow. Although there's variety within the shadowed areas, they remain a cohesive mass, dark in relation to the bright sky and water. If I had stared into these shadows and described everything I saw, I'd have broken up the mass and thus lost the impact of the top-lighted rocks.

COLOR HARMONY
Years ago, painters strove for a harmonious "Rembrandt effect" by running brown glazes all over their pictures. They tried to manufacture the harmony that dust and varnish had given to the work of the old masters. The outdoor painter doesn't need such tricks, for nature has its own special harmony, created by the unifying influences of light and atmosphere.

Unfortunately, many students can't see this unity; they're too worried about local color. If the grass is green, they paint it "green"—sometimes right out of the tube. They are likely to paint the dark roof of a sunlit house black, even when, compared with a shadow thrown on it by a chimney or nearby tree, the roof appears relatively light and warm. Similarly, a macadam road is always dark to the student because he *knows* it's made of black material. But if you are driving into the sun, the road can stretch like a ribbon of silver before you—and a rich line of dull purple or blue behind you. Because of the effects of light, local color is of little importance.

Preconceived ideas about the appearance of things are one of the main enemies of the painter. Dumond said that we drag such ideas after us like tin cans on a string; sometimes it seems to take dynamite to blast one of them loose. An object itself isn't so important; what counts is what light *does* to it. Thus, if we were to paint the same scene on gray and sunny days, we shouldn't be able to cut the pictures into pieces and interchange the parts. Each set of pieces should have its own unifying tonality.

The Color of Light. When I paint, I want the viewer to feel the kind of day it is and the exact nature of the weather. Sometimes I begin working simply to record my joy at the day's clear, bright light.

The entire scene must convey the impression of luminosity to the viewer. In prismatic painting—that is, the use of nature's entire spectrum in our color rendering—yellow is the sign of energy—the gold of the day. Violet, at the other end of the spectrum, is the lack of energy—the purple of the night. Think of a bar of iron as it comes from the furnace. At its hottest, it's full of energy, and it's whitish yellow with heat. As it loses energy, it becomes a deeper yellow, then orange, then red, and, finally, violet.

Sunlight is identified with the energy of yellow and other warm colors; shadow, with violet and other cool colors. Of

Figure 39. *Old Farm, Lamy, New Mexico*, oil on canvas, 8 x 10 in. (20 x 25 cm). Although the buildings and ground are lit by the sun, they are still silhouetted against the lighter sky. On such a bright day, darks are of great value in explaining the form of your objects.

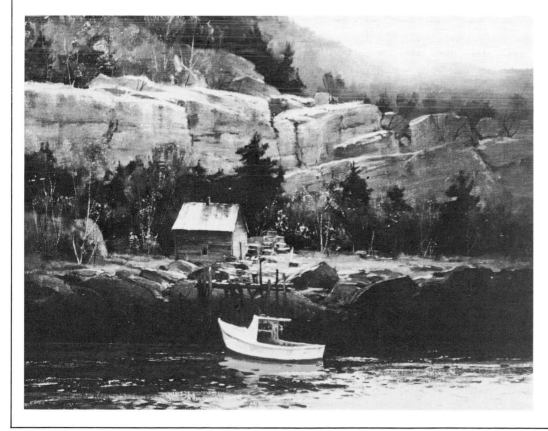

Figure 40. *Granite Cliffs, Maine*, oil on canvas, 24 x 30 in. (61 x 76 cm). On a bright, overcast day, the brilliant, diffused light of the sky reflects down on the top planes of the rocks, land, and buildings.

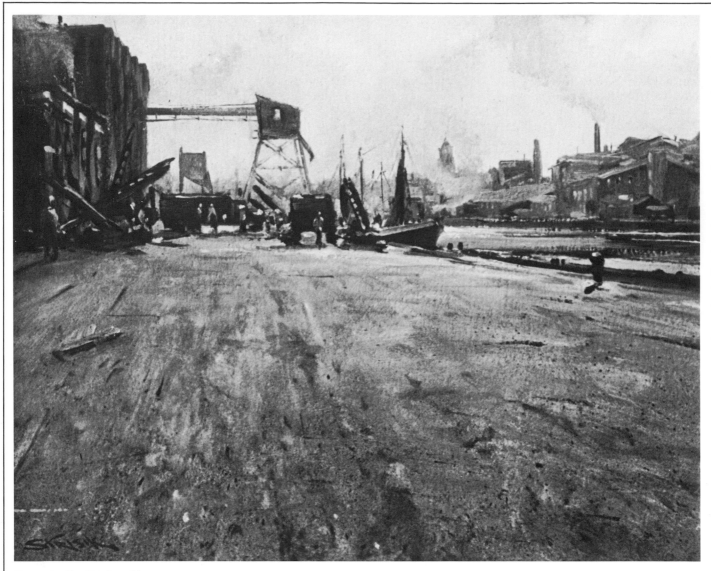

Figure 41. *The Fish Pier, Glouces-
ter*, oil on canvas, 16 x 20 in. (41 x
51 cm). The active distance is ac-
centuated by the large foreground.
A capstan and a piece of board
add interest to this simple area.
The back-lighting silhouettes all
the vertical planes.

course, light from the sun isn't pure yellow, nor is it always of the same strength. Its color and intensity are affected by the sun's position in the sky and by the layers of air, dust, and other suspended matter in the atmosphere through which the light passes before reaching us. At noon on a clear day, for example, the sun is a yellow-white. It shines through a relatively thin layer of atmosphere. As the sun moves lower in the sky, it has to work its way through a thicker, transverse section of the atmosphere. This layer filters out more of the sun's energy. As a result, light from the evening sun looks orange rather than yellow; and as the sun moves even lower, it becomes a cherry red. At each stage, it bathes the landscape with its color.

These are obvious examples of the color of light. Yet the color changes all through the day. If we could "freeze" bits of white paper left outdoors at different times of the day—in the morning, at noon, in the afternoon, at twilight, at night, and on bright and overcast days—not one of the frozen pieces would look pure white. One might be reddish, another a dull blue, one black, another slightly green, and so forth, depending on the time of day and the conditions to which they were exposed. This gives each scene in nature its harmony of color relative to light and atmosphere.

The Color of Shadow. Shadows confuse students because they think of them as being different colors. What color, they ask, is the shadow side of a green tree or a red apple? To understand shadows, don't worry about their different colors. Instead, think of all the shadows in your picture as *related* by the fact that they're devitalized forms of energy. They all share a hint of our most devitalized color, violet. As a simple exercise, try laying-in all the shadows in your picture with the same red-violet color (mixed from ultramarine blue and cadmium red medium). Put down the darks with a posterlike simplicity, thinking more about value than color. If you do a tree, for example, paint its shadowed side gray violet. You can add green later; the violet will mix with it and devitalize the green.

As you understand shadows better, you can temper this simple idea with knowledge and taste. For the time being, however, learn to think of light and shadow in terms of *energy*—energy expressed in terms of values. Seen this way, lights are light; darks, dark. And the color shifts within them are relatively unimportant. If you were to make a page of color samples from the highlights in one of my pictures, you'd see that they were all similar in value and only slightly different in color—like the face-powder charts you see in department stores. The same would be true of the shadows. The purer colors would be seen mostly in the areas of middle values, where neither sun nor shadow exerts an overriding influence on color.

Atmospheric Perspective. As we've seen, the energy of the light is affected by the volume of air which surrounds us and covers distances like a veil. Fog is an exaggerated example of this phenomenon; the material in the air—moisture in this case—becomes so thick that it's visible. Yet even on a sunny day, the accumulation of atmosphere pervades nature with a subtle, elusive silvery-gray quality.

In Figure 41, you can see how the darks of the boats, workers, and wharf gear in the near distance stand out strongly against the hazy, smoke-shrouded city. One of the dangers of too much studio work is that you lose this feeling of air in your paintings. You start thinking in terms of pigment and neglect the atmosphere that ties nature together—the unity of tone that was so important to an older gener-

ation of landscape painters.

Because of the effects of atmosphere, colors tend to get grayer and lighter in value as they recede. You can shout in the foreground—but have to whisper in the distance. In the far distance, colors also get cooler, with the exception of white. It gets *warmer* as it moves away.

This graying and cooling effect occurs over both long and short distances. Take two small pieces of either white or colored paper and put one piece on a table a few feet from you. Hold the other in your hand, a foot from your face. Close one eye and overlap the cards. You'll see that the distant card is a hair grayer, though only a few feet away. Similarly, the next time you're outdoors, pick up a green leaf or blade of grass and compare it to the distant trees. You'll be astonished at the difference in color.

The atmosphere also affects values. A distant black roof is lighter than one near you, even though both may be shingled with the same material. A storm cloud, while it looks quite black in the sky, isn't as dark as you think—compare it to your stick of charcoal. The effect is noticeable even in a still life: a white tablecloth grays a bit as it gets farther away from you. Imagine what would happen if you were painting outdoors and a car were to drive between you and your subject. A cloud of dust would scintillate in the air, obscuring objects in the distance. There's a veil of dust in the air all the time, though it's not always so dramatically visible. Remember that volume of atmosphere when you paint, and you won't make the common student mistake of overstating your distant colors and values.

LUMINOSITY

Having discussed values, the color of light and shadow, and the effect of atmosphere, now let's take a look at those aspects of light which give a picture a feeling of luminosity.

The first thing to remember is that you're working with inert pigments, not sun and air. A sunset has overwhelming color and luminosity, but our pigments don't have that kind of energy range. Compared to the range of light in nature, the luminosity of pigments is as one inch to a thousand miles.

The painter learns to make knowing compromises, realizing that in a painting luminosity and brightness of color are two different things. Many students think they can emphasize the brilliance of a sky by putting a jet-black tree in front of it. The contrast certainly makes the sky look bright, but such lightness is an aspect of paint. You don't want brightness; you want luminosity. And that can only be achieved by understanding some essential characteristics of light: diffraction, reflection, gradation, and transparency.

Diffraction. Light is full of energy, whether it comes directly from the sun or indirectly by bouncing off the features of the landscape. The tremendous energy of the sun's direct light influences everything in its path. For example, if you were to hold a quarter-inch dowel vertically in front of a red, yellow, and green traffic light, you'd see the dowel become slightly red as it passed in front of the red light. In front of the green light, it would take on a greenish tinge, and in front of the yellow light, it would look a little yellow. This happens because the light rays creep around the edges of the wood, an effect known as diffraction.

The same thing constantly happens in nature. The radiant blue of the sky, for example, acts much like the traffic light. John F. Carlson, the respected painter-teacher, noted that the thinner a white church steeple becomes, the more

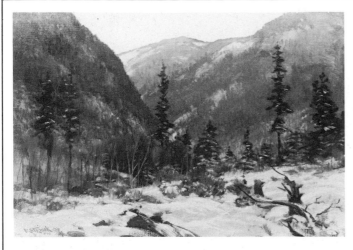

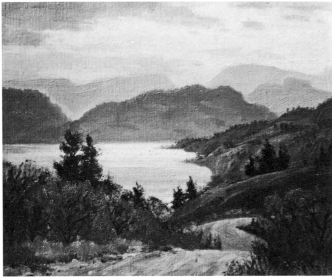

(Top)
Figure 42. *Early Winter*, oil on canvas, 16 x 24 in. (41 x 61 cm). This was painted after a first snow in bitter, ten-degree cold. The foreground was actually a straight macadam road, but I took bits and pieces from the surroundings to create lines leading into the picture.

(Above)
Figure 43. *Skaha Lake, British Columbia*, oil on canvas, 8 x 10 in. (20 x 25 cm). A hazy morning, looking into the light. The heavy atmosphere of the day flattened the scene, making it look like a Japanese print.

it's influenced by the blue sky behind it. In theory, it's therefore cooler at its apex than at its wider base. Branches against a blue sky are also influenced by the energy of the sky. The smaller the branches, the cooler they appear. These effects aren't always visible, but the painter can *use* these principles to create more convincing work.

Direct sunlight has an even stronger influence. In a harbor, for example, the rigging of a ship seems to disappear when the mast passes in front of the sun. In Figure 42, the light from the overcast sky eats away at the contour of the distant mountain, making it light in value and warm in color. On an overcast day, the energy of the sun eats away at nearby clouds. As a result, the darkest clouds are usually those farthest from the light (Figure 43). The clouds nearest the sun are also the warmest and lightest, for the sun's energy creeps around and through them.

We can see a similar effect when we look at a window on the sunlit side of a white house. In this case, we're not dealing with light directly from the sun. But the house reflects so much energy that it becomes, for all practical purposes, a source of light in itself. The brilliance of the house in Figure 44 has an effect on the windows, eating into them and keeping them relatively warm in color and light in value. The outline of the window is also softened by the energy of the surrounding light. J. M. W. Turner used this idea with brilliant effect in his Venetian paintings. When he painted a white palazzo bathed in sunlight, the windows nearly disappeared. The sunlit white house radiates light away from its outside edges, too; thus, the line between house and background would be fuzzy in places, rather than harsh and sharp.

We can now return to our original problem, the dark tree in front of the light sky. The tree wouldn't be jet black all over; on the contrary, the light would eat away at it. As the branches got smaller, they would not only get lighter in value but also slightly warmer in color. This effect is particularly evident in Figure 45. As soon as the trunks and branches move in front of the brilliant distance, they become lighter in value. These value changes add luminosity to the picture.

Reflected Light. As we've seen, light reaches us in two ways. It comes directly at us or it's reflected off objects. The amount of reflection depends on the nature of the material. A harbor in the Bahamas is light because the sun goes through the ocean, bounces off the white, sandy bottom, and illuminates the clear water. The boats seem to float in air. In New England, on the other hand, the light also goes easily through the water; but it's absorbed by the dark bottom and by suspended matter in the ocean itself. Similarly, a golf course is all grass, but the well-mowed putting green reflects a lot of light, the thicker fairway reflects less, and the rough actually absorbs some light. When you look across the course, your eye sees the different values and you immediately know what is smooth, semi-smooth, and rough.

As a student, it took me a while to understand this principle. I once painted a field in flat light; the sun was directly behind me. I struggled to get the feeling of a sunlit meadow; but the more yellow and white I used, the less convincing my effect was. The teacher listened sympathetically to my problem and told me to take a handkerchief and lay it down far out on the field. When I got back to my easel, he noted that the handkerchief appeared as an obvious white spot in the meadow. But when he took a dab of white paint and put it on my painted meadow, it barely registered. In trying to

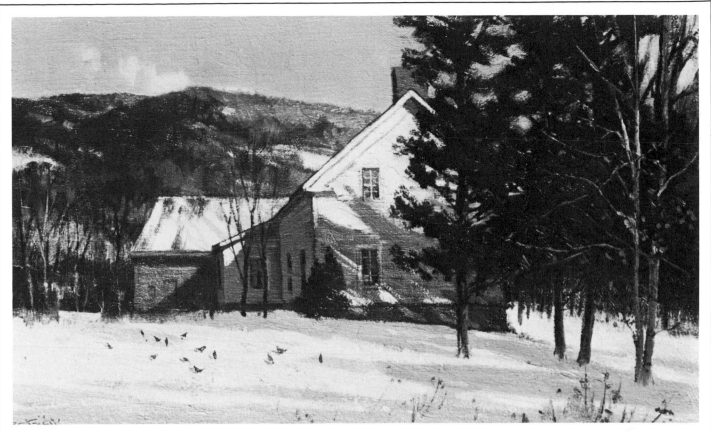

Figure 44. *November Light, Vermont*, oil on canvas, 12 x 20 in. (30 x 51 cm). The dark evergreens break the shape of the house and prevent its being too stark and symmetrical.

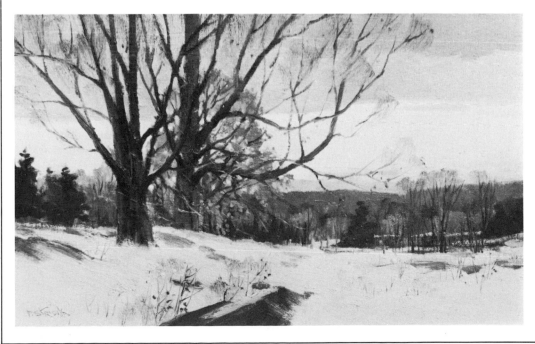

Figure 45. *Winter Mood*, oil on canvas, 12 x 20 in. (30 x 51 cm). A late winter afternoon. The sun breaks through the distant clouds, brilliantly illuminating the sky. Since the source of light is in the sky, the ground and trees are in relative shadow.

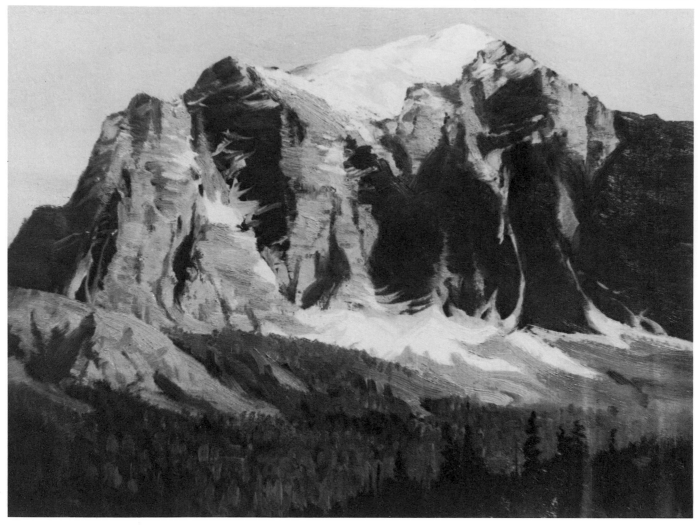

Figure 46. *Mt. Temple, Alberta*, oil on canvas, 10 x 14 in. (25 x 36 cm). I treated the mountain in terms of a few simple abstract patterns. The small size of the panel made it possible to record essential information quickly and easily.

make the meadow bright, I'd made it too light in value. I'd forgotten that such a surface absorbs much of the light from the sun. You can see this idea at work in Figure 46. Both the distant, sunlit mountain and the foreground evergreens have local colors that are similar in value. When illuminated, however, the hard surface of the rock looks lighter; it reflects more sunlight. The trees, on the other hand, act like a sponge and absorb great quantities of light. Even if both the mountain and trees were the *same* green color, the difference in their textures would still make the rocks appear lighter in value.

Gradation. Reflected light varies in intensity. This variation takes the form of gradation. When sunlight hits a very reflective surface, like metal, it's reflected almost perfectly, and the result is a brilliant highlight. But only a small part of the material reflects the full force of the light. Other areas catch the light at different angles. As a result, you can never just create a highlight with a spot of white paint. It will always look like white paint. A real highlight, on the other hand, is bordered by areas which become progressively *less* bright; it's shaped like a teardrop or like a comet with a tail at both sides. The *gradation toward the light* is what makes the highlight so effective. In the middle of a quiet musical passage, a cymbal crash would be noise; but as the final note in a crescendo, it's exciting and stirring.

This basic principle—seen in miniature in the case of a highlight—applies to the landscape as a whole. Imagine a field covered with thousands of pocket mirrors. Given the lay of the land, a few of the mirrors would be positioned in such a way that they'd reflect sunlight directly into your eyes. Those spots would have a glare, others would reflect sky, etc. As the mirrors moved up and down the adjacent, irregular planes of the landscape, they'd naturally reflect less light. Occasionally, a bump in the terrain might angle a mirror so that it caught a glare from the sun—but that would occur only here and there.

In Figure 47, the wet mud acts as a reflector. Notice how the mud gradates in brilliance toward the strongest light—the area around the boat. Throughout the picture, I used highlights very economically. Brilliantly lit areas are more effective when used sparingly. The rocks, for example, were given the most brilliant touches only where the angle of a facet allowed it to perfectly reflect the sun. If you could chromium-plate the rocks, this principle would show up even more clearly. Figure 48 illustrates the same idea. Here, however, the sun has broken through a hole in the clouds and illuminates only part of the landscape. The brightest spot is near the dark trees on the right. The light then gradates away from it on all sides.

Taking Liberties. Gradation helps give a landscape a feeling of luminosity. If you ignore it, you merely label things: "This is light; this is shadow." As labels, simple light and dark masses are no more convincing than the jet-black tree against a bright sky. They make you think of paint—not light. Since gradation is so important, I introduce it into a picture even if I don't actually see it. Corrugated metal farm roofs, for example, often reflect the light as a single brilliant glare; you can't see a hint of gradation. But you won't express the brilliance of such a roof by painting the entire mass with white and yellow pigment. The roof glows with the reflected energy of the sun, while paint is just paint. When I painted the site in Figure 49, the roof of the mill reflected light like a mirror. I purposely took advantage of some rusty spots and *made* the roof gradate toward a few

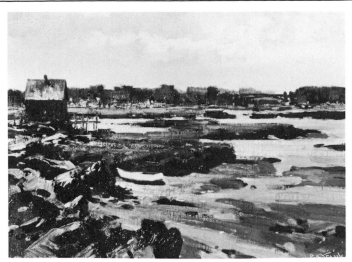

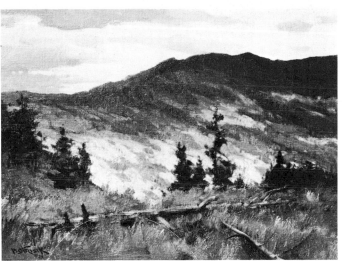

(*Top*)
Figure 47. *West Gloucester Marshes*, oil on canvas, 10 x 14 in. (25 x 36 cm). This sketch was done in early summer. Back-lit, the horizontal planes sparkle brilliantly and accentuate the rich darks of the vertical ones.

(*Above*)
Figure 48. *Valley Sunlight*, oil on canvas, 12 x 16 in (30 x 41 cm). The sun shines on the mountain slope through a break in the clouds. The light area gradates from its bright center, in back of the shadowed foreground pines, to its dimmer edges.

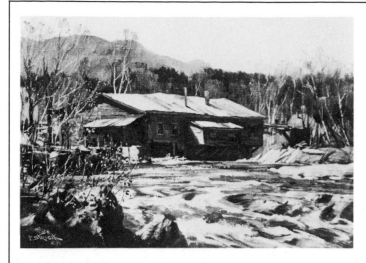

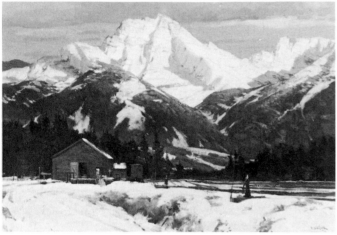

(Top)
Figure 49. *Saw Mill, Vermont*, oil on canvas, 16 x 24 in. (41 x 61 cm). I liked the sparkle of the day and tried to show this in the roof, the glare on the water, and the brilliant highlights of the foreground leaves.

(Above)
Figure 50. *Day's End, Banff*, oil on canvas, 24 x 36 in. (61 x 91 cm). The low-lying sun illuminates the distant mountain while dramatically throwing the foreground into shadow. This painting, which is also shown in color on page 85, was developed in the studio from notes and sketches made on the spot.

key highlights, working up to an explosion of brilliance. The shadowed sides of the building help dramatize this effect.

Transparency. Light from the sun and sky is not only reflected toward the eye; it also bounces into nearby shadows, warming them, lightening their value, and giving them a transparent quality. You feel as if you can see into them. That's a function of light; wherever the sun can't get to directly, sky and reflected light will. Otherwise, shadows would be pure black. Nighttime is a different situation, of course, for moonlight is a reflected form of sunlight and is very weak. By the time it gets to earth, there's little energy left to bounce into the shadows. Shadows on a moonlit evening are therefore very dark and contain no visible detail.

During the daytime, however, the only *black* shadow is in your pocket. When I was a student, I did a picture of an Arab merchant standing in front of the door to his shop. In order to make the shop front look white and brilliant, I painted the interior black. When my teacher looked at the painting, he asked me if the man could read a newspaper inside his store. Of course, there had to be reflected light inside the shop; and I immediately saw that the door was like a dead hole in the canvas. At the beginning of this chapter, I said that darks should not have too much light in them—but neither should they be heavy and opaque.

The effect of reflected light on shadows is especially noticeable in Figure 50. The shadows on the distant mountain receive reflected light from nearby areas of sunlit snow. You know they're shadows, but they still look transparent. The challenge in painting such a scene is to make the shadows look like shadows—while also keeping them *luminous*.

Sometimes, it may be necessary to make arbitrary changes in shadows, much as I altered the glare on the roof in Figure 49. That is, a shadow on a white house will sometimes *look* very dark—even black. But, again, light is one thing; paint, another. Nature gets away with strong contrasts because its darks are rich and its lights are full of energy. Unfortunately, students see these strong contrasts and try to copy them literally, unaware of the limitations of the palette. In Figure 51, you can see the very light shadows inside the niches on the front of the church. These actually looked dark at the site. But if I'd made them too dark, the white would have looked white, but not luminous. I had to juggle the visual "facts," using my knowledge of both light *and* paint to create a more luminous overall effect.

VARIETIES OF LIGHTING
Having discussed certain technical aspects of light, I should briefly mention the characteristics of the kinds of lighting generally used by outdoor painters.

Of course, the most familiar form is side-lighting (Figure 52). The sun strikes objects from either the right or the left, and the resulting shadows are valuable for patterning a picture and also for defining forms.

Front-lighting, in which the viewer is looking away from the sun, flattens objects. There's lots of color with this kind of head-on light—but fewer useful shadows. When I looked at the scene in Figure 53, for example, the light was hitting buildings so directly that I had *no* shadows to define my form. As a result, I took the liberty of moving the sun slightly to my right, creating a few useful darks. Without these darks, the rocks, buildings, and grass would have all blended together.

The opposite of front-lighting, back-lighting gives great value contrasts and simple masses, but little color, since you

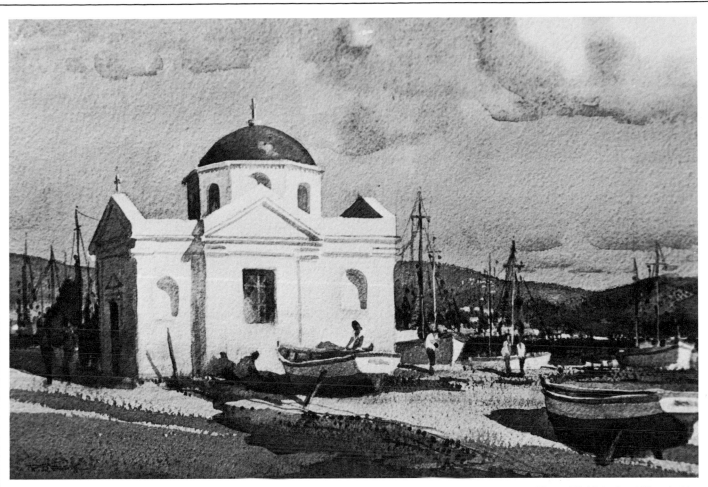

Figure 51. *Waterfront Church, Mykonos*, watercolor, 14 x 21 in (36 x 53 cm). I liked the contrast between the simple church and the active wharves. I introduced the foreground dories, figures, and nets to lead you into the picture and to break up the stark shape of the church.

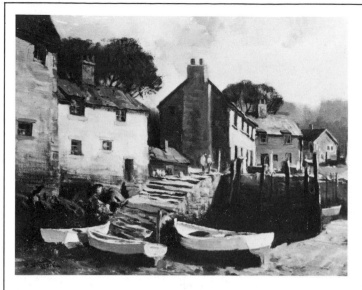

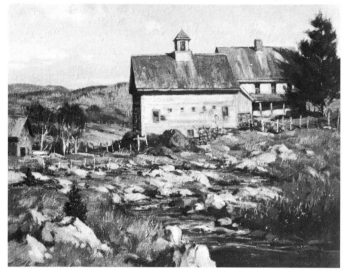

are looking at the shadowed side of things. In Figure 54, the light is directly in front of us and we get a strong glare from the flat planes of the wood and rocks. As I've already noted, the objects try to mirror the sun; how well they do this depends on their angle relative to the light and on the nature of their reflective surfaces.

Within these three basic lighting situations, you will often find that large areas of a picture receive a half-light, meaning that these surfaces are neither in shade nor in full light. Instead, they catch a raking light from the sun. In Figure 55, for example, the front of the adobe church isn't in shadow; it simply catches a less direct light and is therefore darker in value than the fully sunlit lefthand side. The slanting dark area to the right is the only actual shadow. In Figure 56, you can see how the low winter sun throws most of the foreground snow into a half-light. You can see the distinction between the half-lit snow and the dark shadows cast by the foreground trees. Only the vertical planes of the house receive a direct blast of light.

THE GRAY DAY

Students think of gray days as dark and ominous—and paint the sky accordingly. But since the sky holds the light on a gray day, it's really full of energy. If you were to think about the cause for a minute, you could understand the effect better. Imagine a glass door to an office. If the office is illuminated and the glass is clear, the light goes right through it. You can see everything that goes on in the room. But if the glass is frosted—like the sky on an overcast day—the door becomes a bright, luminous rectangle. I usually ask students to stare at the ground on a gray day. When they suddenly look up at the sky, they involuntarily squint. That shows how much energy radiates from a gray sky. You don't squint when you look at a blue sky. If you hold a white canvas against a gray sky, you'll see that the canvas looks dark in comparison.

The key to painting a gray day is to understand the brilliance of the sky and to see how it does two things: first, it throws a silvery light down onto the top surfaces of all the earth planes, as in Figure 57; and second, it acts as a light foil against which the planes of the earth, building, and trees form a dark silhouette, as in Figure 58. In winter, this second aspect of the gray day is exaggerated. In Figure 59, the light sky and snow are a background for the contrasting pattern of trees and rocks.

EMPHASIS

Although I've talked a lot about the physical characteristics of light, remember that there will always be times when you'll want to change what you see in order to get closer to the psychological truth of the subject. For example, atmosphere dulls color and value, but inattention to an area can also make it less vibrant. If you were to take two white business cards and hold them the same distance in front of you but about a foot apart, whichever card you stared at would look *whiter* than the one seen with your peripheral vision. Even though they were the same distance from you, they'd change in appearance, depending on which one got your attention. Similarly, if I were to talk to you as I walked around a room, you would look at my head—and never notice what was behind me. You wouldn't be interested in the background, and you'd see it only when you stared at it. A background should always be painted so that it remains a

Figure 54. *The Old Shack*, oil on Masonite, 16 x 24 in. (41 x 61 cm) The rocks gradually lead you toward the building, my center of interest. The foreground was a boring, straight riverbank, but I purposely dropped the ground on the left to show more of the distant water.

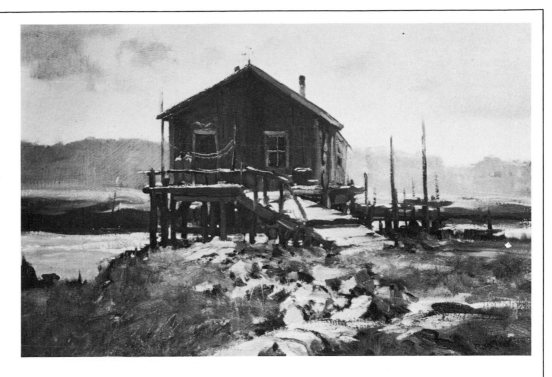

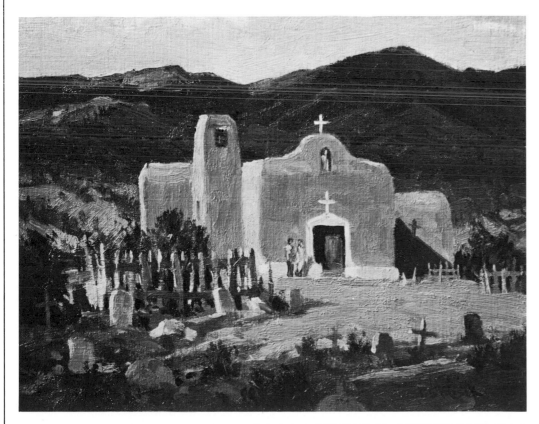

Figure 55. *Church at Golden, New Mexico*, oil on canvas, 8 x 10 in. (20 x 25 cm). A quick sketch done in the late afternoon. Cloud shadows shifted all afternoon, but I saw this effect—the sunlit church against the shadowed mountains—and decided to paint it, ignoring all further changes in the light.

Figure 56. *Duck Hollow*, oil on canvas, 20 x 30 in. (51 x 76 cm) The center of interest in this picture is the area around the white house. I subdued the mountain by throwing shadows over it to the left and right. The white house is brighter than the ground, first because it's a vertical plane in relation to the light, and second because it has a more reflective surface than the porous snow.

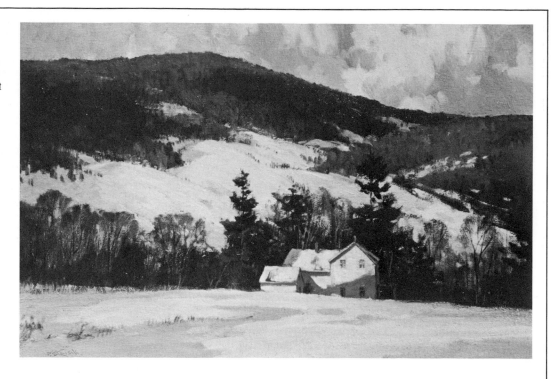

Figure 57. *A Coastal Meadow*, oil on canvas, 16 x 30 in. (41 x 76 cm). This scene would have little impact on a bright, sunny day. Its power comes from the way the moody, windy day complements the rugged character of the coast.

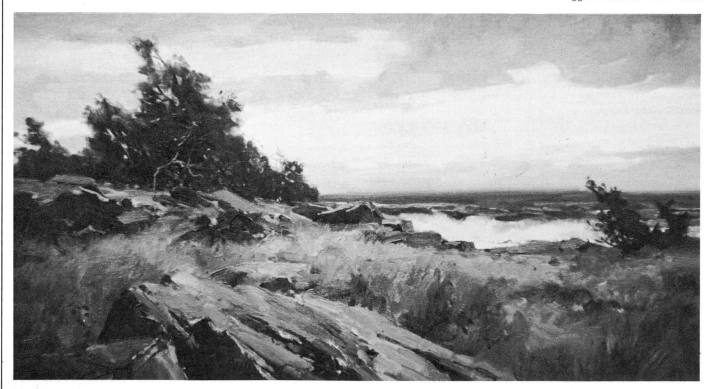

background, subordinated to the elements that are the real subject of your painting.

EMOTIONAL TRUTH

There's also the question of the painter's emotional response to a scene—a most important part of painting. When I began to paint, I was very academic, just as a student should be. I handled values in a naturalistic and methodical way. I always located my darkest dark and lightest light in the foreground and never contradicted the rules of atmospheric perspective by having anything as dark or as light in the middle or far distance. But today, I don't hesitate to break such "rules." If a distant sunlit sail looks like a sparkling jewel to me, I don't contradict my emotions by surrounding it with "atmosphere." I don't throw excitement out the window simply to adhere to "correct" academic rules.

Similarly, there are days when parts of a very clean blue sky, glimpsed through massed yellow foliage, look like dark sapphires. But you can't paint the sky that color. The sky is full of energy, and even if you were to match the value and color perfectly on your canvas, you'd never get the luminous quality in paint that you feel so strongly in nature. It would just look dead and gaudy. That's why, when I paint fall trees against a bright blue sky, I usually raise the sky's value. I also gray it somewhat so that the reds and oranges have more quality. Again I contradict the "facts"—knowing, in this case, that although I'm excited by an aspect of nature, there's no way I can actually capture certain visual effects on canvas. Part of being a professional is knowing what *can't* be painted!

Finally, there are certain situations in which the very life of a picture contradicts all our hard-won knowledge. For example, I once saw a painting of a man wearing a huge, flowing white tie. I liked the head but felt that the tie was a distraction. Yet when I blocked out the tie, the head became commonplace. These elements contradicted an obvious rule of composition—but together they also gave the picture strength and individuality. The same thing sometimes happens in landscape painting. You like a picture; but as you study it, you find parts that don't seem logically right. Spots of color are in the "wrong" place. Values aren't accurate. But by correcting every flaw, you might lose the sparkle and vitality of the painting. In some indefinable way, the strangeness of a picture can often be an essential part of its charm.

(Top)
Figure 58. *Autumn Mood*, oil on canvas, 6 x 9 in. (15 x 23 cm). A small sketch done in my car on a gray, rainy day. Although people think gray days are dreary, they're wonderful in the fall because the dullish skies complement the bright, warm foliage.

(Above)
Figure 59. *Cedar Inlet*, oil on canvas, 12 x 20 in. (30 x 51 cm). Cedars, rocks, and snow create a simple pattern against the light winter sky. I was attracted by this pattern and avoided delineating the subject matter at the expense of the large effect.

Now that we've discussed a few general principles of light, we can see how the ideas work in a series of full-color pictures.

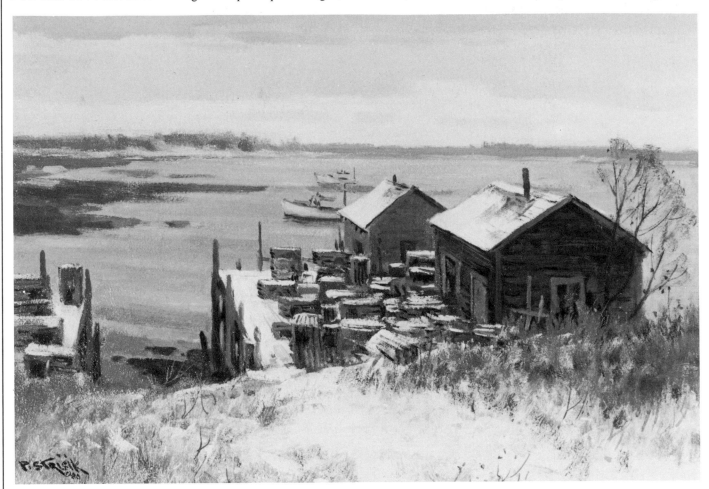

Winter Wharfs, oil on Masonite,
10 x 14 in. (25 x 36 cm). One April
morning in northern Maine, I
awoke to find it snowing, but I went
out painting in my car anyway. I
had painted these wharves in sun-
shine only the previous day, but
now they had an entirely new look:
the snow cover created strong
contrasts in shapes, and the
bright, overcast sky unified the
scene with a silvery gray tonality.

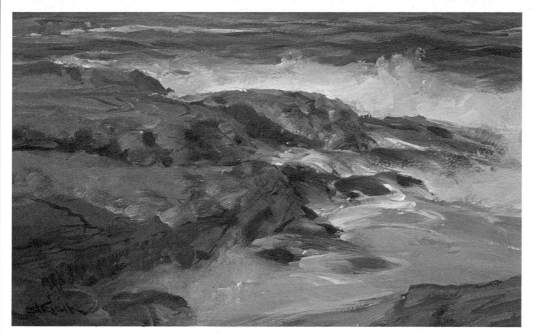

Rising Tide, oil on Masonite, 10 x 16 in. (25 x 41 cm). This picture illustrates a number of facts about direct and indirect light. I painted it in the afternoon, when the sun was low in the sky. The *upright* planes caught the sun's direct rays, but the horizontal surfaces received less sunlight and so were more influenced by the surrounding sky. This was particularly evident in the horizontal rocks, which were wet and thus acted as reflectors. You can clearly see hints of the blue sky on the tops of the rocks. If these rocks had been dry, the blue sky would still have affected them—but not so noticeably. The blue of the sky also reflected down into the troughs of the ocean. The angled sides are like a window, through which you can look into the ocean.

The shadows on the rocks tell you a lot about reflected light, depending upon their position. The shadow near the center of the picture, for example, is fairly dark; it's in a deep, sheltered crevice and little light is reflected into it. The shadowed rocks directly beneath it, however, are wet and face toward the sky and water. Therefore they are influenced by reflected light, and they become both lighter in value and cooler in color.

Autumn Glow, oil on canvas, 16 x 24 in. (41 x 61 cm). In this backlit picture, everything grades toward the source of light. All vertical planes are in shadow. Compare the dullish light hitting the foreground rock to the glare on the rock near the center of the picture. The grass also gradates in value toward the distant rock, where parts of it are particularly brilliant. Similarly, there's a variation in the shadows on the foreground and distant rocks. The nearest shadow is relatively dark, but the one in the background receives more reflected light from the sunlit grass. The metal roof of the house is most brilliant near the eaves; the values of the roof grade toward that glare.

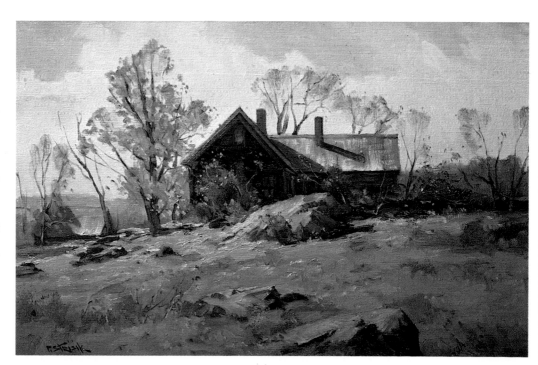

Marshall Point, oil on canvas, 20 x 30 in. (51 x 76 cm). When I arrived at this spot, I didn't feel like painting "another lighthouse picture." Instead, I walked around *behind* the lighthouse and was struck by the way the light sparkled on the foreground rocks. The dark pines are a nice foil for these strongly lit rocks. As in *Autumn Glow*, the brightest area is near the center of the picture, and the rocks become progressively darker as they move toward the foreground. The horizontal planes get less light, whereas the angled planes reflect more of the sunlight from the left. I dulled the blue of the actual sky in order to keep the effect from being too picturesque and "sweet."

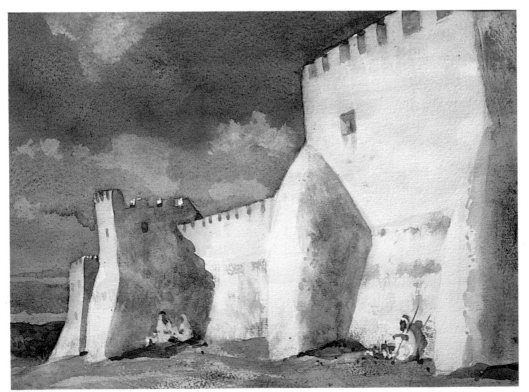

The Fortress, watercolor, 10 x 14 in. (25 x 36 cm). This is another view of the fortress at Agadir (page 24, Figure 19). The turbulent sky sets off the white fortress. In addition to warm sunlight, the building also receives cool color from the sky. If I'd left the building a flat white, it would have had no relation to the sky—it would look as if I'd cut it out and pasted it onto the background. As the building nears the sky, it actually becomes slightly more *blue*, it grades from the warmest and lightest area, near the sunlit middle buttress. Bathed in sunlight, the earth also reflects warm color into all the shadows, and a unifying atmosphere pervades the picture.

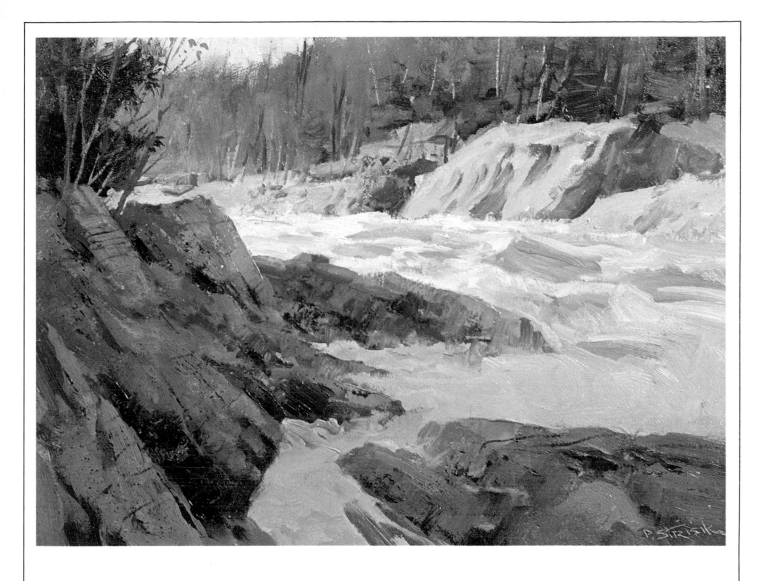

Rapids, oil on canvas, 12 x 16 in. (30 x 41 cm). Here, the brilliance of the white water increases with its approach to the source of light on the left. The right bank also becomes more brilliant as it nears the light. I painted the distant large rock a flat, warm color and then added cool grays to the surfaces nearest us. The rock has only *one* brilliant area. The distant trees also become lighter and warmer as they near the source of light. I need the shadowed foreground rocks as a foil for the sunlit distance and the rock on the lower right, to break the area of water and direct your eye into the picture. In order to emphasize the rapids, I kept the amount of sky to a minimum.

Winter Cottonwoods, oil on canvas, 12 x 16 in. (30 x 41 cm). This small autumn study of a cottonwood tree near Santa Fe, New Mexico, is a good example of the Southwest's high-key color. Not only are the trees, leaves, and ground light, but the effect is exaggerated by the strong front-lighting. Fortunately, the small log hut provides a valuable dark which sets off the light tree-trunk. Despite the flat lighting, I overstated some of the other tree shadows in order to create form.

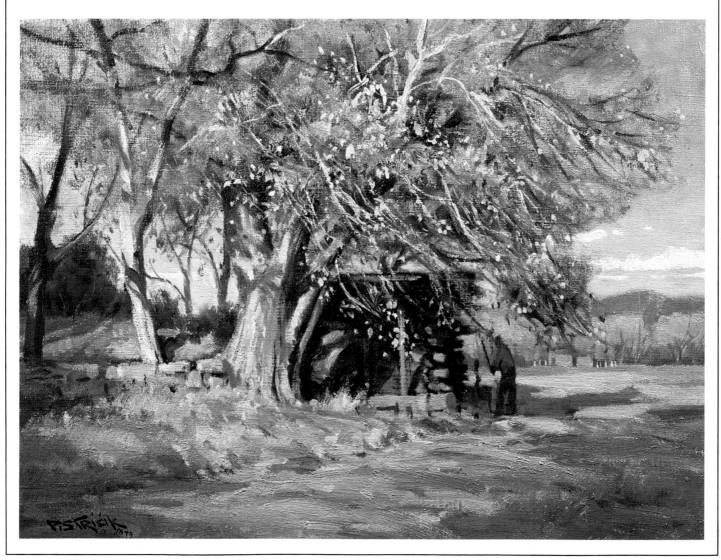

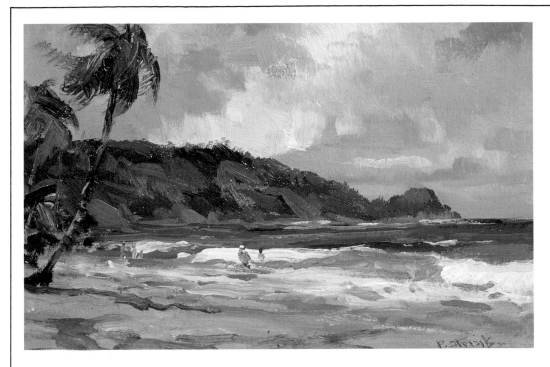

Beach, Trinidad, oil on canvas, 6 x 9 in. (15 x 23 cm). On a clear day in Trinidad, there's very little atmospheric perspective. Because of the brilliant light and clear air, the distant shadowed bluff is strong in color and dark in value. Such contrasts are common in the tropics, but less prevalent in northern climates. Although the clouds look light compared with the dark hillside, they're miles away and not as bright as the foreground surf. I find quick, small sketches like this one very useful when I'm working in the studio.

Canyon Sunlight, gouache, 10 x 14 in. (25 x 36 cm). In the Southwest, the clear air and light earth emphasize the brilliance of the sun. In this painting, the sun hits the distant hill with a strong blast of light, bleaching out all detail. The hillside and trees become simple masses of high-key color. Even the trees' shadows are light in value—the only real darks are inside narrow crevices in the rock. The warm color of the sun affects not only the land and the shadows, but the sky as well, giving it a warm greenish tone.

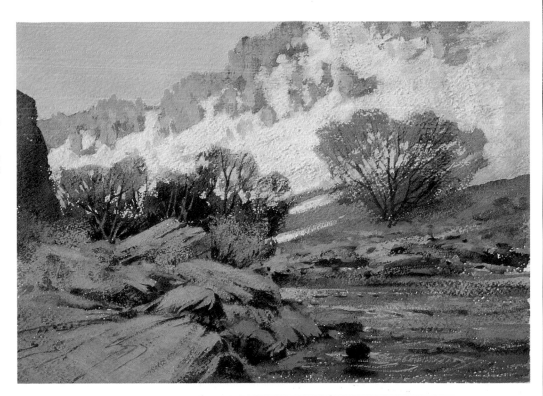

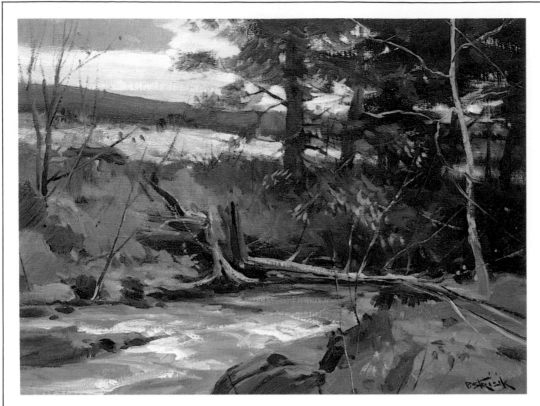

Woodland Stream, oil on canvas, 12 x 16 in. (30 x 41 cm). Emphasizing just a few elements creates a strong and effective pattern. The trees, riverbank, and distant hills are very simply painted, and a few gray rocks add interest to the bank. I want the viewer to feel as if he's retreating into a heavily shadowed avenue of trees. Notice that the trees grade toward the darkness. As they near us, the pines thin out, their foliage is less dense, and the light sky has a chance to eat into and around them—diffraction. The bank itself becomes darker as it recedes, because the thickening pines block out more of the light from the sky.

Winter Thaw, oil on canvas, 12 x 16 in. (30 x 41 cm). On this March day, cloud shadows moved rapidly over the landscape. When light and shadows constantly change, I *choose* the most effective pattern for my painting—in this case, I like the sunlit trees sandwiched between the darker mountains and foreground. Since the shadowed foreground snow was in open country, where it received a lot of reflected light from the sky, the shadow looks neither dark nor especially blue. Deep in the woods, a similar area of snow might look proportionately darker; you have to analyze each situation before you start to paint.

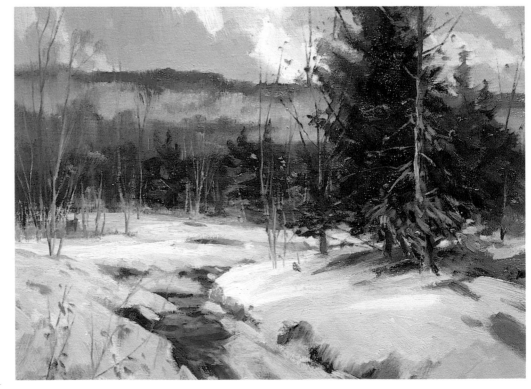

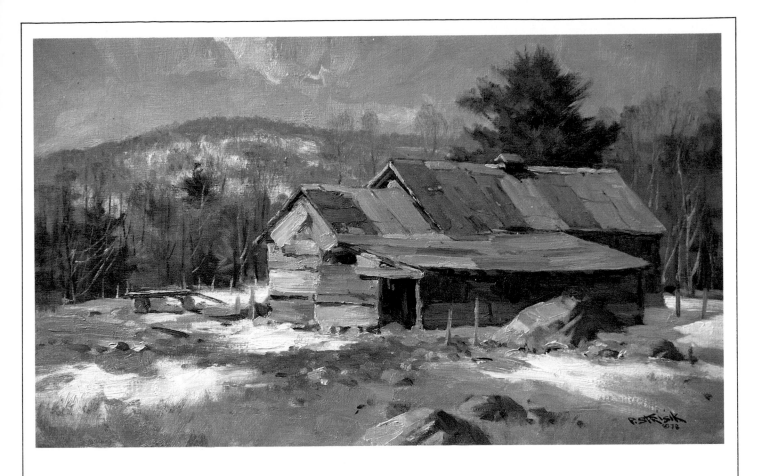

The Patched Barn, oil on canvas, 12 x 20 in. (30 x 51 cm). This subject is strongly lit, but the shadows and dark trees give form to objects. Since the atmosphere is heavier in Vermont than in the Southwest, the sun has a gentler effect on the landscape. It doesn't obliterate the color of objects. I particularly liked the shifting colors of the roof and the patches, and made them my center of interest.

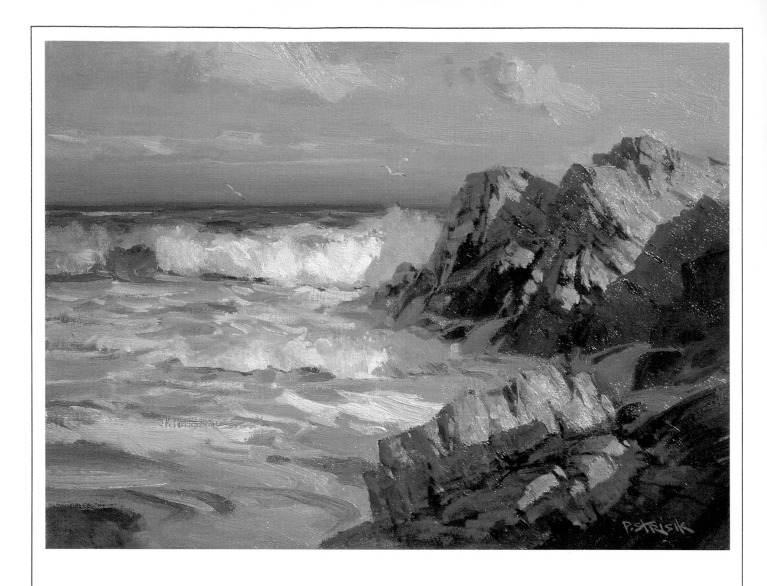

Surf at Eagle Point, oil on canvas,
12 x 16 in. (30 x 41 cm). When I
first arrived at this spot, I was
struck by the tremendous contrast
between the brightly lit rocks and
the dark areas of shadow. Study-
ing the scene, I felt it would be easy
to paint such an obvious subject,
in terms of black-and-white con-
trast, but I forgot that nature's
shadows, though dark, are full of
light energy. The energy in my pig-
ments isn't sufficient to keep such
deep shadows from looking like
dead spots in the canvas. There-
fore I created luminosity in the
painting by *exaggerating* the
amount of reflected light on
the shadowed side of the rocks.

Stream, Arroyo Hondo, oil on canvas, 8 x 10 in. (20 x 25 cm). This small sketch shows the effects of light in the Southwest. Although the foreground is shadowed, I kept it light enough to suggest reflected light bouncing into it. Remember: shadows must be dark to reinforce the light; but if they're opaque, they won't have a feeling of luminosity. I used the dark cracks in the foreground rocks to make the shadows look even more transparent. The foil of the blue sky, reflected in the water, is needed to relieve the dominant warm colors of the painting.

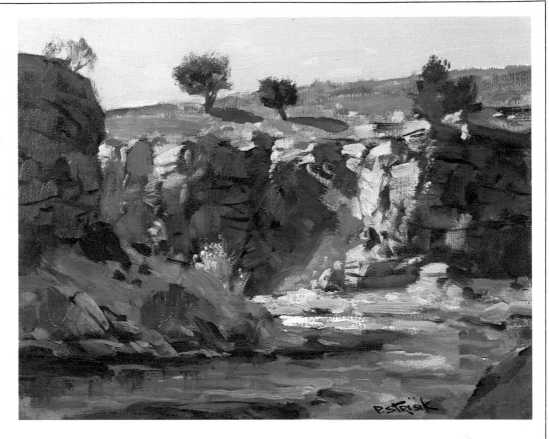

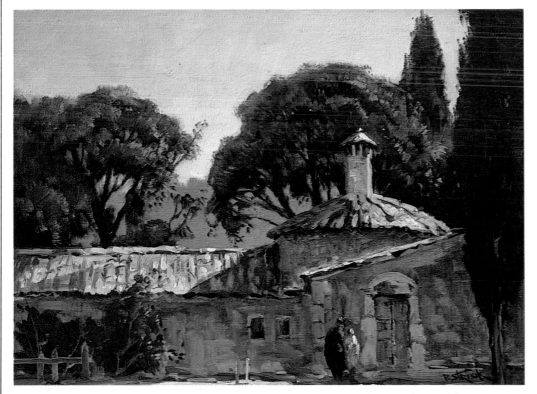

Kaissariani Monastery, Athens, oil on canvas, 12 x 16 in. (30 x 41 cm). I was struck by the way the brilliant top-lighting affected the roofs of this monastery; parts of the surface glitter here and there, while other parts are in halflight. The dark cypresses are a perfect foil for the sunlit areas. Although the shadowed side of the monastery is dark, notice that it also gets a lot of warm reflected light from the ground. I added the figures to give interest and scale to the picture.

Sparkling Light, Cornwall, oil on canvas, 12 x 20 in. (30 x 51 cm). This painting doesn't try for a grand effect; it's just an attempt to record a bit of the truth as I felt it. The water mirrors the sun. Its brightest reflection is nearest the viewer, next to the rocks. As your eye moves to the right and into the distance, the reflection becomes less bright. The thick atmosphere eliminates the yellow from the glare, which gradually becomes grayer and pinker as it recedes. In the far distance, mist rises from the base of the headland and catches and retains the light; you can see a warm glow near the horizon. Similarly, warm light reflects up into the bottom of the triangular rock in the middle distance. It becomes cooler toward the top, where the sky has more opportunity to affect it. Since we're looking toward the sun, all the vertical planes are in shadow and silhouette against the light sky. Notice, however, that the sky is *not* as light as the brightest spot of reflected sunlight on the water.

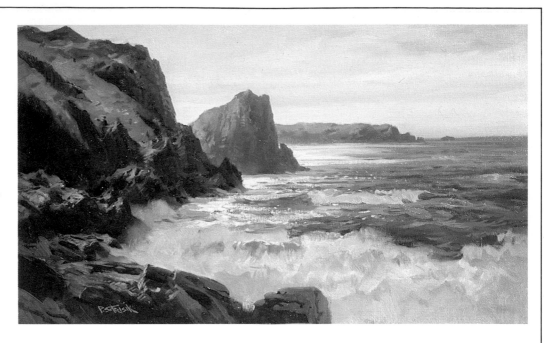

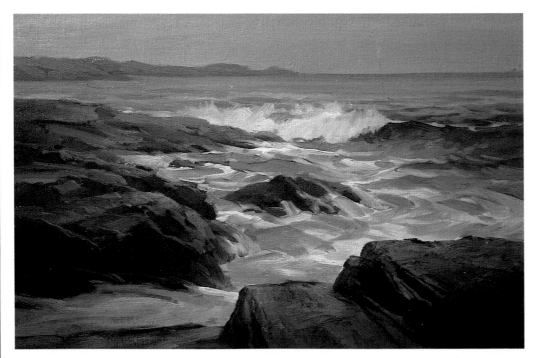

Lifting Fog, oil on canvas, 16 x 24 in. (41 x 61 cm). A wet, misty morning. No matter what the weather, atmosphere always knits the colors of a scene together. In a fog, however, this fact is particularly evident: the atmospheric effects of half a mile on a sunny day now occur in less than a hundred feet. In this picture the horizontal planes are light and cool, illuminated by diffused light from the sky. The sides of the rocks are the darkest areas. The effect is silvery, quiet, and gentle.

Snowing, oil on canvas, 8 x 10 in. (20 x 25 cm). This sketch was done in my car during a snowstorm in the Canadian Rockies. Painting during a snowstorm is similar to working in a fog or mist: colors gray and lighten considerably as they go back into space. The far distance becomes a single flat value, with little detail within the mass. Because of the nature of the day, all colors have a silvery tonality. I resist splattering the picture with white to indicate the falling snow; it's too mannered and false a device.

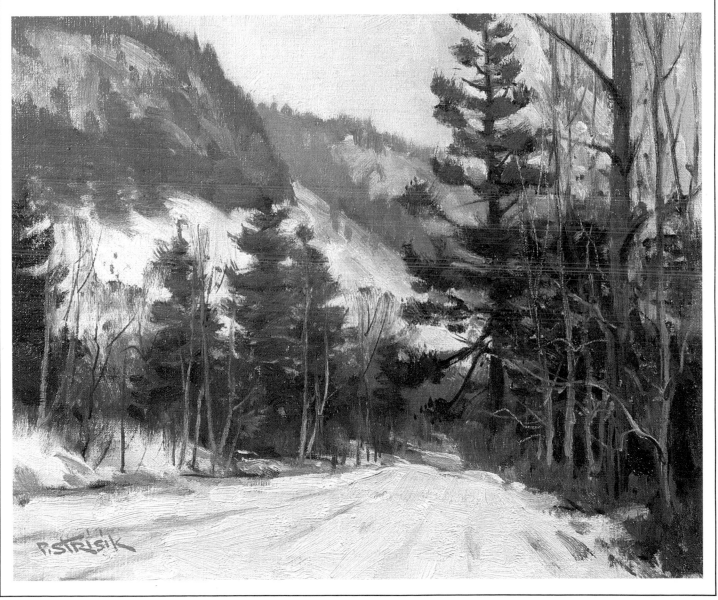

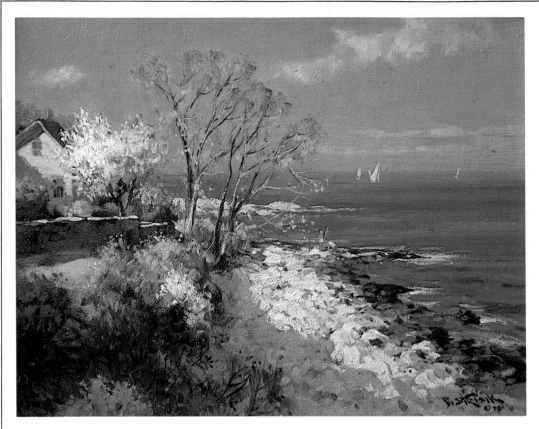

Along Marmion Way, Spring, oil on canvas, 10 x 14 in. (25 x 36 cm). Here are two examples of how a change in season also changes the character of a subject. This view from behind my house was painted on a clear spring morning. The rich colors of the ocean, trees, and flowering shrubs create a happy, lyrical mood. Shadows subdue the foreground and direct your eye toward the flowering bushes. A spit of land adds interest to the distance, while the white sails further enhance the tranquil character of the day.

Along Marmion Way, Late Winter, oil on canvas, 12 x 16 in. (30 x 41 cm). This is the same view seen in the late winter. This time of year gives nature a sobriety and dignity that I like. When doing blossoming trees and blue skies, there's always the danger of making a painting too ''sweet'' and pretty. In this particular painting, however, the lyrical colors of spring would be completely out of place. I used mostly warm, analogous tones, set off by hints of green and by the simple expanse of blue ocean.

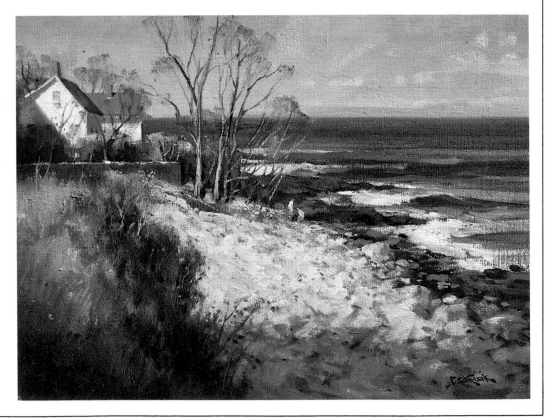

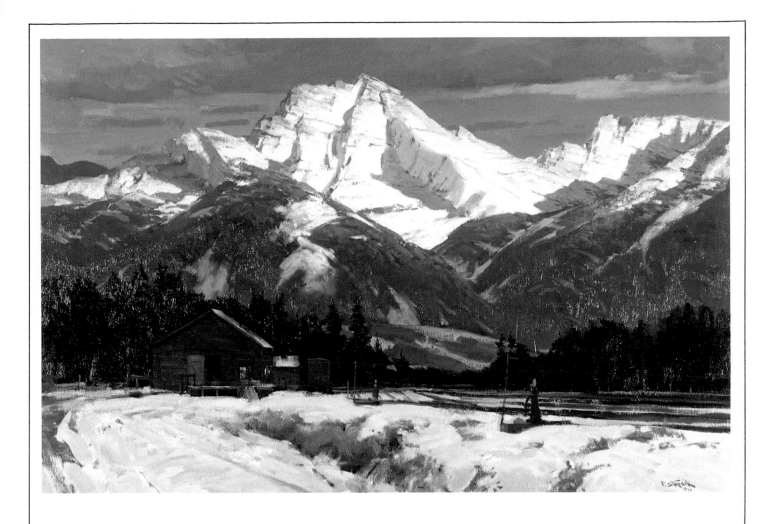

Day's End, Banff, oil on canvas, 24 x 36 in. (61 x 91 cm). You can see an unusual light effect in this painting of the Canadian Rockies. The sun has set, throwing the valley into twilight—yet the distant peaks are still lit with a pinkish-orange glow. I made a quick 8-x-10-in. oil sketch of the subject on the spot, trying to capture the value and color relationships. I completed the larger painting later, in my studio. When doing such a subject, it's important to avoid making the shadowed areas a dark, opaque, and uninteresting mass. Compared with the sunlit peaks, they *look* dark. But since a large part of the scene was in shadow, I used my judgment and lightened it, thereby giving added interest to the area in twilight.

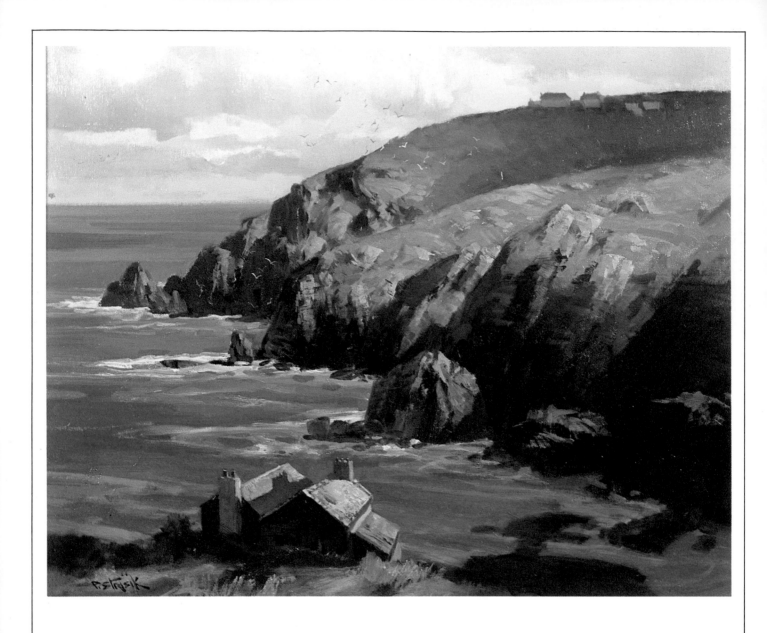

Gurnard's Head, Cornwall, oil on canvas, 16 x 20 in. (41 x 51 cm). In Cornwall, England, the air is very clear, and little of the blue sky reflects into shadows. The area is lush and green, and distant colors appear untempered by atmospheric perspective. Here, the shadowed distant bluff sets off the nearby hill. On the right, sunlight hits an outcropping of rock at the base of the cliff. Theoretically, these nearby highlights should be as bright as—if not *brighter* than—the sunlit area of rock toward the center of the painting. But I suppressed them in order to keep your eye from being pulled into a subordinate corner of the picture. I sacrificed the "truth" to make a more coherent pictorial statement.

Tree Patterns, oil on canvas, 6 x 9 in. (15 x 23 cm). A sketch done on an autumn day, after a rainstorm. The overcast day had turned the scene into a simple light-and-dark pattern. The mist gives the background an elusive, cool tone which complements the warm color of the foreground trees. Autumn foliage is especially effective when painted on such days, for the subtle gray skies emphasize the rich color of the leaves. Against a clear blue sky, such foliage might look harsh and gaudy. The dark fir tree acts as a foil for the brightly colored leaves.

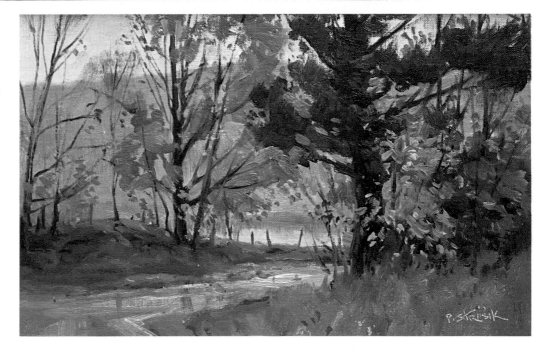

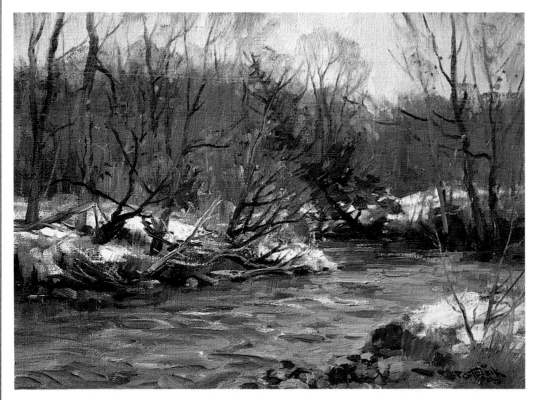

April Stream, oil on canvas, 12 x 16 in. (30 x 41 cm). On this gray day, the land formed a dark silhouette against the bright sky. The snow itself was broken with weeds and bushes, giving it a more elusive quality. In theory, if the sky reflects down onto the surfaces of both the water and the snow, then the snow should be slightly grayed. But I contradicted the "rule" by making the snow very white toward the center of the picture, to attract attention to my focal point.

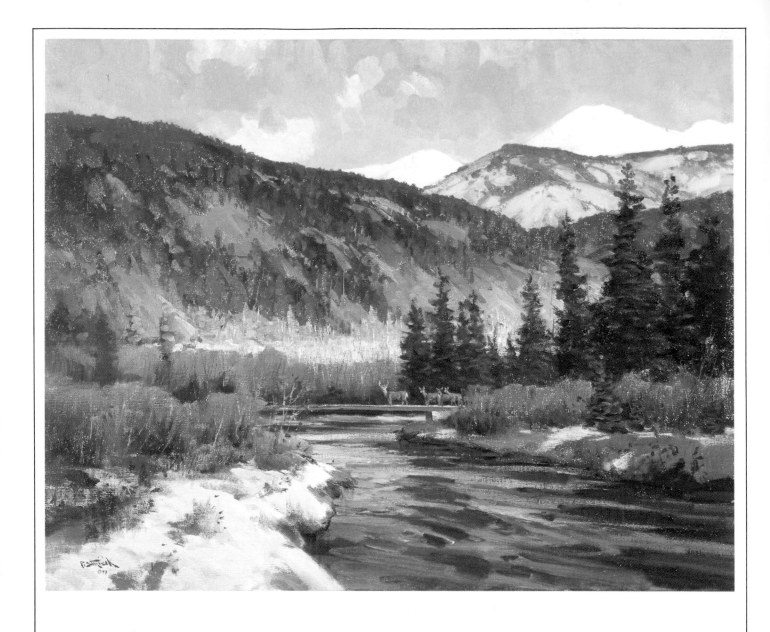

The Crossing, oil on canvas, 24 x 30 in. (61 x 76 cm). I had to change many aspects of this site to make it a valid pictorial subject. I liked the foreground and left it much as it was, but the background mountain was a domed, tree-covered hill with an uninteresting contour. I altered it and then, to suggest its rugged surroundings, introduced two mountain ranges in the distance. The near one is high and has snow patches on it; the background mountain, higher still, is completely covered with snow. The simple wooden crossing upstream was, in reality, an iron railroad bridge. I added a mule deer and does as a center of interest.

DEMONSTRATIONS

(Top)
Figure 60. *Beach Scene, Florida,* oil on canvas, 6 x 9 in. (15 x 23 cm). A thumb-box picture painted in the shade, looking toward the light. The effects of sunlight are heightened by the brilliant white sand and the deep tropical water.

(Above)
Figure 61. *Welcome Shade, Jamaica,* oil on canvas, 12 x 16 in. (30 x 41 cm). The theme of this picture is the interesting silhouette made by the figures, boat, and trees.

Each time you paint, you should look at the landscape as if you've never seen it before. Unfortunately, it's easy for painters to develop pet formulas.

For one thing, we admire other artists and unconsciously adopt some of their mannerisms. It's hard to avoid this, since each of us is a link in a long chain—and I believe that it's our *duty* to know the work of our predecessors, a surgeon must know what has gone before him in order to make a contribution to his field. The danger for the student, however, is that he's often more influenced by paintings he's seen than by the subject he's painting. The charm of a child's drawing is that it shows just what the object means to him. As we grow older, our paintings should become more and more a product of our own life and emotions, but we don't always paint our own paintings. We paint someone else's point of view, and it takes intense self-analysis and thousands of pictures before we arrive at a way of painting that's truly personal.

In addition, we all have our favorite outdoor locales. If you always work in one general area, you'll begin to get it down pat, and your pictures will become all surface and mannerisms. You may do lots of marines and, having developed a way to paint rocks, use the formula every time you're at the shore. Or you may have a standard background that you put into every picture because the subject matter has become all too familiar.

THE IMPORTANCE OF NEW VISTAS
Figures 60 through 63 reflect my belief in travel as the only way to regain the enthusiasm lost through the repetition of subjects, palettes, colors, and compositions that have become too familiar. If you look at all the great painters, past and present, I'm sure you'll find they all traveled. They kept themselves fresh through new challenges, challenges that forced them to solve unfamiliar and stimulating pictorial problems.

In parts of the American Southwest, I don't find traditional subject matter, as such. I've had to discover ways to make the scenes interesting. While New England can be designed in terms of black-and-white patterns, as in Figure 64, the western sun obliterates such patterns; to paint the West, I've had to learn to work in areas of color. When I painted Cornwall, England (Figure 65), I was at home with the boats and fishermen, but I had to get used to the classical look of things and to the patina given to objects by centuries of use.

The skies in New England are relatively colorless in comparison to those in more southerly climates, and it's easy to paint clouds with very limited color. In England, on the other hand, the air is clear and luminous, and the clouds are colorful. The sky is never an intense blue, and landscape shadows, though dark, are always luminous. In Greece—as in the American West—the brilliant sun taught me to see in terms of color again. Working extensively in Maine had led me to paint in gray tones; now, I use more color. I've also added yellow ochre to my palette, thus lightening my key after years of relying on raw sienna. When I returned to Vermont after my trip to the West, my pictures were both lighter in key and more colorful.

Extended painting trips are also good, because I'm not the type who can jump out of his car and into a picture immediately. I need to walk around a site and become part of it. When I painted boats at the Gloucester wharves, I always felt somewhat guilty that I'd never gone out in them. Had I experienced part of the life of the fisherman, I'd have had

Figure 62. *Hacienda Gate*, watercolor, 14 x 21 in. (36 x 53 cm). Long shadows frame the gate and clearly show that it's my center of interest.

Figure 63. *Monastery of St. Nicholas, Anapavsas*, oil on canvas, 12 x 16 in. (30 x 41 cm). I added silhouettes of broken rocks to explain more fully the fantastic shapes of the outcroppings near Meteora, Greece.

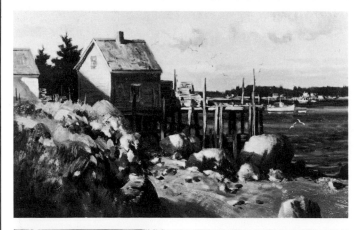

(Top)
Figure 64. *Perkin's Wharf*, oil on canvas, 12 x 20 in. (30 x 51 cm). Late-afternoon sun creates sharp contrasts of light and dark, forming interesting patterns among the rocks and broken mud flats at low tide.

(Above)
Figure 65. *Mousehole, Cornwall*, oil on canvas, 12 x 16 in. (30 x 41 cm). Most of these houses are in shadow, creating a powerful light-and-dark pattern. I increased the height of the houses on the right to break the strong downward thrust of the perspective lines from the left and add stability to the design.

more sympathy with the subject. And it's this involvement that makes the magic in a work of art.

When I go on a painting trip, I always stay a few weeks in each area. It takes time to build up momentum. I spend the first week tuning up, and by the second, I've reached my stride. There are no interruptions, and painting dictates all my other activities. If I want to work through the day, I can. When you go on painting trips, you should slowly allow yourself to become part of the locale. This way, you can penetrate the obvious and get to the area's essential character. Without this get-acquainted period, your pictures would look like the average tourist's photo—you'd paint what strikes everyone who comes to the spot for a few days. Over a period of time, however, you become aware of the differences that make the place *uniquely itself.*

UNDERSTANDING YOUR SUBJECT

Before you start to paint, you should do some thumbnail sketches to get an understanding of your subject and plan your composition (Figure 66). Three-by-four-inch scribbles are enough. You can use a sketchbook, file cards, folded typewriter paper—or even part of your canvas (once you start working, you can paint out the sketch).

The quarry in Maine shown in Figure 67 looked "unpaintable," but I decided to draw it just for fun. As I drew, I found that I solved a lot of my problems. I discovered, for instance, that I could use the distant building as a center of interest, scaling it down in order to emphasize the size and texture of the foreground rocks (Figure 68). At the actual site, material was scattered around haphazardly, but in the final painting (Figure 69), I used shadows to emphasize form and to concentrate attention in one area. The dark trees, shadows, and the brilliant white house form the center of interest on the right. A shadow subdues the foreground rocks, while other shadows explain the contour of the hill.

BEGINNING TO PAINT

There are many ways to start an oil painting. Some teachers recommend drawing on the canvas with charcoal. Others believe in using a turpentine wash of raw umber. I prefer to use a big brush to lay-in rough color washes, almost as if I were doing a watercolor. Figure 70 shows an actual site, and Figure 71, my initial lay-in.

Since I consider these washes *vitally important* at the start of a painting, I'll devote most of this chapter to them. This simple lay-in is useful for three reasons.

1. Judging the Composition. The wash-in allows me to establish my composition immediately. By the time I begin the wash, I've studied the site and an idea has crystallized in my mind. I have the conception but haven't solved all the questions—I want to find some answers as I work. With the brush, I draw a few lines to establish the horizon line and some basic divisions of the canvas. This takes no more than four or five strokes, which you can see in Figure 71.

Then I use large washes, working thinly so I can correct the drawing with a wipe of a rag. For example, I rub out the position of a foreground tree in Figure 71. I push things around a bit, making no firm commitments. This is the most abstract part of the process. I worry about spaces, not subject matter; masses, not details. This approach is not unique to my way of working. I'm sure that many painters start their pictures in much the same way. I must think in the broadest terms: in painting, the whole contains the parts, but individual parts don't make a whole! Because he spent

fifteen years at Koerner's farm, Andrew Wyeth's sketches of it always express completeness, no matter how "rough" they may appear. You can sense an *understanding* behind the most casual-looking strokes.

Done properly, the washes give you an out-of-focus look at the whole picture. A few large strokes of color, a few dots—and someone fifty feet away should be able to see your effect easily. The viewer feels the general impact, just as you can recognize a friend from a block away without seeing the details of his face. The lay-in washes can be compared to the framework of a house, which tells you how big the rooms will be and where the closets are. Bricks, shingles, clapboards, and other details have no bearing on the essential nature of the structure. Once you establish the main compositional masses, you've got the heart and soul of your painting. That's the most important stage. The old story about needing two people to paint a picture—one to put on the paint and the other to knock the artist over the head when he's done—isn't really true. When you "overwork" a picture, it's because you are attempting to make right an effect you missed at the outset.

2. Judging Values. By working in large color masses, I quickly eliminate the unfriendly white canvas. That white distorts my ability to judge values, since almost everything looks dark in comparison to it. When you work piece by piece, it's possible to "finish" what seems to be a dark area, only to find its values are wrong when the rest of the canvas is covered. I avoid this problem by covering the canvas during the first fifteen or twenty minutes of work.

3. Judging Color. The wash-in also allows me to establish my color masses quickly. At this early stage, I don't worry about getting the values and colors exactly right. I start strong because it's easy to tone things down later—but difficult to pump up a weak picture. I remember a landscape by the great Russian-American painter Nicholai Fechin in which you could see the remnants of his boisterous outdoor sketch. In the studio, he had toned down and harmonized the outdoor colors with other mixtures. Some of the original strong colors were still visible, however, and they gave vitality to the picture.

You should also remember that there are no absolute colors in nature. You may be sensitive to blue, while a friend looks at the same scene and sees more reds and yellows. In fact, there's often a difference in color perception between your own right and left eyes. The only color "fact" is the relationship between warm and cool tones. Everything in nature has a temperature bias, whether it's marked or slight. As a result, I never tell a student what *color* to paint an area. I show him where one part of the scene is cooler than another, but how he suggests the coolness is his own business.

The relationship between colors is more important than the individual colors themselves. Working in big washes helps you to judge these relationships. Unfortunately, most students mix colors by looking at each one individually. Studying one of my paintings, a student often thinks I got a particular tone by adding a special pigment to my palette. If I were to cut a hole in a piece of paper and isolate the color, however, the student would see that its unique character is wholly the result of the colors around it. You can paint delicate "violet" clouds, for example, by using only ivory black and white. When painted into a blue-green sky, the mixture takes on a violet tinge—violet *in relation* to the surrounding green. Dumond used to say that "mud" is a good color used in the wrong place.

Figure 66. These are thumbnail sketches from my notebook. Sketches allow me to solve problems before I paint, and in the sketches above and left, I tried to develop a dynamic design for a windblown pine tree.

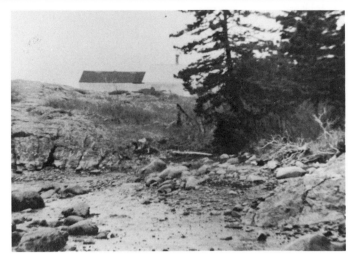

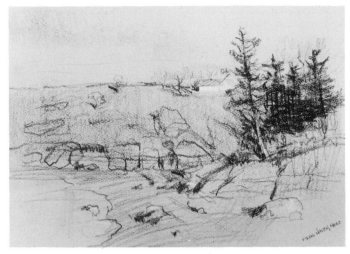

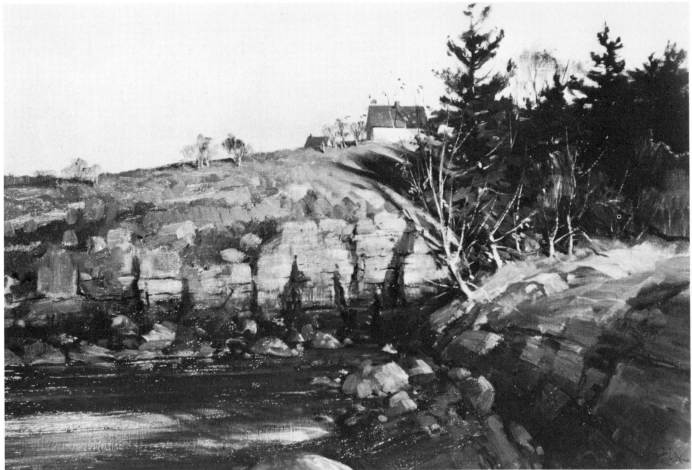

(*Top, left*)
Figure 67. A quarry site in Vinalha-ven, Maine.

(*Top, right*)
Figure 68. A drawing of the area on gray paper, done with pencil and a touch of white chalk.

(*Above*)
Figure 69. *Granite Ledges*, oil on canvas, 20 x 30 in. (51 x 76 cm). This is the final painting, done after I had solved the basic composi-tional difficulties in preliminary sketches.

When I start a painting, I'm never sure that my colors are absolutely correct. I try to reason them out. As the elements come together, my judgment dictates where changes should be made. In this way, I avoid many unpleasant surprises. A violet mountain in the background may look good against a blue sky, and you might be tempted to "finish" the mountain before painting the rest of the picture. Later, the addition of a warm yellow foreground might make the distant mountain look overly violet. You couldn't completely *see* the violet as long as it was related only to the blue of the sky. Think of it this way: it's easier to arrange furniture when the pieces are all in the room than when you buy them piece by piece and arrange them as you go.

REFINEMENT

After the all-important wash-in, the subsequent stages of painting are merely a refinement of your original conception. Most students don't understand this; they feel that the *real* painting is when you delineate all the separate parts of the picture. They want to know how to paint the bark of the tree, not realizing that the important decision, that of where to put the tree in the composition, has already been made. The fact is that after you've worked for three hours on a picture, it should have the same overall appearance from twenty feet that it had after you'd worked only thirty minutes. As I keep repeating: the total effect is what matters.

WORKING OUTDOORS VS. THE STUDIO

When working on the spot, I cover the canvas but leave final decisions for the studio. Both indoor and outdoor work contribute to the quality of the final painting. Outdoors, your adrenaline flows. Each day and every subject are different, and you find colors, values, and shapes that are ever new. In the excitement of the moment, however, you often miss subtle points that can be evaluated better in the leisure of the studio. You see more clearly indoors, for the details of the scene no longer distract you. There, the picture has to stand on its own as an expression of a single idea.

I like to bring my picture home, put it aside, and study it two or three weeks later. By that time, I've forgotten the unimportant elements of the scene and can judge how close the picture comes to my remembered impression. Again: the emotional truth of the subject is more important than the literal facts.

Yet there's also a danger in too much studio work. It makes you force things into preconceived molds, over-dramatizing color and values in order to attract attention to your work. What you gain in compositional force, you lose in subtlety of color. Outdoors, you see and record these subtleties—when I work from my oil sketches in the studio, I'm often surprised by the colors I find in them. That's why I need the initial rapport with nature. It's like music: you can't play the variations till you've learned the theme—then the variations will have the ring of truth.

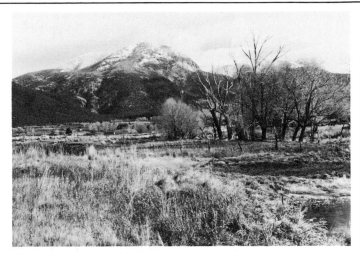

(*Top*)
Figure 70. Farmlands in the Southwest.

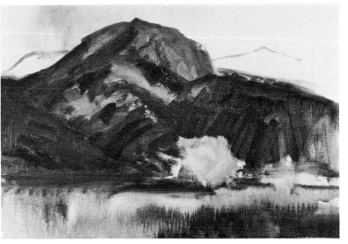

(*Above*)
Figure 71. The lay-in reduces the complex details of the area—trees, grass, and mountain—to a few simple masses.

In the demonstrations that follow, you'll see the effects of both my outdoor and indoor experiences, for I'm a product of that endless subject of debate among painters: whether it's better to work spontaneously (outdoors) or more carefully (in the studio). I can talk from experience, for when I first started painting, I used to vigorously dash off large canvases on location, rarely touching them after the two or three hours spent in the open air. I can remember hauling a 30-by-36-inch canvas halfway across Monhegan Island in order to do an *a la prima* marine!

As time passed, however, I began to feel that a morning or afternoon was insufficient time for an important commitment. The quick, rough statement had great charm, but it was still only a sketch—the nucleus of an idea. I was working in a hit-or-miss fashion. Sometimes I was lucky and the picture worked, but more often than not, the scene didn't have time to filter through my emotions. I had to think fast to fill big canvases; as a result, each picture looked more or less like the others. I missed the sensitive, personal response that could have resulted from further reflection and work.

Of course, painting is too elusive for rules. You have to find your own best way of working. I'm often asked how much time it takes to paint a picture. An old Maine lobsterman, when asked how long it would take a boat to get to the mainland, replied, "Well, some makes it faster than others." Some people work slowly and others, quickly. Painting sil-very aspens in the quiet, unchanging light of a gray day, I'll take my time. Straddling a rushing stream on a bright, sunny day, I may be so excited by the light and the moving water that I'll do a sketch in an hour. Just remember that your painting will be judged by the final result: you don't get extra credit for fast work, so don't feel you have to paint as if someone were chasing you. Sorolla, the great Spanish impressionist, once told a student that one day he might paint a nose in three strokes, whereas on another day it might take five hundred.

MY BASIC APPROACH

Before going on to the actual demonstrations, I'll explain how my method works in a sample demonstration, reproduced in black-and-white photos. This will be followed by a series of nine demonstrations in black-and-white and color, each of which is photographed *at the painting location*. The demonstrations show me at work in different parts of the country, but regardless of my subject matter, I use the same basic approach: I decide on the conception, block in the compositional masses, develop the design of individual parts, and finally refine the picture, if necessary, in the quiet of the studio. A photograph of the site is included in each demonstration so you can see how I composed my basic material. The painting is photographed as it looks at various stages, as well as after completion indoors.

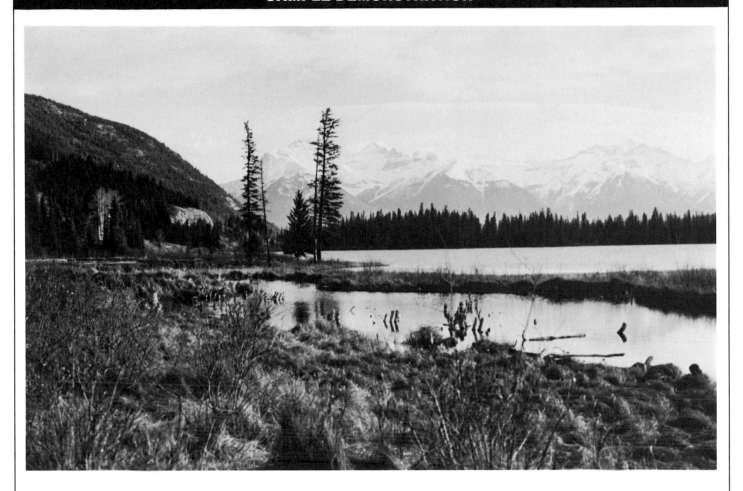

Step 1. *The Subject.* For this demonstration, I've decided to paint part of the Canadian Rockies near Banff, Alberta. Painter-friends have often suggested that I visit Canada, and their arguments appeal to my own affinity for the dramatic shapes and heroic character of the Rockies—as well as the marvelous paintings other artists have done of that area, most notably John Sargent, Carl Rungius, A. T. Hibbard, and more recently Robert Lougheed. I decided to go late in October, before the cold becomes a real handicap. As you can see in this photo, I'm not disappointed: the mountains' great variety of shapes and structure poses a challenge, and although I've spent three weeks in the area, I feel that I've yet to penetrate the essence of its epic grandeur.

Here I am attracted by the low morning light and by the atmospheric haze in the distance, so I decide to stop and paint. Sometimes you can be too analytical, searching and searching for that better spot around the corner, but today, I trust my instincts.

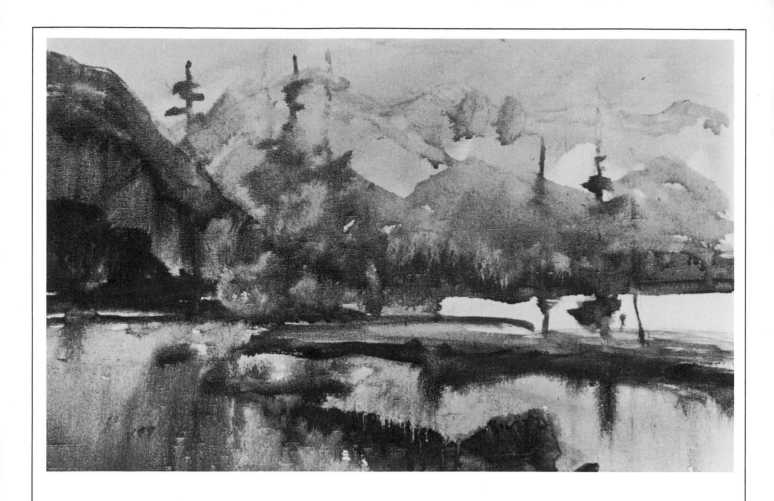

Step 2. *The Lay-in.* Rapidly I wash-in my compositional masses. You can see that I am applying paint thinly, using lots of turpentine—and *no white*. One mass literally drips down into another. This thin wash dries in a few minutes, and I can work heavier colors over it. If it dries too slowly, I can speed the process by turning the canvas to the sun for a few minutes.

I feel the best procedure is not to let any of my initial wash show in the finished work, no matter how attractive it may look at this stage. Oil paint is by nature shiny and fat; thinly painted areas, which suggest watercolor, will not be consis-tent esthetically with the more solid areas of the painting. In addition, a paint film that is not healthy could be washed away during future res-toration work. By the same token, it's bad policy to leave uncovered canvas in a picture. The white spots may look good today, but what happens when the priming yellows or grays years later? The change could disrupt your color relationships. If you insist on letting canvas show, you should first prime the canvas with the same white that you use for painting. Then the surface of the final pic-ture will be homogeneous and all the paint will age in a similar way.

Step 3. *Developing the Picture.* Once the wash has established the composition, I can begin to use my normal painting procedures. As in the lay-in, many of my colors are created intuitively. In the following demonstrations, I'll mention mixtures, but I've determined their components only by studying the final picture. I can't remember precisely how I got each color, so don't work by formula. I'll suggest one possible way of approximating the mixture, but you may find a hundred other ways of getting the same color.

This photograph shows how my picture looks after a few hours on the spot. By this time, my eye has begun to tire and I decide to take the picture home, where I can study it at my leisure.

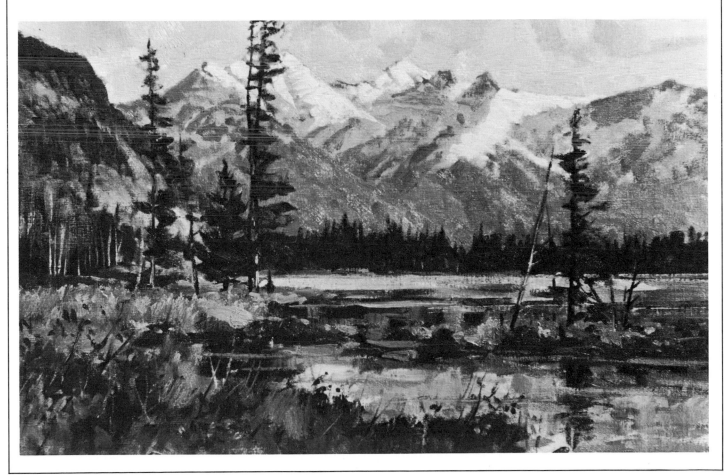

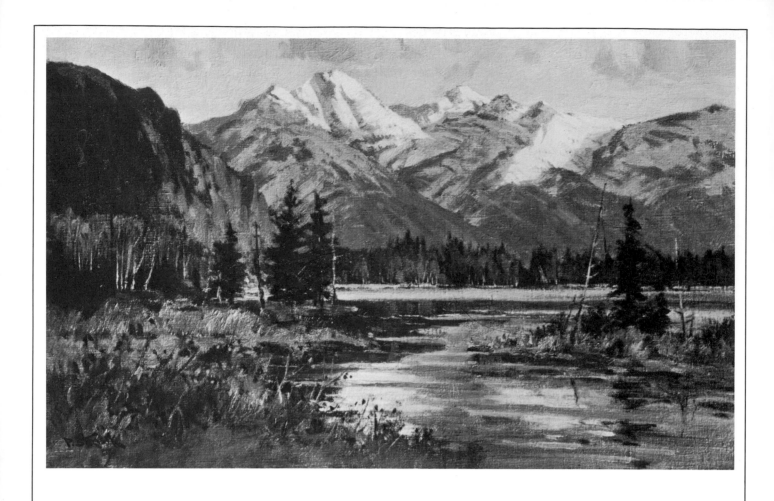

Step 4. *The Studio.* Looking at Step 3 in the studio, I feel that it captures neither the dignity of the mountains nor the breadth of space that I felt on the spot. Step 1 shows that the foreground trees are tall, a ''fact'' of the site. Yet, if you hold a penny close enough to your face, it can cover the whole world. Sometimes large foreground objects give depth to a picture, but in this case, I need to lower these trees so that the epic character of the mountain can be more easily seen. I also simplify the foreground and open up the area of water, creating an easier entrance into the picture. By eliminating foreground obstacles, I add to the painting's feeling of spaciousness.

The painting has come a long way from my loose, transparent lay-in. But the rough start was a prerequisite for the more considered finish. It quickly established my general effect, and all my subsequent work was based on that initial conception.

Step 1. Unfortunately, by the time I photographed this site in New Mexico, clouds had moved over the mountain and temporarily obscured it. However, you can still see what attracted me: the strong contrast between the sunlit foreground and the shadowed mass of the distant mountain. This effect is heightened by the natural lightness of the aspens and of the dried foreground grasses. The old barn adds additional interest to the scene.

Step 2. Quickly I distribute my main masses with washes of color. I don't worry about the trees at this point: later, it will be easy to paint them over the washed-in mountain. The sky changes rapidly, and I paint the cloud shadows with white, ultramarine blue, and burnt sienna. This gray is easily cooled with blue or warmed with burnt sienna. For the sunny areas of the clouds, I use more white and some yellow ochre. I mix ultramarine blue and ivory black for the mountain range, warming it with cadmium red medium where it receives light in the distance. The basic hue of the adobe farm is burnt sienna, with white added in the light areas and ultramarine blue, in the shadow. The lightest portions of the foreground grass are yellow ochre, and I add burnt sienna and ultramarine blue to the darker areas. Now my canvas is covered, and I've established not only my basic colors but my darkest and lightest values.

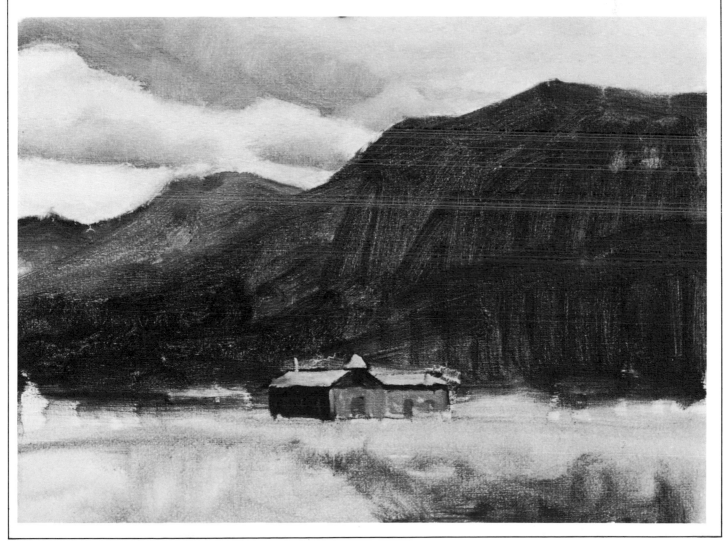

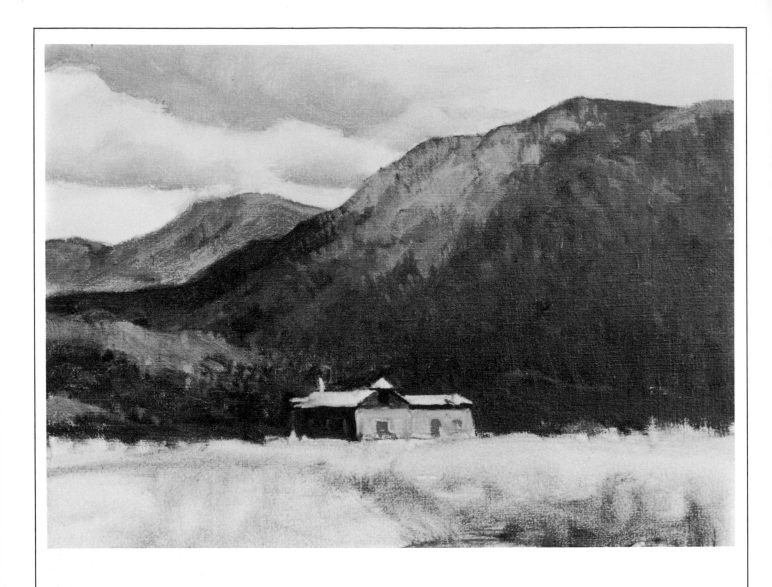

Step 3. At this stage, I change the shapes of the sunlit areas as I paint, choosing those that most appeal to me. I want to suggest areas of light without disrupting the impressive mass of the mountain. I mustn't lose the initial contrast between the profoundly dark, shadowed mountain and the brilliantly illuminated trees. If I lose that impression, I've lost sight of the impulse that led me to paint the picture. In the distance, I gray the mountain with a combination of terra rosa and white, which makes a dull, cool red. I also add touches of terra rosa to the foreground mountain to suggest areas of bare earth. I paint the sunlit area of the hill in the middle distance with chromium oxide green opaque—not straight from the tube, of course, but grayed slightly to make it stay back in space. I add a touch of phthalo blue, mixed with yellow ochre and white, to the sky near the horizon. The color suggests the clear mountain air. I paint the metal roof a high-key, silvery blue-green.

Step 4. I add the light trees, some overlapping the barn and others showing in the distance. I don't want all the trees to be growing in one neat clump. I also vary their sizes so they'll be interesting to look at. I simplify them, since I can't paint every branch. Instead, I first use a worn No. 2 filbert to paint the trunks and principal branches over the half-dry wash, using white with a touch of yellow ochre. Once I have the main branches drawn, I scumble the same tone, darkened slightly with the mountain color, over the trees to suggest masses of small branches. By doing the mass of branches last, I can blur some of the previously drawn limbs, making them less harsh and giving them a "hide-and-seek" quality. I place a few dots of mountain color among these branches, clarifying their drawing and sug-gesting open spots.

I begin to draw the building more accurately, casting a shadow across it from the nearby trees. These shadows add interest to the shape, as do the blue doors and window. I paint the foreground with yellow ochre and burnt sienna, occasionally adding gray-violet to suggest areas of shadow. I flatten the clouds, since their rounded shape is too interesting and detracts from the foreground. I add the inevitable western fence, not bothering with barbed wire. Notice, too, that interchange of values is at work in this fence; that is, the posts look *dark* against the light, sunlit earth but *light* against the shadowed mountain. I ignore highlights and shadows on the posts, since such details add noth-ing to my statement.

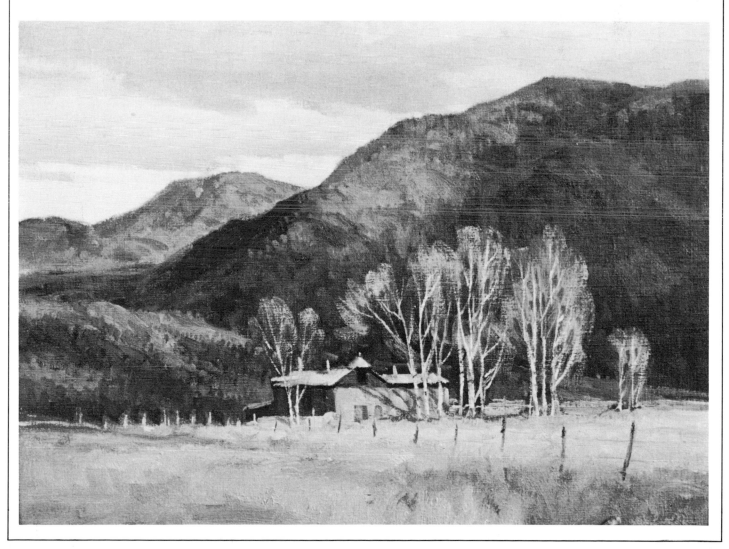

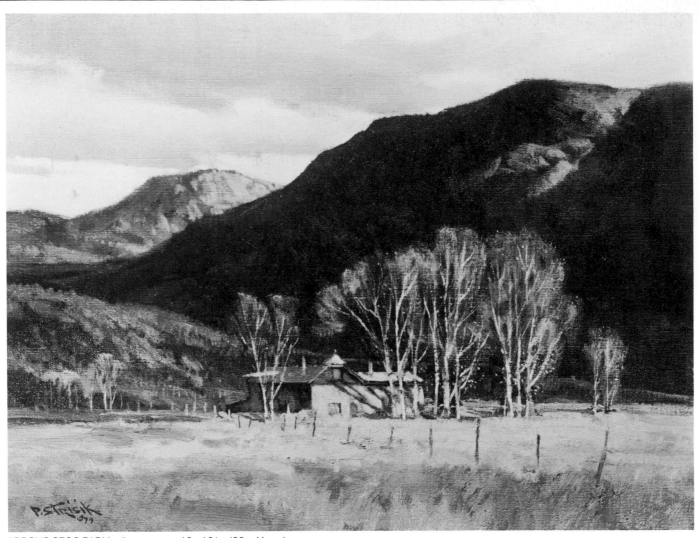

ARROYO SECO FARM, oil on canvas, 12 x 16 in. (30 x 41 cm)

Step 5. Back in the studio, I decide to eliminate much of the light from the nearest hill. I want to return to my original impression of an inky, blue-black mountain mass, but I do add some light at the upper right in order to keep the mountain from being too flat and boring. I add details to the building and shadow to the left side of the roof, thus concentrating my main lights at the right, near the trees. A fully lit roof would diffuse the impact of the light. I raise the value of the foreground grass, bringing it nearer to the yellow-white appearance it had on the spot. Notice, however, that the brightest area is next to the trees—my center of interest—and it diminishes in brightness as it moves away from that spot. I create shadows on the field with raw sienna and touches of cadmium red medium, ultramarine blue, and white. These delicate violets complement the warm, brilliantly lit areas of the field. In the foreground, I use bigger strokes to suggest the nearness of grasses and other materials. I also work on the anatomy of the trees, adding a few dead leaves to give the scene an added sparkle. Some smaller trees on the far left keep the principal trees from appearing isolated.

Step 1. I first saw this site on a sunny day and felt it would be perfect on a day like today—bright, but overcast. I especially like the lone tree silhouetted against the sky, and I'm also attracted to the dynamic, contrasting movements of the sloping landscape.

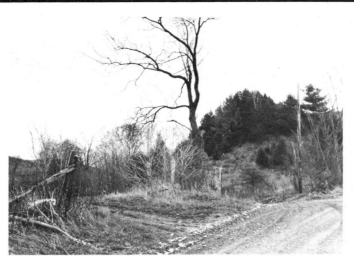

Step 2. I start to block in the picture with washes, exaggerating the contrasting, interlocking lines of the trees and hills. I paint the distant mountain with cobalt blue and cadmium red medium, and for the background pines I mix burnt sienna and phthalo blue. The foreground bushes are primarily burnt sienna, dulled with ultramarine blue. To paint the road I switch to yellow ochre, grayed with a little ivory black. The foreground rocks are ivory black and white, the main tree is ivory black, and the sky, too, is a thin wash of ivory black. That may seem like a lot of black, but washes of this color suggest the character of a silvery-gray day— and it also relates well to the greens and yellows which I'll be adding to the painting later on. When I add these warm colors, my grayish mixtures will take on a subtle violet tinge.

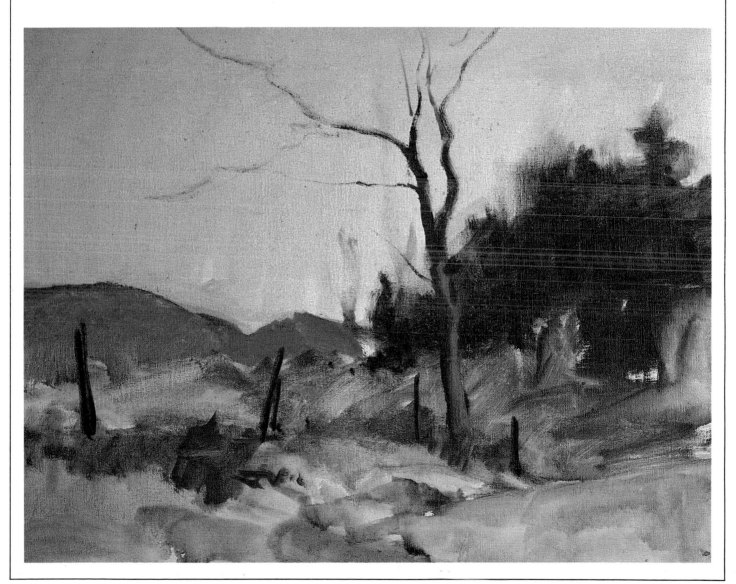

105

Step 3. Now I paint the sky more thickly, using a mixture of ivory black and white, with touches of cadmium yellow and white in the brightest areas. Farther away from the sun, the sky becomes less warm and brilliant, so I replace the cadmium yellow with orange. This is a subtle matter, and I try to vary the color so that you *feel* the change rather than see it. In order to assure that the sky farthest from the sun has less energy in it, I also gray these areas with a hint of ivory black and white.

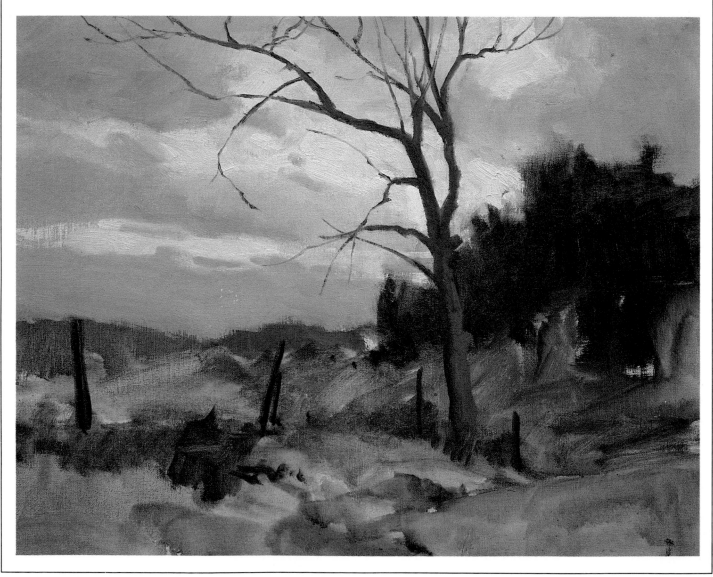

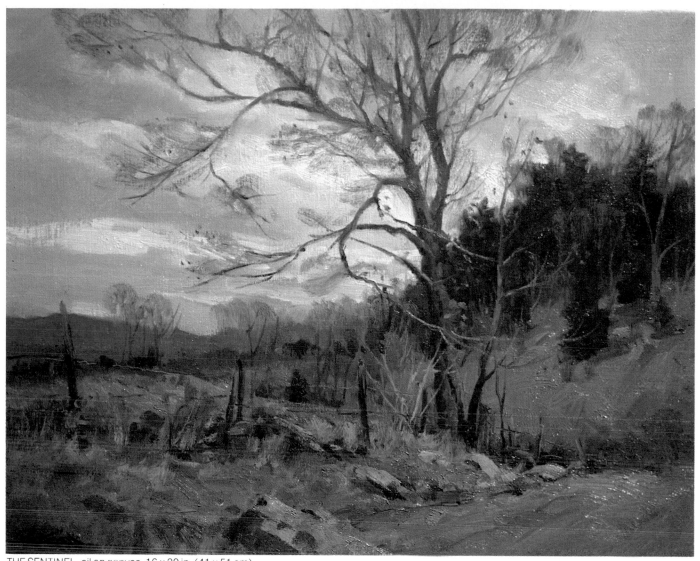

THE SENTINEL, oil on canvas, 16 x 20 in. (41 x 51 cm)

Step 4. Having painted the sky, I can now develop the branches of the tree. The painting is thoroughly established at this stage, and further refinements are like grace notes in a piece of music—they add to the work but aren't important in a structural sense.

I emphasize the quality of an overcast day by scumbling with a silvery-gray color reflected down onto the land from the sky. Notice, for example, how gray and light the road is at its crest. Cadmium red medium, black, and white give me the color I want for the hundreds of small tree branches against the sky. The posts and rocks on the left are needed to balance the weight of the dark pines on the right. Notice, by the way, that although I've kept the mass of firs simple, I do a few of the nearer trees more carefully; they explain the mass without breaking it up. Later, in the studio, I make a few subtle adjustments and corrections, and the painting is finished.

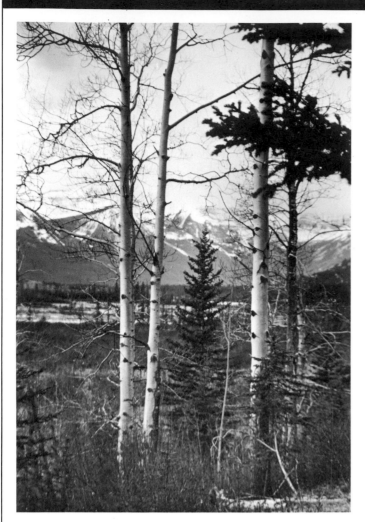

Step 1. Although the aspen is related to the birch tree, it grows quite differently. The birch, a lyrical tree, curves and dances; aspens are straighter and more dignified. The day is overcast, with a hint of light coming from the left, and there are no cast shadows.

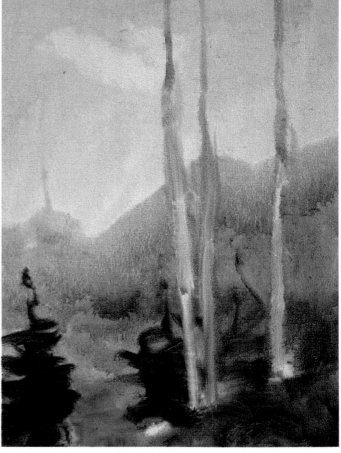

Step 2. At the original site, the background mountains and fields are too horizontal; with the vertical trees, they form a monotonous series of intersecting straight lines. I can't change the vertical thrust of the trees—that's part of their character—but I can vary the other elements. Therefore I give the mountains a slanting contour. I also lower the fir trees and the distant field, emphasizing the *height* of the aspens.

I paint the sky with a very light wash of yellow ochre and cobalt blue—colors which make a warm gray when combined. The distant mountains are ultramarine blue grayed with ivory black and warmed with cadmium red medium. I mix a wash of burnt sienna and ultramarine blue for the distant fields, and use raw and burnt siennas in the foreground, with burnt sienna and ivory black for the weedy area in the nearest portion. For the pines, I make a warm mixture of phthalo blue and burnt sienna. With a twist of my cloth, I wipe out of the turpentine wash for the light trunks of the aspens. In the photo of the site, notice that the trees look *light* against the dark background mountains but *dark* against the light, overcast sky. This kind of "interchange" happens often in nature. Students often worry so much about an object's local color that they ignore the more important aspect of its *value* in relation to its surroundings. Although the aspens are a "light" tree, they form an unmistakable silhouette against a much lighter sky.

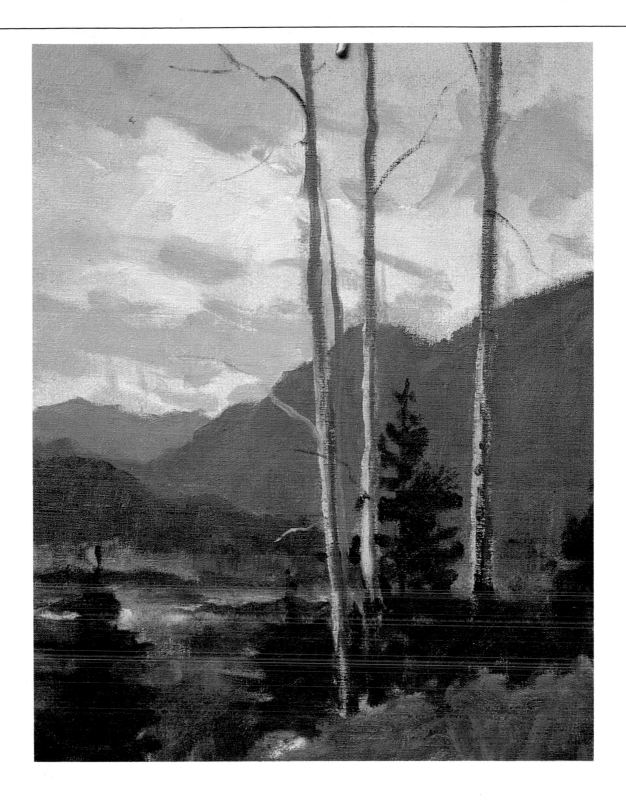

Step 3. I roughly lay-in thicker pigments for the sky, using ivory black and white. At the upper left center where the sky is brightest, I add a spot of pure white with a hint of cadmium yellow light. As light radiates farther from this point, it gets duller and less vibrant in color. There's a hint of orange in the sky as it nears the horizon—and a whisper of pink in the far distance. With a touch of ivory black, I darken the value further at the horizon.

Now I paint the mountain more solidly, using the same colors as before but with more pigment and white to give them body. I use a variety of colors for the horizontal plane of the earth: yellow ochre and raw sienna, grayed slightly; burnt sienna; and occasionally cadmium red medium and ivory black for the bushes.

Step 4. Before developing the tree branches, I refine the sky. Then I consider how to handle the hundreds of small branches. If I draw every one, I'll have a tangle rather than a design, so I simply paint the most important limbs and suggest the rest by scumbling with a dull, reddish-violet mixture. I add and remove branches until the spatial divisions look interesting to me. I pay close attention to the growth of the tree as I paint. Every tree is different, and I don't want to do them by formula. The branches of the aspens wander in a way that contrasts nicely with their straight trunks. They look very green in contrast to the violet mountain. The upper trunks are dark against the sky, which gives them a sense of solidity, but because of diffraction they're not an intense dark. The bright sky eats into them. I add a dark tree on the right, filling up a distracting open area, and keep the pines (a mixture of ivory black and cadmium red) and bushes simple so they remain a background for the trees. Now I have enough information to finish the painting in the studio.

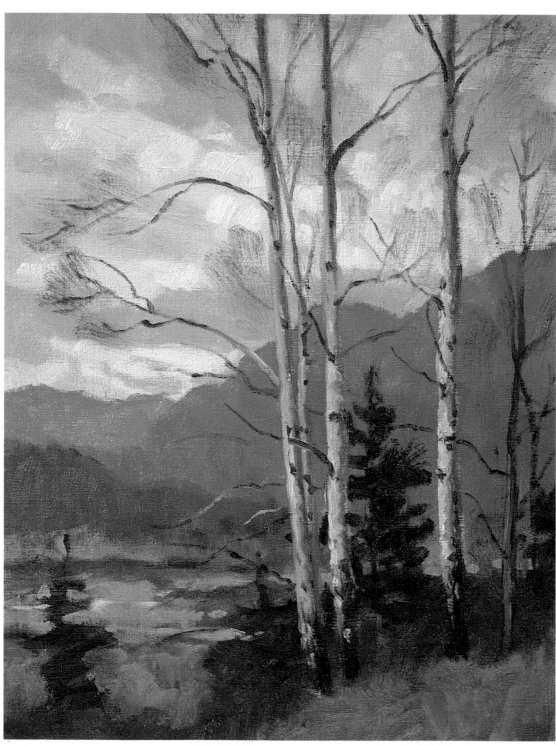

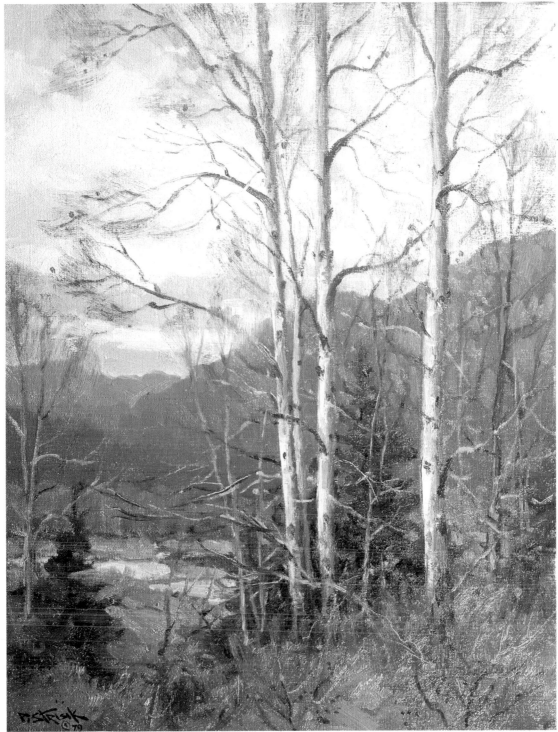

ASPENS, oil on canvas, 12 x 16 in. (30 x 41 cm)

Step 5. In the studio, I add atmosphere to the distance by introducing lighter values along the top edge of the mountains (ultramarine blue, white, and a touch of ivory black). By lightening this area, I suggest the effect of the brilliant sky eating away at it. The sky now looks more luminous.

I develop the branches, put a tree on the left—to stop your eye from going out of the picture—and add a few red (terra rosa) and yellow (yellow ochre) leaves. I use raw sienna where the leaves become dark against the sky. I try not to overdo these spots, since an isolated dot can attract more attention than a large mass. I also add twigs and brush to the foreground. Since I can't paint each branch, I summarize the details in a silvery (ivory black and white) scumble. I apply the scumble with an up-and-down motion of the brush to suggest the way the bushes grow. A few dark branches explain what the scumble represents.

Step 1. This is a real piece of Americana: a sugar shack in Vermont. I find this one especially interesting to paint, for it's made up of a variety of old materials. Nothing matches, and as a result, the building has its own distinctive shape and character. It's late spring, and I especially like looking across the roof of the shack into the atmosheric distance.

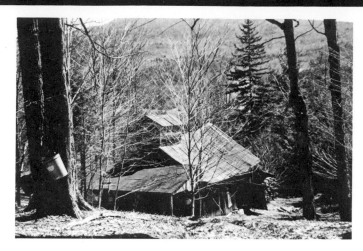

Step 2. The site is interesting just as it is, but I lower the mountain and vary its shape in order to avoid a "domed" look. Since I'm looking into the sun, I have plenty of contrasts to work with. I try to establish the strong light-and-dark pattern early. The mountain is ultramarine blue with a touch of cadmium red medium, and the shadows, ultramarine mixed with burnt sienna. I paint all darks the same color at this stage, since I'm trying to establish value rather than color. The foreground is a light wash of yellow ochre.

Step 3. Now I paint the mountain flatly and more solidly. I add a hint of the green fields in the distance, using a mixture of cobalt blue and yellow ochre grayed with a touch of the gray-violet hue of the mountain. The patches on the rusty roof are a mixture of warm, dull reds (mostly terra rosa) and burnt sienna, with hints of cobalt blue and white in the cooler areas. The tar-paper roof of the nearby shed is ultramarine blue, alizarin crim- son, and white, warmed with yel- low ochre. The result is a color that looks dark but has the vitality you'd expect when a dark surface is lit by the sun. I paint the side of the sugar house with ivory black, white, and yellow ochre. I use a lot of warm burnt sienna in the interior darks so that you feel as if you could look *into* the depths of the shadows. The ground is painted with raw sienna and white.

Step 4. Now I develop the pine trees with phthalo blue and burnt sienna, suggesting some sunlit areas with phthalo blue and yellow ochre. I add descriptive details to the roof and walls and place a few trees in front of the nearby shed, directing attention out toward the clearing. By making the branches light (using yellow ochre and white), I add sparkle to the foreground. I scratch in some branches with the end of my brush. I put in extra leaves, sap buckets, details of the shed door, and so on, until I feel I've gathered enough material to go back to the studio.

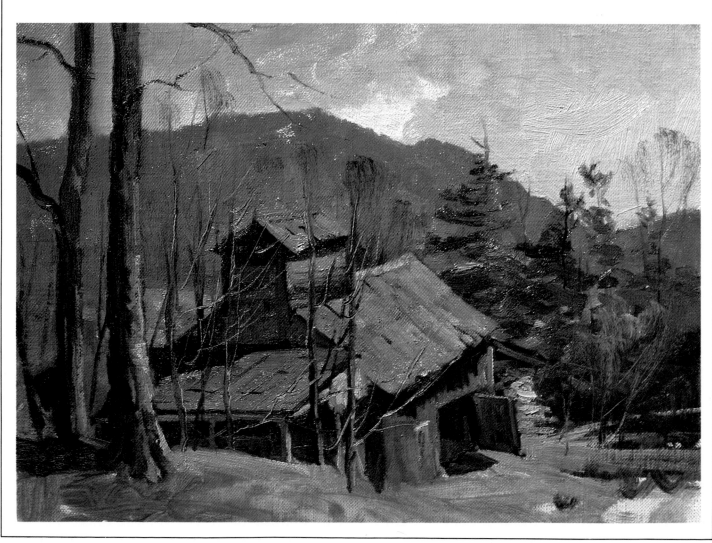

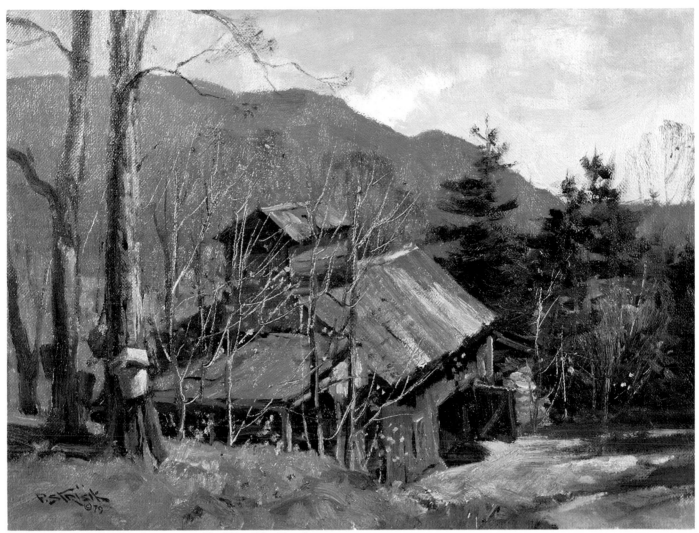

GRIFFIN'S SUGAR SHACK, oil on canvas, 12 x 16 in. (30 x 41 cm)

Step 5. In the studio, I feel there aren't enough darks in the picture, so I make some of the distant evergreens stronger in value. Again I change the contour of the mountain, strengthening its form. I also add blue to the top of the mountain, pushing it farther back in space with atmospheric perspective. I lighten the ground in front of the open shed door in order to separate it more clearly from the foreground bank. I also add more reflected sky color to the roofs of the building. These subtle touches distribute color throughout the painting and give it a stronger feeling of unity.

Step 1. At this site, I am intrigued by the characteristic patterns and rhythms of the willow tree. Since the sun is behind me, the lighting is relatively flat. The white house provides an additional area of interest, while the dark hillside effectively frames my focal point.

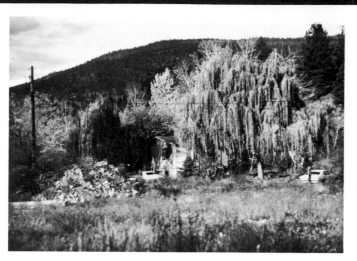

Step 2. I wash-in the areas of the mountain and trees, but my original hill is too rounded and so I wipe it out with a cloth. Changes are easy at this stage. I establish the dark of the willow with viridian and burnt sienna. The actual mixture isn't very important at this stage. Darks are darks, and they don't have much individual identity. I could just as easily have used phthalo blue and burnt sienna or ivory black and a yellow. All would have given me a similar effect. I start with the darks because when you paint with an opaque pigment like oil, it's easier to paint light areas over a dark stain than to work dark strokes into a wet, light mass. The foreground wash is raw sienna thinned with turpentine. The mountain is ultramarine blue, warmed with cadmium red medium and dulled with a touch of ivory black.

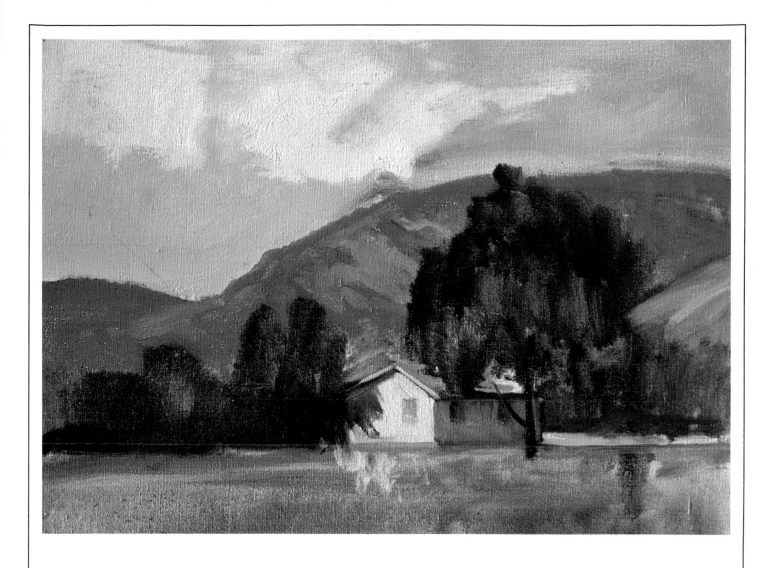

Step 3. I wash-in the sky with phthalo blue and a touch of yellow ochre, which increases near the horizon. Next I indicate clouds with yellow ochre and white, dulled with some of the sky color. I paint the earth showing on the hillside with Venetian red and white, dulled with a little of the mixture I used to paint the mountain. I establish the sunlit side of the house with white and a bit of yellow ochre. For the shadow side, I mix a gray (with ivory black and white), into which I introduce some yellow ochre—of the *same value*—to suggest warm reflected light. With cadmium red medium and ivory black, I wash-in the dark bushes. Had I made the mixture with ultramarine blue instead of black, it would have been too violet for these shadows. I want you to feel the warm color reflecting into them, and by substituting the more neutral ivory black, I give the warm red a better chance to affect the mixture. I'll have covered most of this dark tone before I finish the picture, but wherever it's still visible, it will appear as a transparent, luminous accent.

Step 4. Now I begin to develop the sky and mountain, applying basically the same colors as before, but more thickly. I paint the sunlit area of the willow with phthalo blue, cadmium yellow, and white. This mixture creates a vivid green which, if necessary, can be tempered with a little orange. In the highlights of the willow, I use more orange and white, then restate the darks with phthalo blue and orange. If I wanted to deepen the green further, I could add burnt sienna or alizarin crimson—both devitalize the color. Ivory black would serve a similar function.

I use raw sienna as a basic shadow color for the nearby yellow trees; I paint the sunlit areas with cadmium yellow medium and cadmium yellow light. This is as far as I carry the picture outdoors. The foreground stain gives me enough information to develop it further in the studio.

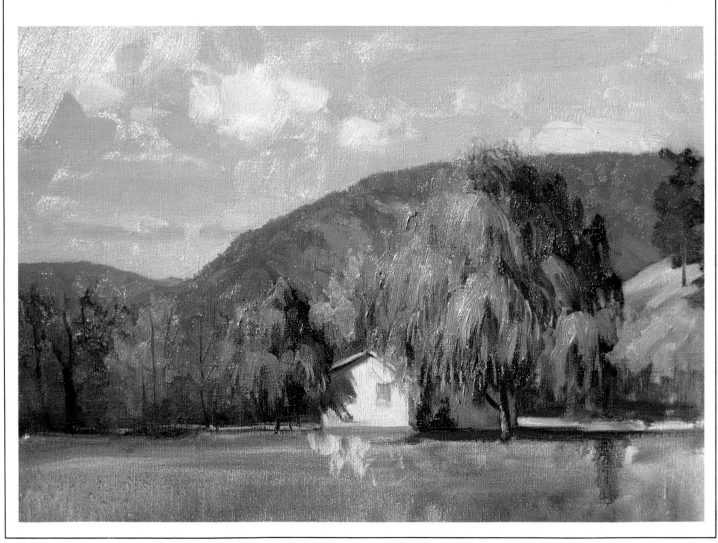

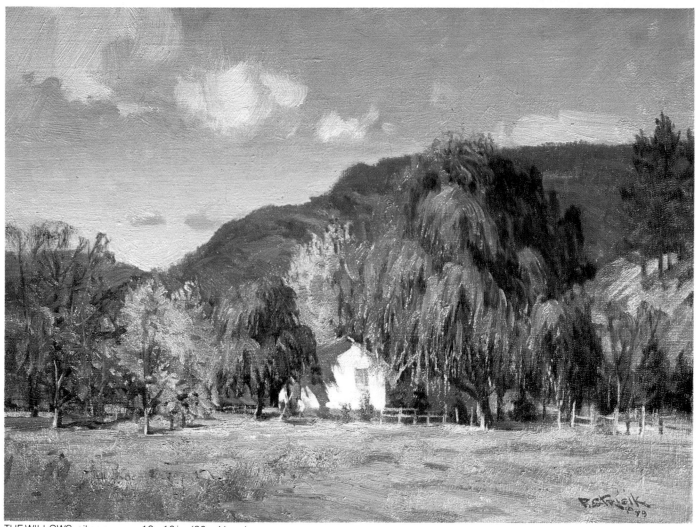

THE WILLOWS, oil on canvas, 12 x 16 in. (30 x 41 cm)

Step 5. Indoors, I give more attention to the painting as an independent entity. I don't like the overly symmetrical contour of the mountain, so I redraw it to make it more interesting. I repaint the sky with cleaner colors, so that it has more of the feeling of a very clear, crisp, dry day. I make the sky greener at the horizon and accentuate the gradation from a warm yellowish sky near the sun to a more violet hue on the right. I restate the highlights on the trees, adding a few sparkling touches at the bottom of the willow. Then I complete the foreground, using darker weeds and patches of earth to lead you into the picture. I add touches of green to the land. They weren't present at the site, but I need them to create a color relationship between the earth and the trees. Next I move some trees on the left into the field, in order to break up the dominant horizontal lines of the picture. I also heighten the trees on the far left. They now cut across the distant mountain, keeping your eye from leaving the picture and also providing added weight to balance the large mass on the right.

Step 1. This is a typical stream in northern New Mexico. Out West, there isn't much green during the late fall; the ochrish colors of the grass and the earth predominate. The clear blue sky reflects vividly in the dark stream. I walk along the stream for half a mile, searching for a strong light-and-dark pattern. Finally I pick this spot because of the large tree on the left, which is a strong dark among the otherwise monotonous tones of the landscape. The bridge also adds interest to the scene.

Step 2. The stream is interesting just as it is, but I angle it a bit to give it a more elegant contour. I also enlarge the background mountain—its cool color acts as a foil to the warm earth tones. I wash the sky with phthalo blue toned with yellow ochre. For the dark shadows, I use a warm mixture of cadmium red medium and ivory black, but burnt sienna with ivory black or ultramarine blue would yield a similar result. Next I indicate the nearest part of the stream with ultramarine blue and a hint of alizarin crimson, and a few touches of orange to suggest the bottom of the stream. I paint the distant ridge of junipers with a dull gray-green mixture, and the background fields, yellow ochre dulled with a dab of cobalt blue. I could just as easily have substituted ultramarine blue or ivory black for the cobalt, since the specific color doesn't matter as long as these fields are the right value and are grayed in color. When I paint on the spot, I simply use whatever color is handy. As the fields come toward us, they're less affected by the atmosphere and are richer in color, so I use yellow ochre and raw sienna in the foreground; a few touches of green add variety.

Step 3. I wipe out a cloud or two with a rag, then begin to define the background, buildings, and the pattern of the distant piñon trees. Next I draw my main tree, approximating the branches and areas of dead foliage. I can develop this tree later. I accentuate the bridge, brighten the rocks, and begin to put more paint on the distant fields (yellow ochre and white). The rocks, too, I indicate with yellow ochre and white; and the weeds and grass, with burnt sienna. The darks under the edge of the bank, which are least affected by the sun, form the darkest areas in the picture, and so I emphasize them with a combination of burnt sienna and ivory black.

Step 4. I continue to work all over the canvas, slowly adjusting values, shapes, and patterns. Slowly the painting comes into focus. I add small, but necessary, details and refine colors wherever necessary. I develop the tree limbs and then paint the sky back into them, to give them added definition. I also add light branches to the foreground tree; that makes you feel as if some branches were coming at you, and others, receding.

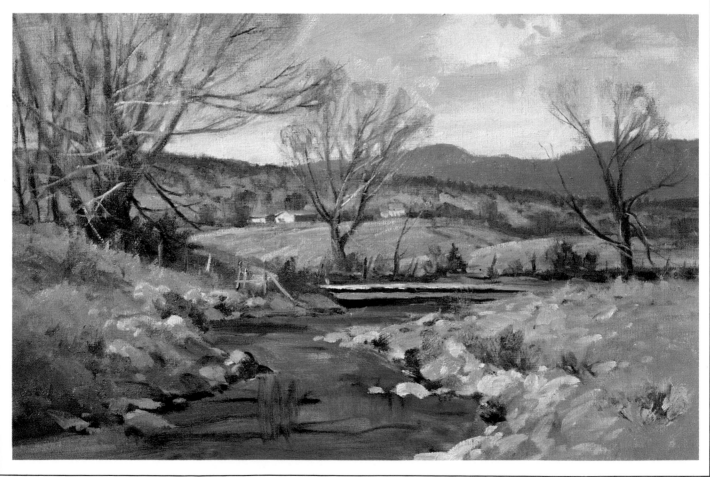

STREAM, ARROYO HONDO, oil on canvas, 16 x 24 in. (41 x 61 cm)

Step 5. Back in the studio, I complete the sky and work on the anatomy of the trees, adding branches and small dead leaves. With the same colors I used for the wash-in, I complete the stream, adding some light greenish-blue reflections from the sky. I lighten the distance in order to add atmosphere to the picture. I cover the distant hills with a dull red earth (cadmium red medium and yellow ochre, grayed with a touch of cobalt blue). The fields become still warmer and yellower toward the foreground, but I keep distant piñons a cool gray-green, suggesting their *pattern* instead of trying to describe each tree.

Step 1. At this site, I'm impressed by the fresh, sparkling morning light. It's late October after a snowstorm, and the snow is still on the trees and the distant mountain. The foreground water is unbelievably rich and blue in color.

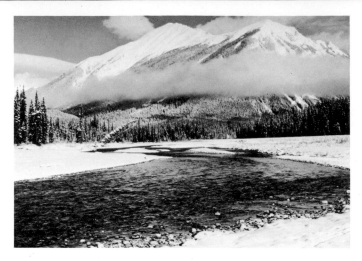

Step 2. I decide to use a simple foreground as an entrance to what is basically a mountain picture. I wash-in the sky with cobalt blue and a touch of yellow ochre, then wipe out clouds with a rag. I also wipe out the top edge of the snow-capped mountain. I indicate the distant trees with a mixture of chromium oxide green opaque and ivory black. For the trees in the middle distance I use the same mixture, darkened, and add blue to the shadows. Next I lay-in the river with phthalo blue, tempering it with raw sienna to keep the blue from looking too "raw." As the stream approaches the foreground, I add more ultramarine blue, using orange here and there to suggest areas where you can see the bottom.

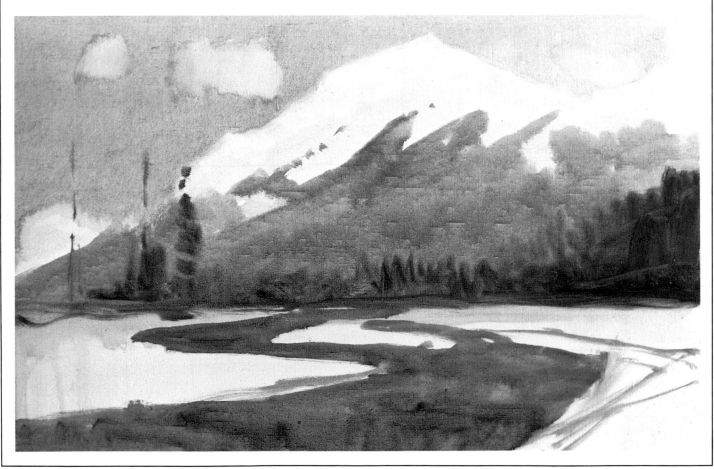

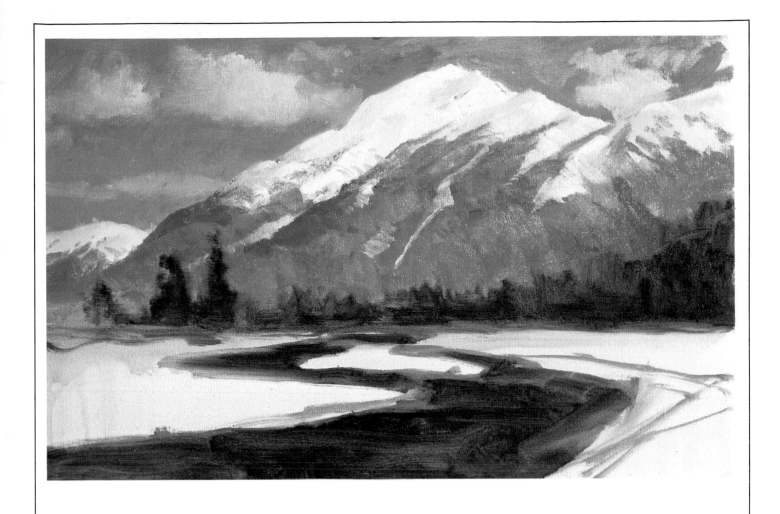

Step 3. Next I develop the mountain, my main area of interest. For the trees on the mountainside I mix chromium oxide green opaque, white, and ivory black. The green becomes lighter in value and less intense in color as it moves away from us. The shadows on the peak aren't very dark; the clouds hang among the mountains and act as reflectors, bouncing light down into everything. Consequently, the shadows would not be extremely dark. The snow on the mountain is white, and I add a touch of cadmium orange in the snowcap. A hint of phthalo blue dulls the shadow areas.

Step 4. With more pigment on my brush, I strengthen the sky, grading it to a greenish blue at the horizon. The clouds are very near, almost as close as the mountain—but they're not as white as the snow because the snow is a solid, relatively reflective surface, while the clouds are soft and absorb light. I paint these clouds yellow ochre and white, muted with a bit of the sky color. I suggest distant trees with small vertical strokes, darken the trees in the middle distance with ultramarine blue and burnt sienna, and combine phthalo blue and orange for the areas in light. Here and there, I temper the color with some yellow. The trees on the left are nearest and therefore the most detailed. I devote less attention to the trees in the middle distance, since they're not as important. In the foreground, the horizontal areas of snow receive less light than the more vertical planes, so I add a touch of phthalo blue and a whisper of ivory black to the white. In the distance, a bit of ultramarine blue gives the snow a more atmospheric, violet character. The sunlit area of snow is white with yellow in the foreground; the snow becomes somewhat more orange as it recedes.

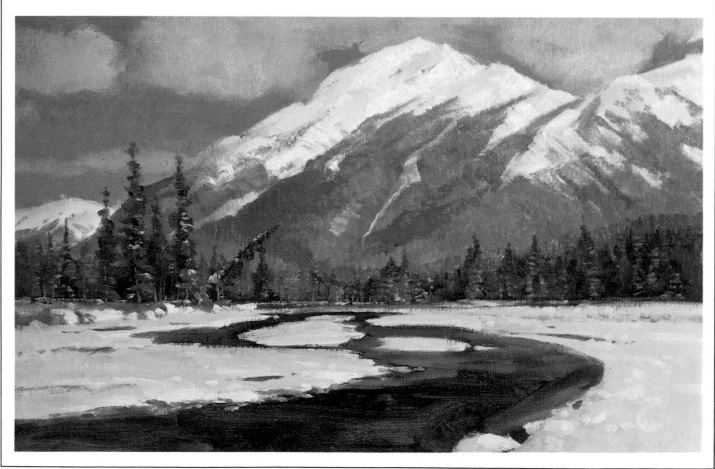

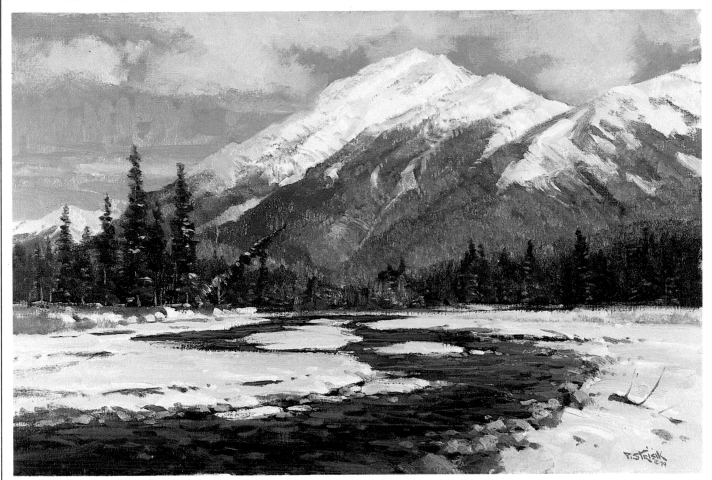

WINTER, KOOTENAY, ALBERTA, oil on canvas, 16 x 24 in. (41 x 61 cm)

Step 5. In the studio, I model the clouds, making them pinker and duller nearer the horizon. I paint the distant water with simple, horizontal strokes, using the same color I applied to the lower part of the sky. In the near foreground, the stream becomes more turbulent and active, so I paint it with richer colors: phthalo blue with burnt sienna and orange. A few random darks suggest the reflections of the background pines. I paint the sunlit rocks with yellow ochre and white and modify the distracting, finger-like shapes of the masses of foliage near the mountain's peak.

Step 1. This site is a natural composition. I especially like the diagonal of the hill. It's dynamic and lively—a welcome relief from the usual horizontal lines of a landscape.

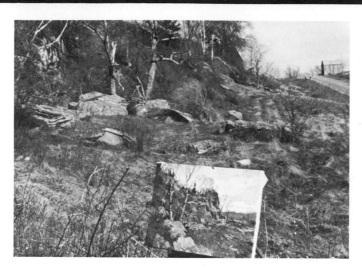

Step 2. When I lay-in the first washes, I immediately establish the silhouette of the land against the sky. Since I'm particularly impressed by the rock outcropping, I emphasize it. I also plan to use the foreground rocks to lead your eye into the picture. Remember: these rocks appeal to *me*—but another painter might be attracted to a totally different aspect of the scene.

The brush is a grayed reddish-violet, which I mix with cadmium red medium and ivory black. For the darks of the rocks, I use phthalo blue and burnt sienna, a color that gives a silvery, gray-green look to the shadows. These shadows harmonize with the greens in the grass, which I lay-in with a very thin wash of phthalo blue and yellow ochre, and complement the reds of the nearby bushes.

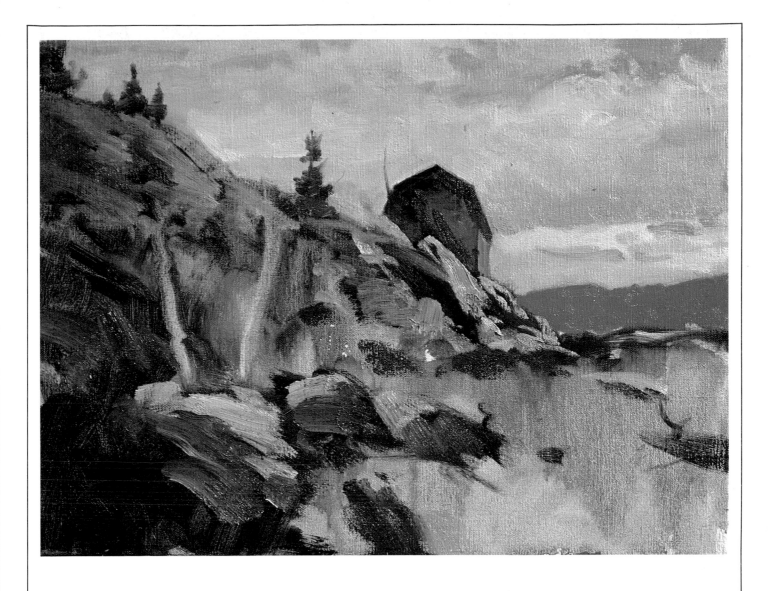

Step 3. Now I add the suggestion of a distant mountain; they're all around me and I want to get them into the picture. The cool blue-violet mountain also gives an added vibrancy to the warm complementary greens of the foreground. I paint the gray clouds with burnt sienna, ultramarine blue, and white, which I apply in varying proportions and in a variety of different values. Yellow ochre and white form the light portions of the clouds. I decide that ultramarine blue is too warm to appear so low in the sky, so instead I use cobalt blue and white. I paint the barn a dull red and the sunlit parts of the rocks, a silvery gray-green mixture of cobalt blue, yellow ochre, and white. These rocks are a particularly attractive feature of the scene, and I don't worry about making too much of them; I can always cover them with bushes later on. With a rag I wipe out some pigment to suggest foreground trees.

Step 4. At this stage, the painting seems to have changed a great deal since Step 3, but I haven't done as much as you might think. Done properly, the wash-in *is* the picture: now I am simply filling the canvas with more considered colors. I make the foreground rocks large to pull that area forward and to give the picture depth. I paint the rocks on the hillside with strokes that reflect their geological character. In general they move down the slope, following the lay of the land, but near the base of the hill, the downward movement is opposed by rocks angled in a contrary direction. The vertical trees also serve as a counterpoint to the angular sweep of the hills. I paint the brush with cadmium red medium, ivory black, and white. The grass is phthalo blue, cadmium yellow, and yellow ochre. Once I have painted the sunlit tree trunks—with the same color I used for the sunlit rocks—I have enough information to finish the painting in the studio.

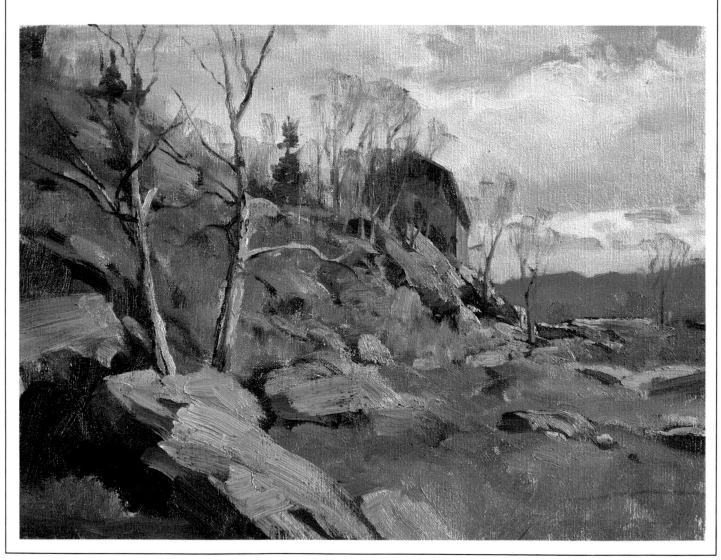

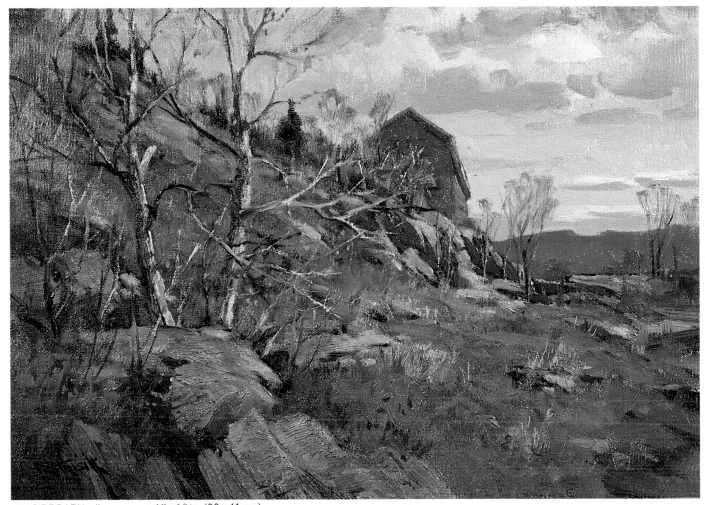

HILLSIDE BARN, oil on canvas, 12 x 16 in. (30 x 41 cm)

Step 5. Back in my studio, I decide to open up the sky near the horizon, using phthalo blue, white, and a touch of yellow ochre. This clean blue-green harmonizes with the reds of the landscape. I remove some of the trees from in front of the barn because I like the building's silhouette and want to see it more clearly. Since the season is early spring, I feel that it needs richer grass tones, and so I add phthalo blue and cadmium yellow medium, which I work over the land in broken strokes. I also lighten the dark sides of the distant rocks. These shadows were dark on location, but by lightening and warming them with raw sienna, I suggest reflected light and increase the picture's luminosity. The darks in the foreground also have more strength.

Step 1. A subject like this New England stream is effective on a gray day. It doesn't suffer from the lack of sunlight, for there are still strong contrasts between the white water and the dark rocks and trees.

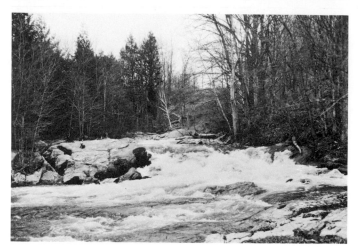

Step 2. I lay-in the sky using a wash of ivory black with a touch of yellow ochre. The yellow ochre gives the sky additional energy and luminosity. I leave out the distant hillside, which I feel would be difficult to explain in the picture. I establish the dark of the trees and rocks with burnt sienna and ultramarine blue and the water, with cobalt blue and yellow ochre. For the pine tree, I mix phthalo blue and burnt sienna. I add this color note, which is unlike any other in the picture, early in order to get a proper sense of the different color relationships. If I were to judge the rocks, for instance, only against the reddish background, I might paint them differently.

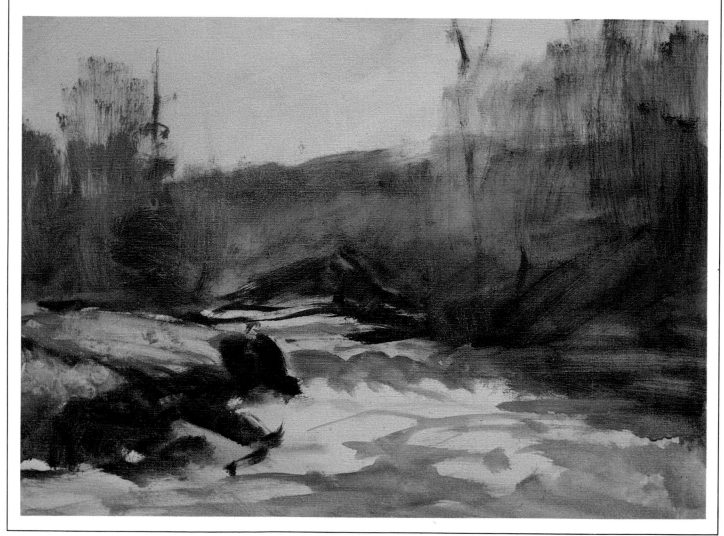

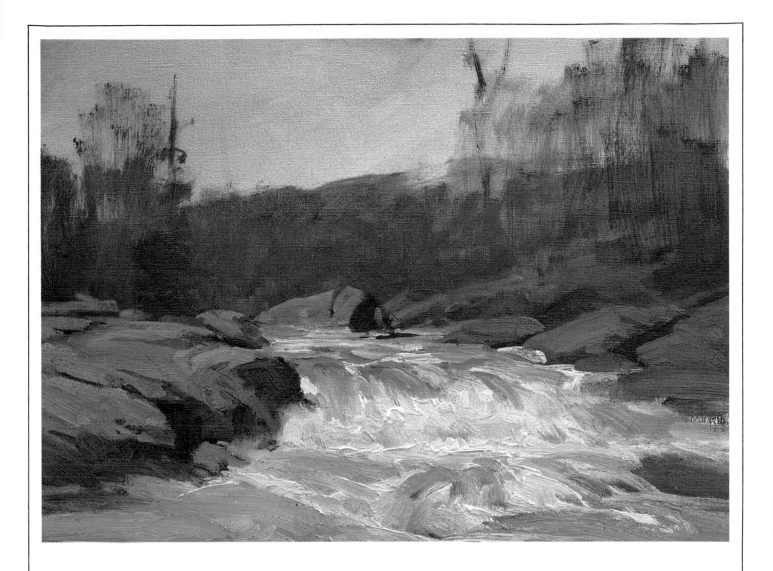

Step 3. Having accurately established the colors and values of the trees and sky, I can paint the rocks and water more easily. The top planes of the rocks, affected by the silver light of the sky, are a mixture of cobalt blue, yellow ochre, and white. Now I use more yellow ochre and cobalt blue in the water, manipulating the mix as I work, so that it reads as either a cool or a warm color. The water is cooler on the top planes, where it reflects the sky, and warmer on the sides, where we can look into the depths. The top planes of the foam receive the most light, so I paint them pure white. However, as I paint the white water I pick up surrounding colors and thus get an interesting variety of values within the foam. Of course, I can't paint the water photographically. Instead, I try to get an emotionally satisfying expression of its character and rhythms. The water at the site, as shown in Step 1, is completely chaotic—at least, that's how the camera recorded it. However, I can study the ordered *flow* of the stream and try to get that feeling into my picture.

Step 4. I place light and dark trees in the background and emphasize the light in the sky by adding brighter color (yellow ochre and white) at the zenith. I modify colors here and there, change shapes, and add details such as the clusters of branches against the sky and the few dried leaves on the tree. I also place other pines around the picture so that the principal pine on the left isn't an isolated spot of color. Most importantly, I redesign the rocks on the left. They're monotonous, so I break them up and give them a more angular shape. Back in the studio, I make more subtle adjustments, and I consider the painting finished.

THE SILVERY STREAM, oil on canvas, 12 x 16 in. (30 x 41 cm)

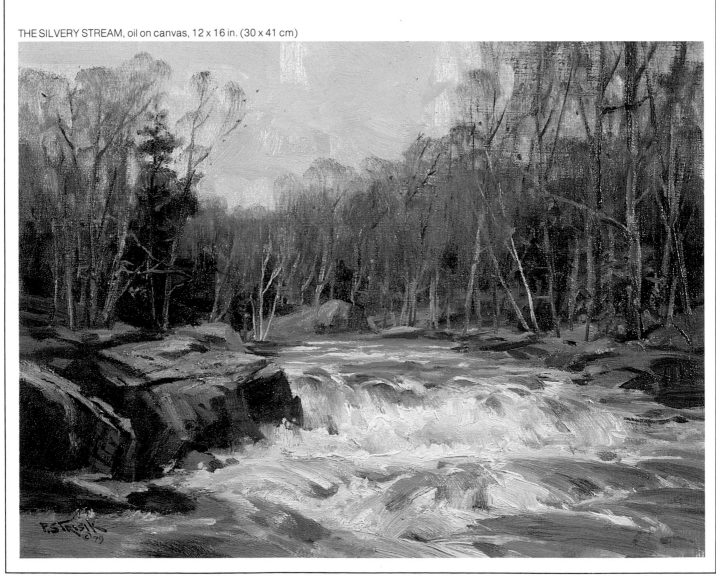

Mountain Shadows, Banff, oil on canvas, 30 x 40 in. (76 x 102 cm). I was attracted to this scene by the patterns of the cloud shadows moving over the landscape. I used these shadows to emphasize the sunlit foreground, to subdue the unimportant middle distance, and to direct attention toward the brilliantly lit mountain peak. Areas of rock show within the shadowed mass of pines. Your eye enters the picture by way of the strongly lit foreground, moves up the broken area of rock outcroppings, and comes to rest on the snow-capped mountain. I keep the sky low in value and muted in color so it doesn't compete with the mountain.

Down-East Workshop, watercolor, 20 x 28 in. (51 x 71 cm). This painting shows the importance of having a single center of interest—in this case, the sunlit vise, which is the brightest area. As your eye moves back into the shed, objects become darker and more elusive; if you squint your eye, the background clutter forms one large mass. By minimizing contrast in this area, I eliminated distracting lights and darks that would have taken attention away from the center of interest.

good painting is all about.

It's this knowledge—that elusive quality called "taste"—that gives a picture the dignity common to all fine things. In the complex business of painting, the difference between good work and a masterpiece is often very slight. But those differences show the hand of the master. That's why a picture of a grand subject can leave you unmoved—while a painting of a simple motif, deeply felt and properly expressed, can bring tears to your eyes.

Some students wait for the teacher to tell them what to do. They yearn, as they often say, to be "only half as good as the instructor." The other kind of student tries to understand the *principle* behind the teacher's words; and then applies it himself. One walks in the footsteps of other painters; the other is on the same road, but finds his own way.

I used to tell students at my workshops that their paintings wouldn't necessarily improve during the two weeks we were together. In fact, they might even get *worse*. You may have the same problem after reading this book. The reason is obvious. At home on your own, you work in a comfortable and familiar groove. There's no one to kick you, no one to open a new gate and push you through. However, when you begin to *learn*, your mind is stirred up. Your old formulas no longer seem valid, and you start to have trouble. Don't worry about it. Once it's in your head, even the smallest idea can be powerful. But it takes time for it to get onto your canvas. The knowledge you get from teachers and books is like the parts of a jigsaw puzzle. You know the parts are valuable, but you don't always know what to do with them. Then, one day things fit, and you discover where the odd piece belongs. That's why one reading of a solid book of instruction is never enough. It must be read and reread, till you fully understand what the teacher is saying. The student skims over many important ideas, thinking that he's read that before. He may have—but did he understand it? My favorite books are worn and thumbmarked. As a student, I read John Carlson's book fifteen times, but I can still pick it up and find passages that seem new to me. Between readings, I've learned more, and each time I return to the book I can better appreciate what Carlson is trying to say.

Painting has a practical side, a side of common sense and judgment that parallels much of what students have been experiencing all their lives. Have you noticed, for example, that there are no child prodigies in painting? They exist in music and mathematics—but not in painting. Painting is the sum total of the human being. At seventeen, a person may have a phenomenal technique, but technique has little to do with the power of conception. That takes experience—not just painting experience but sadness, happiness, personal reactions to the general business of living. Nature can move an adult to tears, but not a child. The child's emotional range hasn't had a chance to be exercised and expanded.

Painters mature in a slow and natural way. So don't worry about starting late in art. I started late myself. You can start at thirty-five, forty, or even later. It may take ten years to develop your skills. But nothing is lost, for you've still lived all those years. The painting you do five years from now can only be done five years from now. You can't rush it, and it can't be done tomorrow. I was as eager a student as anyone, and if there were any shortcuts, I'd have found them. I didn't, and I still haven't. In fact, I have more second thoughts and more struggles now than when I was a student, simply because I've learned to demand more of myself.

The development of your particular mode of expression is also related to your development as a person. If you remember the importance of painting good pictures, of getting beyond the obvious and trite, and of seizing what you *like* in nature—then ten years from now your pictures will be more finished and complete than they are now because they'll say more about their subjects. Of course, when I use the word *more*, I don't mean your pictures will be full of detail. In the early paintings of Velàsquez, you could see the cuticles of his subject's fingernails. In his later paintings, you could barely see the fingers! His work became more elusive and suggestive—more like nature itself. His paintings were more finished, though they contained less detail.

To develop as an artist, you must constantly ask yourself, "What do I want out of painting?" It's easy to paint what everyone paints; but is that material really personal? A red barn, for example, is a common subject, and you have a strike against you when you paint it: people sense that they've seen it before. It's "approved" subject matter. Yet, if you can find a piece of nature and give it design and poetry, it will be *your* picture, expressing your own unique vision. You've seen the world in a different way and can give people a fresh and individual experience. I'd rather see one rock painted with sincerity and feeling than a canvas full of grand-opera effects. Making a "picture of things" is easy. But when you let people see the soul and drama of a subject, you've let them see it through the eyes of an artist.

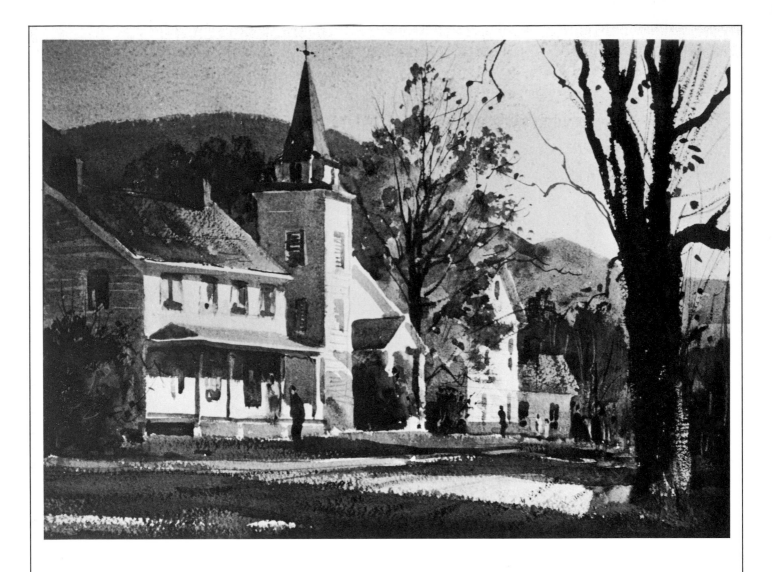

Bondville, watercolor, 14 x 21 in. (36 x 53 cm). You do not have to be literal to be truthful in painting. In this watercolor I made changes in the scene which not only emphasize the flavor of New England architecture, but also enhance my composition: I shortened the church tower so it would fit the oblong composition without the other buildings becoming too small; eliminated a house that did not contribute much to the overall design; pulled the foreground elm into the picture; and diminished the importance of the road by throwing it into shadow, thereby giving more punch to the sunlit areas. The maple in the middle distance obscures some of the houses and thus plays up the importance of the church. Because of these careful additions and omissions, the painting actually looks more like the street than the street itself—that is, it's more expressive of the nature of a small Vermont town.

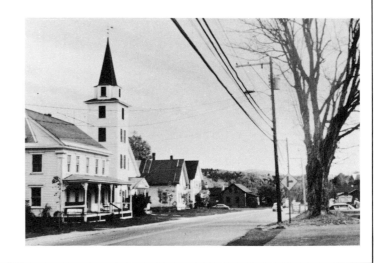

The following is a brief list of books that come immediately to my mind. As a student, however, you should make it your business to read everything you can about art. Every book has something of value in it.

Carlson, John F. *Landscape Painting*. New York: Dover Publications, 1974.

Fawcett, Robert. *On the Art of Drawing*. New York: Watson-Guptill, 1958.

Grosser, Maurice. *The Painter's Eye*. New York: Holt, Rinehart & Winston, Inc., 1955.

Hawthorne, Charles. *Hawthorne on Painting*. New York: Dover Publications, 1960.

Henri, Robert. *The Art Spirit*. Philadelphia: J. B. Lippincott Co., 1930.

Rewald, John. *History of Impressionism*. New York: Museum of Modern Art, 1961.

Reynolds, Joshua. *Discourses*. New York: Collier Books, 1961.

And the one book that should be in every painter's library: Mayer, Ralph. *The Artist's Handbook of Materials and Techniques*. New York: Viking Press, 1957.

INDEX

Edited by Betty Vera
Designed by Bob Fillie